THE BIG BOOK OF
PAINTING
NATURE
IN PASTEL

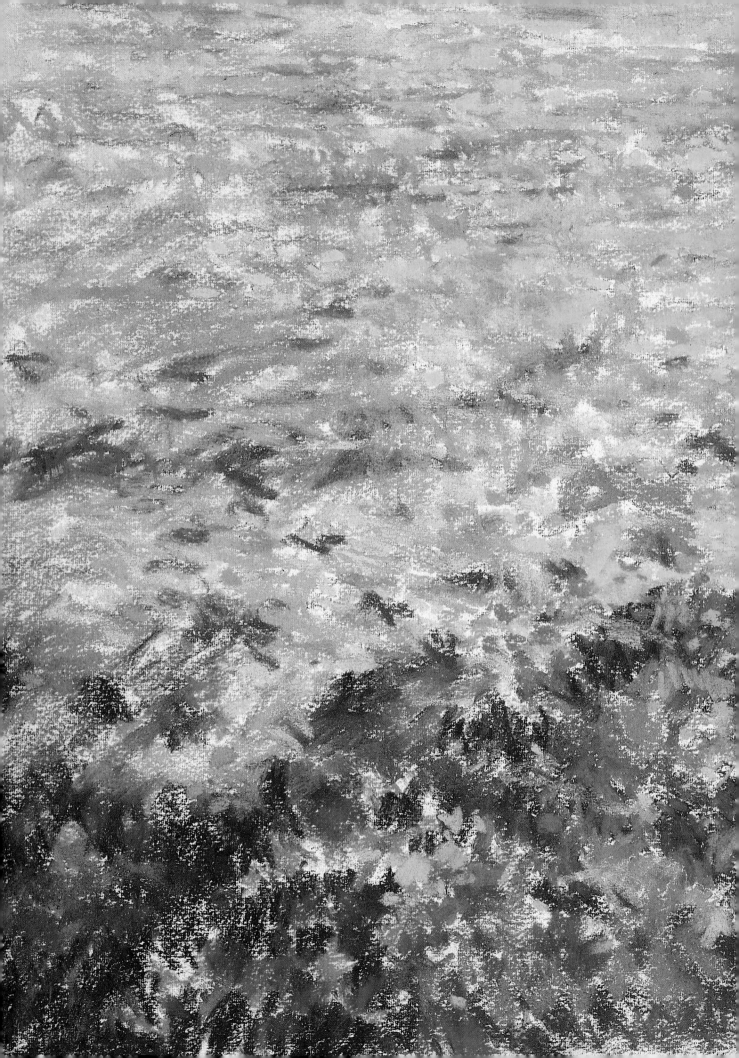

THE BIG BOOK OF
PAINTING
NATURE
IN PASTEL

PAINTINGS BY S. ALLYN SCHAEFFER

PHOTOGRAPHS BY JOHN SHAW

WATSON-GUPTILL PUBLICATIONS/NEW YORK

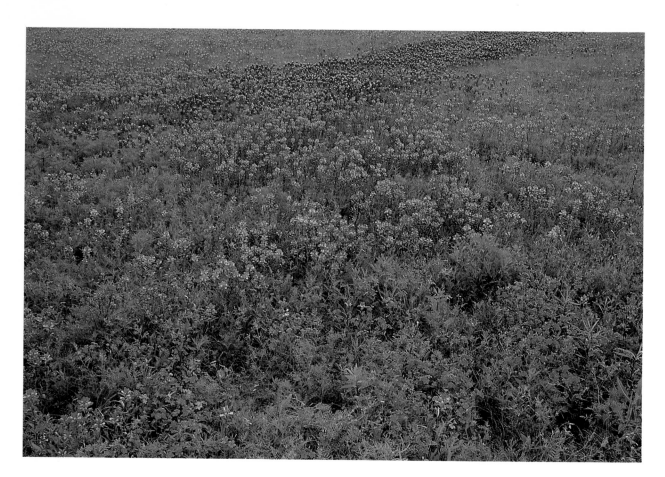

Edited by Marian Appellof
Designed by Bob Fillie
Graphic production by Ellen Greene
Text set in 11-point Century Old Style

Copyright © 1993 by Watson-Guptill Publications

First published in 1993 in the United States by Watson-Guptill Publications, a
division of BPI Communications, Inc., 1515 Broadway, New York, N.Y. 10036

Library of Congress Cataloging-in-Publication Data
Schaeffer, S. Allyn, 1935-
 The big book of painting nature in pastel / paintings by S. Allyn Schaeffer ;
photographs by John Shaw.
 p. cm.
 Includes index.
 ISBN 0-8230-0504-6 (pbk.)
 1. Landscape in art. 2. Nature (Aesthetics) 3. Pastel drawing—
Technique. 4. Drawing from photographs. I. Shaw, John, 1944-
II. Title.
NC795.S35 1993
743'.83—dc20 93-17234
 CIP

Manufactured in Italy

First printing, 1993

1 2 3 4 5 / 97 96 95 94 93

Contents

Introduction

Pastel offers the artist something no other medium can: the simultaneous pleasures of drawing and painting in lush, vivid color. Pastel is extremely responsive; the minute you touch one of the deliciously soft sticks to paper, color and line just seem to flow by themselves. Indeed, it's this quality of immediacy and spontaneity that makes pastel so ideal for capturing nature expressively. Pastel is especially practical for working outdoors, since you don't need much equipment. No sooner have you opened a box of pastels and clipped a sheet of paper to your working surface than you're ready to begin.

As long ago as the Renaissance, such artists as Leonardo da Vinci, Michelangelo, and Raphael were discovering the expressive possibilities of drawing with red and white chalk and charcoal, the precursors to modern pastels. Over the centuries, as more and more colors became available, the art of pastel painting evolved. This medium became a special favorite of the Impressionists, who found its ease of application uniquely suited to their explorations of light, color, fleeting atmospheric effects, and the transitory quality of life. Of all artists who have ever worked in pastel, it is the Impressionist master Edgar Degas who probably best defines what can be done with this sensuous medium. He produced hundreds of beautiful works in pastel, considering them not merely sketches but finished paintings equal in stature to his masterpieces in oil. Degas explored pastel as no other artist before him ever had, applying it in innovative ways and daring to mix it with other mediums as he sought its artistic potential.

One of the distinct advantages of this medium is that, unlike paints with an oil or water base, pastel is a dry paint. This means not only that you don't have to worry about drying time, but also that the color you put down stays the way you see it then and there and always looks fresh; it won't sink into the painting surface and change color or turn dull the way oils or watercolors can when they dry.

As for color, the range available to pastelists today seems almost limitless. In fact, if you're accustomed to working in liquid paint, and thus to mixing one tube color with another on your palette to get the exact hue you're after, you may find pastel baffling at first, since in this medium colors are blended directly on the painting surface. However, the compensating advantage pastel offers is, you never have to worry about matching colors; you just pick up the same sticks each time.

Pastels are extremely versatile. You can build up compositions slowly, adding layer after layer of color. Or you can work quickly and directly, making loose, impressionistic strokes using the tip of the pastel or laying in broad swaths of color using the side of the stick. You can blend color to a smooth, even softness with your finger or other tool, or simply let the strokes blend themselves as you lay one atop another. You can scrape color off a pastel stick and press the particles onto your painting for a delicate, hazy effect. You can also create washes of color as you would with liquid paint by brushing a pastel-covered area with water or rubbing alcohol. It's possible as well to take advantage of what fixative can do besides help adhere the pastel to your working surface.

Pastel is such a flexible, unintimidating medium that you'll welcome every chance you get to practice with it, and will soon find yourself working confidently, even daringly. Whether you want to paint broad vistas or intimate closeups, majestic mountains, quiet lakes, a single flower, or a bird poised for flight, painting your subject in pastel will prove endlessly challenging, always fresh, and immensely satisfying. It's hoped that you will find pastel as exciting as Degas did, and that you'll adopt his spirit of exploration as you make your way through the pages of this book.

HOW THIS BOOK IS ORGANIZED

This book brings you everything you need to begin painting nature in pastel. We start with the basics, the essential materials and techniques. Next, we explore color, then go on to special effects that can add excitement to your work, such as dusting, working with solvents, and using oil washes as underpainting. Once you have gained a good understanding of the color information and pastel techniques presented in this section, you can work your way through any of the 72 lessons that make up this book.

You will explore numerous ways to depict all kinds of subjects in nature, in every season, all kinds of weather, and in a wide variety of geographical settings: spectacular snow-covered mountains in the Pacific Northwest; brilliant North Carolina summer sunsets; delicate

seashells washed up on a Florida shore; incredible rock formations in the deserts of the Southwest; cold, angry Midwestern skies; and billowing cumulus clouds, alpine meadows carpeted in wild flowers, cypress forests, meandering and rushing streams, autumn foliage, even lowly dandelions. You'll learn to paint the light as it looks at different times of day; water in all its guises—rivers, lakes, oceans, ice, fog, and snow; and all kinds of trees, plants, and animals.

Each lesson concentrates on a concrete problem that you are likely to encounter when you paint nature. First the challenges that each situation presents are analyzed, then a working procedure is outlined. As you work your way through the book, you will find that many situations have more than one solution, and you will come to understand how and why decisions are made as you read about how each of the paintings is executed.

Each lesson explains all the steps in the painting process, clearly pointing out what is done and how it is accomplished and providing specific information about the colors and techniques used. Many of the lessons have step-by-step demonstrations that make it easy for you to see how the painting was developed.

Supplementary assignments are included throughout the book, either elaborating on a point covered in the lesson or branching out in a new direction. All the lessons are designed to get you involved in painting with pastel and to take you beyond the limits of the illustrated demonstrations.

Feel free to turn to any lesson that interests you; they need not be done in any particular order. However, since some of the assignments are based on the lessons, it may be helpful to read the corresponding lesson before you work on an assignment.

THE PHOTOGRAPHS

This book includes the actual photographs the artist worked from as he executed the paintings, giving you an advantage that few painting instruction volumes provide. These photographs are an invaluable aid to understanding how to translate what you see into good paintings. Before you read each lesson, spend a little time looking at the photograph and at the finished painting; that way you'll start to grasp how the artist interpreted what he saw.

These superb photographs can help you discover new subject matter and new ways of composing your paintings. When you study a photograph, note how the scene is composed. What angle did the photographer use? How did he frame the subject? What kind of light fills the shot? Did he achieve any unusual effects? Then, when you are outdoors, try to apply what you have learned as you search out new ways to see the world around you.

If you are inexperienced with composition and are unsure of how to frame your subject, try using a viewfinder. They are easy to make. Measure the paper or board you will be working on, then divide its height and width by 4 (by 5 or 6 if you are painting on a really big surface). Draw a rectangle in the resulting size on a piece of cardboard, then cut the rectangle out using a hobby knife or scissors. Outdoors, hold the cardboard up and look through it at the landscape, framing what you see. Try to envision all the possible views. Don't just look at the subject horizontally; try looking at it vertically, too. Step closer to your subject, then try looking at it from a distance.

Using a viewfinder makes it easy to ignore distracting elements and to find and focus clearly on a subject. It simplifies preliminary work, just as studying the beautifully composed photographs in this book will do.

DEVELOPING YOUR OWN STYLE

As you work through the lessons in this book, don't feel you have to copy them slavishly. Instead, try to think of fresh solutions to the problems posed here. Look at each photograph before you read the lesson. Analyze it, and try to figure out how you would approach the scene if you encountered it outdoors. Then read the lesson critically. If the solution we offer seems more effective than the one you've thought of, follow it, but if you prefer your own approach, give it a try. As you will quickly learn, there is no one way to paint any subject in nature—there are thousands of ways, and discovering them, as well as what the medium of pastel can do, will be ceaselessly fascinating.

Materials

Happily, painting in pastel doesn't require a lot of equipment—basically all you need are the pastels themselves, papers or other supports, and a few additional tools and materials. Always buy the best you can afford.

PASTELS

Pastels are chalklike sticks composed of pure powdered pigment plus a binder. There are three kinds: soft pastels, hard pastels, and pastel pencils. (Oil pastels, the oil-based cousins of chalk pastels, are not covered here.)

Soft Pastels

Soft pastels deliver generous amounts of color that goes down velvety and is easily smudged. They are also water soluble. Most brands are cylindrical and come in a paper wrapper; others are rectangular, with square tips and flat sides.

Soft pastels are available as individual sticks and in sets of a dozen to several hundred colors. There are assortments of colors selected specifically for landscape painting, and others designed for figure and portrait work.

If you're just starting out, buy the largest set of pastels your budget allows. A box of 15 colors would be enough to get you acquainted with the available range. Sets of half sticks give you more colors for the price. As you become more proficient, you can always add new colors by purchasing single sticks.

Among the best-known brands of soft pastels are Sennelier, made in France in more than 500 colors; Rowney, made in England by Daler-Rowney in a range of 144 colors; Rembrandt, made in Holland by Talens and available in over 200 colors; and

Holbein, made in Japan in 144 colors. Other fine brands are Quentin de la Tour/Girault (France); Grumbacher (United States); and Schmincke (Germany).

Hard Pastels and Pastel Pencils

Hard pastels are firmer and denser than soft pastels, which makes them good for drawing, sketching, and fine detail. They are especially useful in the early stages of a painting, both for drawing and for rapidly laying in the basic color and compositional scheme. Well-known brands of hard pastels are NuPastel, made in the United States by Eberhard Faber, and Conté, made in France.

Pastel pencils are hard pastels in pencil form and are used for much the same work. They can be sharpened to a fine point like drawing pencils. Two well-known brands are Othello, made in Germany by Schwan, and Conté.

PAPERS AND OTHER SUPPORTS

Pastel can be used on grounds that range from paper to plywood, and reveals the character of the surface you apply it to.

The amount of "tooth," or surface texture, a support has is very important. When you apply pastel to a surface, the pigment adheres to its ridges. As you add more pigment, the tooth fills up and the surface becomes smooth. Eventually it becomes too smooth to hold any more pastel, and pigment will start to flake off. The more tooth a surface has to begin with, the more layers of pastel it can hold.

Pastel papers come in a wide array of colors. What you choose will depend on your subject and the feeling you want to convey, since a colored ground strongly

Rowney soft pastels in sets of 24 and 12 colors.

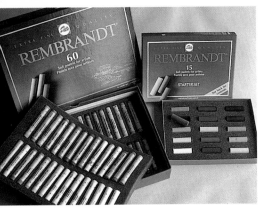

Rembrandt's landscape-painting set of 60 full-size soft pastels and 15-color half-stick starter set.

Sennelier soft pastels in a wooden-boxed set of 100 colors for landscape painting.

influences all the color and value relationships you establish in a painting.

To ensure the best results, always work on high-quality papers with a neutral pH. The supports mentioned here, all of fine-art quality, are but a sampling of what's available.

Pastel Papers

One of the best-known brands of pastel paper is the French-made Canson Mi-Teintes, which comes in 51 colors and is textured on both sides. Some other makers of fine pastel papers are Strathmore, Crescent, Daler-Rowney, Fabriano, Larroque, and Lana.

Sanded and Coated Papers

Sanded pastel paper, available in fine and extra-fine grits, comes in both sheets and rolls. This surface can hold a lot of pastel pigment and is especially good when you want smooth texture.

La Carte Pastel board, made in France, has a vegetable-fiber coating that is slightly abrasive and takes pastel beautifully. It comes in over a dozen colors.

Sabretooth pastel paper is a stiff bristol board coated with sanded latex, making it very receptive to pastel. Produced for Holbein, it comes in nine colors.

Pastel cloth, a synthetic material, has a strong tooth that really holds pastel pigment. It can be stretched on a frame like canvas.

Velour paper, available in over a dozen colors, has a velvety, suedelike surface that gives pastel applied to it a blurred, soft-focus look. It doesn't permit textural buildup or crisp lines.

Other Supports

Watercolor and printmaking papers, especially cold-pressed (medium-textured) and rough finishes, are excellent surfaces to work on. Generally heavier than pastel papers, they can take more abuse, and their tremendous wet strength makes them ideal when you want to use wash techniques or combine pastel with water-based mediums.

Illustration board and museum mat board are firm, durable supports that will stand up to vigorous pastel work, especially erasing and other abrasive techniques. You can also mount paper on these supports.

TONING AND TEXTURING SUPPORTS

You needn't limit yourself to colored pastel papers when you want a toned ground. You can tone grounds yourself with watercolor or acrylic paint, or any medium that won't affect the surface adversely. You can also create sanded grounds using powdered pumice and acrylic. In both cases, it's best to use watercolor paper or illustration board as your support.

To tone a ground with watercolor, simply lay in a wash and wait until it is thoroughly dry before you apply pastel. With acrylic you can create either transparent or opaque tones, depending on how much water you use.

To create a sanded ground, in a wide-mouth container, mix acrylic paint of the desired color with about an equal amount of water. Into this mixture sprinkle some powdered pumice stone, and stir. (Powdered pumice is available in hardware stores in various grades. You can also use marble dust or finely ground quartz.) The more pumice you use, the coarser a surface you get. The best support for this kind of ground is illustration board or museum mat board. Lay your board flat and, with a 3-inch housepainter's brush, cover the surface rapidly with the mixture using broad strokes. Smooth out the coating with parallel strokes, aiming for an even distribution of the pumice particles. When the board is dry, place a heavy weight on it and leave it overnight to flatten it.

Holbein soft pastels in a set of 24 colors; the large sticks are water-soluble soft pastels.

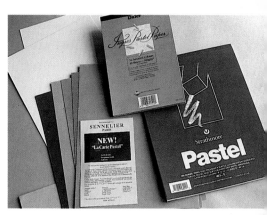

A selection of pastel grounds. Left to right: Sabretooth paper; La Carte Pastel board; Daler Ingres pastel paper; Strathmore 400-series pastel paper.

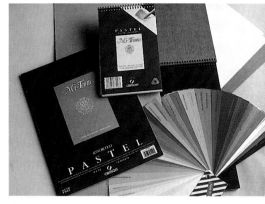

Canson Mi-Teintes pastel paper is available in a wide array of colors and formats, including loose sheets, rolls, pads with detachable sheets, and spiral-bound sketchpads interleaved with glassine paper.

FIXATIVES

Fixative is a dilute solution of varnish that is sprayed on a pastel painting to help the pigment particles adhere to the surface. Commonly sold in aerosol spray cans, fixative also comes in bottles and can be used with an atomizer or, for special effects, applied with a brush. There are two kinds of fixative, workable and final. Both darken pastel color.

Workable fixative is extremely useful when the buildup of pastel on your painting surface has become so thick and the surface so smooth that color begins to flake off, yet you're not done working. A spray of workable fixative binds and isolates the layer of pastel particles and renews surface tooth, allowing you to apply more color on top of it. Final fixative is applied only to pastel paintings that are considered finished, since it doesn't permit further work. Both types help guard against smearing.

An interesting fixative can be made by mixing acrylic matte medium with water and, if you want texture, powdered pumice. This solution is sprayed on with an atomizer.

Use fixative only where ventilation is adequate, and always read the manufacturer's directions. Test-spray fixative before applying it to a painting to ensure a fine, even mist.

SOLVENTS

Pastels are water soluble, meaning that you can create beautiful wash effects just by applying a paintbrush dampened with water to passages of pastel color. (It's best, however, to use water only on surfaces with good wet strength, like watercolor paper.) Turpentine, mineral spirits, and isopropyl alcohol (rubbing alcohol) are good alternatives that dry almost immediately.

Solvents are useful in the early stages of a painting when you want to establish color and value

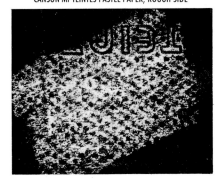

CANSON MI-TEINTES PASTEL PAPER, ROUGH SIDE

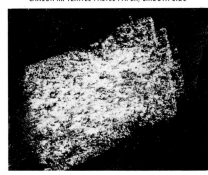

CANSON MI-TEINTES PASTEL PAPER, SMOOTH SIDE

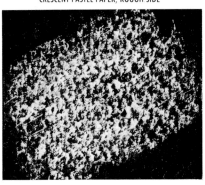

CRESCENT PASTEL PAPER, ROUGH SIDE

CRESCENT PASTEL PAPER, SMOOTH SIDE

Pastel papers vary in texture from brand to brand, and many of them have a more pronounced texture on one side than on the other. You can work on either side, depending on what effect you're after. Here is a comparison of the way pastel looks when applied to the rough and smooth sides of Canson Mi-Teintes and Crescent pastel papers.

structure quickly; simply stroke on pastel in a shorthand way, then use a brush dipped in solvent to spread it for a washlike underpainting. In later stages, solvent applied with a pointed brush helps when you need to sharpen edges; it dissolves the pastel just enough to let you move it where you want it with precision.

PAINTS

Water-based paints—watercolor, gouache, acrylic, casein, and tempera—as well as oil paints can all be used to create thin underpaintings for pastels. Water-based paints work on most surfaces, but to avoid buckling, don't use them on thin papers—strong watercolor papers are a safer bet.

Acrylic paint is versatile, permitting both transparent and opaque effects. It dries fast and is permanent. To make an acrylic wash, mix the paint with water and/or acrylic medium to a thin consistency.

Pastel works well over thin, transparent washes of oil paint. To create oil washes, mix your paints with plenty of turpentine to a thin consistency. (*Never* use linseed oil or any other slow-drying paint medium; they would take too long to dry and would result in a slick surface that pastel won't adhere to.) Give washes sufficient time to dry before working over them in pastel.

PALETTES

In pastel, a palette isn't a mixing surface but a place to organize your colors, whether you have a dozen pastel sticks or hundreds.

Many artists divide their pastels into two or three categories: a working palette containing just the colors being used for a given painting; a master palette containing the overall range of frequently used colors; and a supplementary palette of extra and less often used colors.

To hold the colors of your

working palette, a small tray will do. A compartmented wooden box like the ones larger pastel sets are often sold in works well as a master palette. Shallow cardboard boxes, each containing a different color group, could serve as a supplementary palette.

DRAWING BOARDS
Your work surface can be a piece of hardboard or Plexiglas—almost any firm, even surface will do. Get a board that's large enough to accommodate at least the largest standard-size sheet of pastel paper (about 19 × 25 inches) or watercolor paper (22 × 30 inches), with a generous margin on all sides.

When mounting your paper to the drawing board, place one or more sheets of the same size—never smaller—underneath it to provide some "give" so your painting surface will take pastel evenly.

EASELS
If you work indoors, invest in a solid, well-constructed studio easel that adjusts to different sizes of painting surfaces. It must raise, lower, and tilt backward and forward, and should have a top bar for bracing your drawing board. For outdoors, a folding French easel or portable aluminum easel is handy.

WORKTABLE
You need a large, sturdy worktable to hold your pastels and supplies comfortably and within easy reach. The best location for a worktable is between your easel and the light source so you can see all your colors. Whether you sit or stand to work, the table's height should suit your needs.

CHARCOAL AND DRAWING INK
For sketching your subject, you need soft vine charcoal, which can be wiped away with a tissue.

For more detailed drawings, charcoal pencil gives you extra control. In either case, you may need to spray your preliminary drawing with fixative before working over it in pastel.

Some subjects call for strong, dark underdrawings that won't get lost when you paint over them with pastel. Black drawing ink applied with a brush makes it easier to establish large, dark forms, solid silhouettes, and fine details early in a painting. Use a good-quality small, pointed round brush, the kind used in watercolor painting.

BLENDING TOOLS
Besides your fingers, you should have on hand a few other blending tools. Tortillons and stomps, rigid, pencillike cylinders of soft, rolled paper with pointed tips, allow you to blend and spread pastel cleanly and precisely, especially in small areas. Other blending tools include soft rags, chamois, paper towels, and sponge brushes.

PALETTE KNIVES AND RAZOR BLADES
A smooth, flat palette knife can be used to press loose particles of pastel into your painting surface to help them adhere (as in the dusting technique). You can also use the knife to gently scrape color off a painting.

Single-edge razor blades are handy for scraping color off a painting to reveal an underlying color or to make a correction. They are indispensable as well for scraping particles of color off pastel sticks in the dusting technique. You can also use them to sharpen hard pastels and charcoal pencils, and to cut large paper to size.

SHARPENERS AND ERASERS
Keep a good pencil sharpener on hand for sharpening your pastel pencils. A sandpaper pad is handy for this, too.

A kneaded eraser is useful for

lifting color off your painting surface without smearing, and is relatively kind to paper. First scrape away as much pastel as you can with a razor blade or palette knife, then press a clean kneaded eraser firmly against the painting surface to lift color.

TAPE, CLIPS, TACKS, AND STAPLES
Masking tape can be used to fasten painting surfaces to your drawing board; ½-inch or 1-inch-wide tape is fine. Some artists prefer spring or clamp-type clips for this purpose; others like pushpins or staples.

CARE AND CLEANUP
Painting is more enjoyable if you work in a clean environment. To keep the problem of pastel dust in check, vacuum your studio regularly. Have soft rags and tissues on hand to clean pastel sticks after use and to wipe loose pigment off your hands. To avoid inhaling pastel dust, don't blow loose particles off your paintings, since that only disperses the dust into the air. Wash your hands often to guard against ingesting pastel particles.

Store loose sheets of paper and boards flat, out of sunlight, and away from dirt in a cabinet or closet. Make sure the storage space is dry, since humidity can cause paper to mildew.

STORING YOUR PAINTINGS
Properly framed behind glass, pastel paintings are virtually permanent. Unframed pastels, however, call for some special precautions. The best place to store them is in a large, flat drawer away from dust, dirt, and dampness. Cover individual paintings with a sheet of acetate, glassine, or other smooth, acid-free paper. Make sure the protective sheet is securely attached to prevent lateral movement that could cause smearing. Then you can stack the paintings in a drawer, or in an artist's portfolio laid flat.

Color

Working with color is one of pastel painting's great delights, for in this medium you are working with virtually pure pigments. Yet many beginning artists feel overwhelmed by the vast range of hues that exist, as well as by color relationships and by the seemingly infinite possibilities color offers for personal expression. Handling color may seem difficult at first, but once you understand the basic vocabulary, all you need to do is explore.

UNDERSTANDING COLOR
Red, yellow, and blue are called primary colors—colors that cannot be mixed from any other colors. Mixing these primaries together results in the secondary colors: green (yellow plus blue), violet (blue plus red), and orange (red plus yellow). When primary and secondary colors are mixed together, tertiary colors result—colors such as blue-violet and yellow-green. The easiest way to illustrate color relationships is to place the colors on a color wheel.

Any two colors that lie across from each other on the color wheel are called *complements,* or opposites. Green and red, orange and blue, and yellow and violet are examples of complements. A group of colors that share the same primary, and are thus adjacent to one another on the color wheel, are called *analogous* colors. Blue, blue-green, green, and yellow-green, for instance, are analogous because all share the primary color blue.

COLOR CHARACTERISTICS
Every color has three main characteristics: hue, value, and intensity. *Hue* refers to the color's name; blue, green, and red-violet are all names of hues.

Value refers to how light or dark a hue is. White is the highest value, black the lowest. All colors can be measured the same way. If you find it difficult to distinguish how light or dark certain colors are, try squinting, which emphasizes the lightest lights and darkest darks. Or imagine how something would look if it was photographed in black and white.

Intensity refers to a hue's brilliance. Bright red is high in intensity. To reduce a color's intensity, or neutralize it, you can add white or black to the color, which will change its value; or, you can add the color's complement to it, which will change its hue and sometimes its value. (This depends on how light or dark each of the complements is.) Adding a touch of bright green to the red makes it duller and less intense, but doesn't lower the value because the two colors are of about equal value. Adding a touch of violet to bright yellow, however, both dulls the yellow and darkens it.

TEMPERATURE
Color is often described in terms of *temperature*; some colors are considered warm, others cool.

RED-ORANGE

RED-VIOLET

RED

ORANGE

VIOLET

YELLOW-ORANGE

BLUE-VIOLET

YELLOW

BLUE

GREEN

YELLOW-GREEN

BLUE-GREEN

Large squares indicate red, yellow, and blue—the primary colors. Medium squares indicate orange, green, and violet—the secondary colors. The smallest squares were mixed from the adjoining primary and secondary colors and indicate tertiary colors. The gray square in the center is a neutral made up of the three primary colors.

Broadly speaking, yellow, orange, and red are warm colors, and green, blue, and violet are cool colors. But within a hue, temperature varies; there are, for example, warm reds (those that lean toward yellow on the color wheel) and cool ones (those that lean toward blue). Permanent red is a warm red, madder lake deep a cool one; cerulean blue is warm, ultramarine blue is cool. Temperature can change in context. Against cool violet and blue, madder lake deep looks warm. Beside permanent red, cerulean blue looks cool.

Temperature is a useful compositional tool, for warm colors tend to advance and cool ones recede. Adding a little violet to a distant mountain can push it back visually. Using bright yellow in the foreground of a painting can push the area forward.

SELECTING YOUR PALETTE COLORS
Pastels are manufactured in a range of pure, or basic, colors; each basic color is then mixed incrementally with white to produce several *tints* of progressively lighter value, and likewise with varying amounts of black to produce a gradated range of *shades*. The French manufacturer Sennelier, for example, offers 83 pure-color soft pastels, and for each of these, enough tints and shades to comprise a total of 552 sticks! Every manufacturer has its own system for naming or numbering colors and indicating the amount of black or white added to them.

This doesn't mean you must buy an enormous set of pastels to have an adequate hue and value range to work with. Fortunately, even small sets are made up of a selection of pure colors, tints, and shades. What's important is that your palette include a good balance of both warm and cool colors in a range of values.

A basic beginner's palette of soft pastels might consist of the following pure colors (names

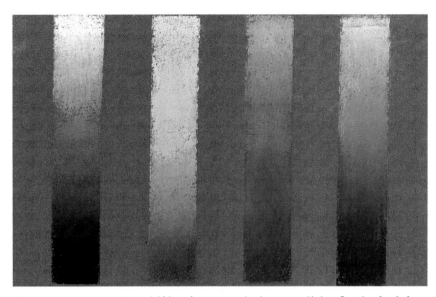

Here you can see values shifting from very dark to very light. On the far left, pure black occupies the bottom of the column; increasing quantities of white are mixed into the black as you move up the column. The three primary colors are similarly adjusted with additions of black and white.

vary according to manufacturer), plus perhaps one tint and one shade of each:

White
Light yellow
Yellow ocher
Permanent red light
Madder lake deep
Caput mortuum red
Burnt sienna
Burnt umber
Mars violet
Violet
Ultramarine deep
Cobalt blue
Prussian blue
Cerulean blue
Chrome green light
Chrome green deep
Permanent green light
Olive green
Gray
Black

Because you will use hard pastels and pastel pencils chiefly for sketching and drawing, you don't need as many colors. A selection of each, keyed to your soft pastel palette, should suffice.

ORGANIZING YOUR PALETTE
It's important to organize your pastels according to a system

that lets you find the colors and values you need easily every time you paint. As mentioned, many artists set up a master palette containing a broad range of colors, and from this choose their working palette—the colors they need for a specific painting.

Some artists arrange their master palette with all the warm colors in one group and all the cool ones in another. Others arrange their colors by hue, more or less following the color wheel. Still another system is to arrange your colors according to value, dividing light, medium, and dark tones into separate groups. Figure out what scheme works best for you.

When you are ready to choose the colors for a particular painting from your master palette, analyze your subject carefully. First determine the value of a specific area, then determine its temperature. Select the pastel stick that best matches what you see, and use it to make shorthand strokes of color in that area. Continue this way until you have established the value scheme for your entire painting.

For middle and light values, it's best to use rich colors that

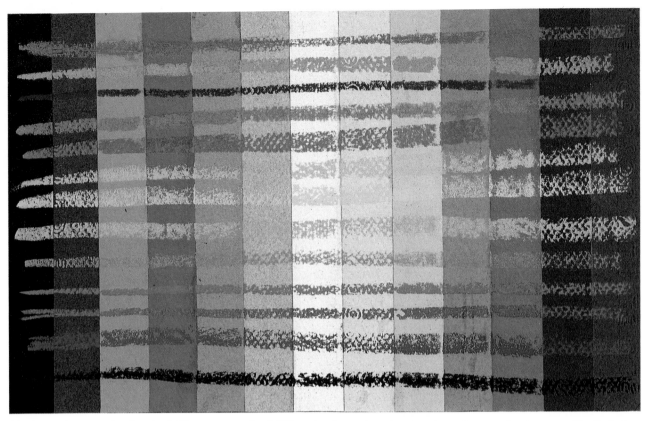

Explore what pastel colors look like on grounds of different colors—how temperature, hue, and value are all affected. A warm pastel color might look cool against a warmer background; a dark-value pastel might look light against a darker background. When choosing a ground for a painting, you have to consider such relationships carefully.

are brighter and darker than what you may think is called for initially. Because pastels are inherently lighter in value than many other mediums, it's easy to end up with a washed-out, chalky-looking painting unless you start out strong.

Once you've set up overall value relationships, you can adjust the colors of specific areas as needed—but trying as much as possible not to alter their values. If, for example, you need to neutralize (tone down) a color that seems too intense, don't go over it with a lighter, weaker color; instead, find its warm or cool complement of the same value and stroke over the area. That way you will not change your value structure or lose color richness.

As you choose colors from your master palette for a specific subject, set them aside on a tray or other surface, because you will use them repeatedly

throughout your painting. This becomes your working palette, where you can readily find just the colors you currently need without having to search for them in your master palette every time. Once your painting is finished, return the colors to their assigned places in your master palette.

EXPLORING YOUR PALETTE

The only way to learn how color works is to systematically practice mixing colors. Record your experiments, then refer to your practice sheets when you are searching for a particular color effect. To get started, try the following color exercises.

1. To become acquainted with your palette, select a sheet of medium-value, neutral gray pastel paper and paint a swatch of each of your soft and hard pastel colors on it. Label the swatches, indicating which ones are pure

colors, which are tints, and which are shades.

2. Assemble scraps of a dozen or so different colored pastel papers. Paint swatches or stripes of all your pastel colors on each piece of paper. Note what effect the color of the paper has on your pastels.

3. Using your finger or a stomp, blend two colors together three or four times, each time varying the amounts. Do this with different pairs of colors. How does a little of one hue affect another? How does a lot affect it?

4. Try mixing colors in pairs without blending them. Lay down a swatch of closely spaced linear strokes of one hue, then apply linear strokes of another hue on top of the first color. What effect does this produce? Try lighter colors over darker ones, and vice versa.

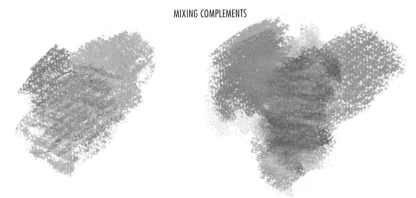

5. Mix complementary colors together in equal parts. Make three swatches for each pair. For the first, blend the colors—say, violet and yellow—together with your finger. For the second swatch, don't blend; put down strokes of violet, then apply strokes of yellow over them. Reverse the order for the third swatch, laying down yellow strokes first, then violet.

6. Using white and black, try mixing a range of tints and shades of each of your pure pastel colors. Note how adding black to some colors can affect hue as well as value.

When you mix complementary colors, you get grayish, neutral hues. Here, medium-light tints of green and red have been pulled together and blended to create a gray. The same has been done with a blue and an orange.

NEUTRALIZING COLOR WITH GRAY

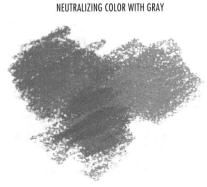

CREATING DARK VALUES WITH BLACK

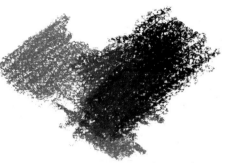

Another way to neutralize, or dull, a color is to add gray to it. Here, the addition of gray lowers the red's intensity.

Here, a very dark value of green has been achieved by first laying down black pastel, then stroking the green over it.

DARK OVER LIGHT VS. LIGHT OVER DARK

Because pastel is an opaque medium, it's customary to paint light colors over dark ones as you would in oil painting. But you can do either, depending on what effects you are after. In the example at left, brown pastel was applied over the lighter-value yellow; in the other example, the yellow has been applied over the brown.

Working with Pastels

Because pastel is both a drawing and a painting medium, there are many ways it can be applied. The surface you apply it to—smooth, rough, or toned—also has a profound influence on the way pastel looks. You can manipulate pastel in various ways—with blending tools, a razor blade, a palette knife, an eraser, water and other solvents—to create a wide array of effects. And, pastel combines beautifully with other mediums, such as watercolor, oils, and acrylics. No other medium lets you create such luscious textures. Indeed, pastel's expressive potential seems endless.

Whether you use a linear approach or a more painterly one, pastel involves working in multiple layers of color.

LINEAR STROKES

To make linear strokes, apply pastel with the tip of the stick. Used this way, soft pastels produce a relatively thick line, while hard pastels and pastel pencils give you fine, thin lines. You can render a subject with hatched, or parallel, strokes, or with cross-hatching—lines that crisscross each other. You can space lines loosely for a very animated feeling, or close together for a tighter rendering. Juxtaposing strokes of different colors produces a vibrating effect.

A linear approach is useful for blocking in your composition in the early stages of a painting. The major shapes are rendered in line, usually with hard pastels, then soft pastels are used to fill in color in broad strokes.

SIDE STROKES

Made by holding the pastel stick on its side against your painting surface, side strokes deposit color in broad swaths. Lightly applied side strokes reveal the texture of your surface, creating a sparkling, broken-color effect. Heavier pressure results in a blanket of smooth, dense color that fills in the surface tooth.

Practice this technique with both soft and hard pastels. Try it on different grounds and with variations in the amount of pressure you apply. You may be surprised by the subtle gradations and textural effects you can get. Avoid excessive pressure to prevent overloading the surface with pigment, which can lead to muddy, chalky-looking results.

BLENDING

In pastel painting, blending lets you mix colors placed next to each other or in layers on your painting surface to create new hues. It is also a way to model form, soften an edge between two colors, create even tones, and produce subtle color gradations. To blend smaller, more detailed passages in a painting, a fingertip, tortillon, stomp, or small brush works best. Rags, chamois, tissues, and the like are good when you need to blend large areas. Your fingers are great tools for blending because they move pastel color around without really taking it off. Just be sure your fingers are dry and free of grease, since pastel won't adhere to an oily surface.

Beginning pastelists often make the mistake of blending too much, then end up with dull, deadened color or a monotonous, all-over soft-focus look. Use blending judiciously so you don't lose all of pastel's liveliness.

SCUMBLING

Scumbling means lightly dragging one color over another without completely covering up the underlayer. In pastel it's done by skimming a soft pastel held on its side over the desired area to deposit a delicate veil of broken color. You can scumble light colors over dark (the traditional oil-painting method) or dark colors over light. It's best not to scumble more than one or two colors over the first layer, since you might end up with mud. If you need to add more color, spray the area with fixative first to isolate the pastel layer. (This also darkens the color, meaning you can add a lighter layer over it.)

Scumbling makes it possible to create passages of sparkling color and texture. Use it to soften hard edges, subdue bold forms, cool down or warm up a color, darken a value or lighten it.

FEATHERING

Feathering means stroking one pastel color over another in thin, diagonal parallel lines. The narrow strokes produce an almost translucent effect that approximates what glazing in oil or watercolor painting does. Used over a flat, overly blended area, feathering can reanimate a passage gone dull. It is often used to modify an underlying color, create subtle gradations, and in general, to harmonize a painting. You can use hard or soft pastels for this technique. Feathering calls for a very light touch. Hold the pastel stick loosely by the end and, with the tip, stroke on color in delicate, closely spaced, parallel diagonal lines.

DUSTING

To create a soft haze of color, try the dusting technique. Lay your painting flat and away from drafts. Hold a pastel stick over the painting and, with a single-edge razor blade or palette knife,

gently scrape the pastel so that it deposits a fine shower of colored particles in the desired area. (Alternatively, you can rub the pastel against a piece of fine-grit sandpaper or an emery board.) Then, to set the pastel particles, press them into your painting surface with a perfectly clean, smooth palette knife.

Before using this technique in a painting, practice on scraps of paper to get a feel for how much pastel dust to scrape off and how to control where it lands.

USING FIXATIVE CREATIVELY

Besides binding pastel pigment to the painting surface and making it possible to work in layers, fixative allows you to darken color overall or selectively, and to create subtle tonal gradations that can facilitate the modeling of three-dimensional form. To darken a specific area, mask the parts you don't want affected, then spray on fixative. For a graded tone, spray fixative over the desired area in a controlled way so that you get the heaviest application where you want the value to be darkest, and gradually decrease the amount as you move toward the lightest value. This technique lets you establish shadows when you don't want to add more color to your painting.

It's also possible to get interesting textural effects with liquid fixative. You can spatter it onto a painting with a brush to get a mottled effect, or paint it directly over a layer of pastel color to create a wash. Also, try dipping a pastel stick into liquid fixative and applying it wet.

WORKING ON A TONED GROUND

Pastelists have traditionally worked on toned surfaces. The tone, or value, of your ground sets the stage for all the values of your composition. The ground you choose depends on your subject and on what you want to convey.

Light-value grounds make pastel colors look richer and darker,

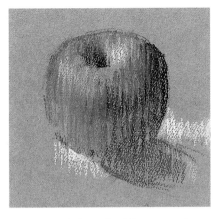

4. This apple was painted with broad strokes laid one over the other, with no physical blending. Applied this way, the strokes blend themselves.

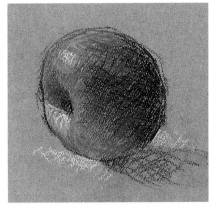

2. Crosshatched strokes follow the apple's form to give it volume. Much of the paper's color still shows through.

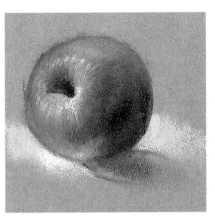

1. Unblended vertical linear strokes placed side by side using the edge of the pastel stick create an animated effect. The colors mix optically.

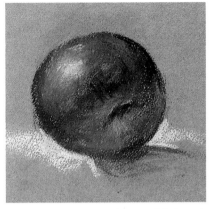

3. This apple was blended with fingers and a stomp to create soft, even tones. Only a little of the paper's color and texture show through.

and are thus best when you want to stress dark tones in a painting. Middle-value grounds are probably most often used in pastel painting, because they show light and dark colors equally well and thus make it easy to judge value relationships. Dark-value grounds, especially black ones, provide maximum color and value contrast to pastel and give a dramatic effect. Dark grounds make most colors look lighter, and are thus best for when you want to emphasize the lights in your painting. The dark ground can serve as your shadow value.

MAKING CORRECTIONS

Although erasing a mistake in pastel can damage the painting surface, sometimes it is

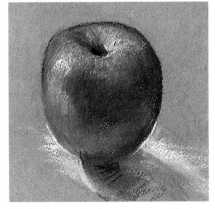

5. All four techniques were used to paint this example: hatching, crosshatching, blending, and broad, unblended strokes.

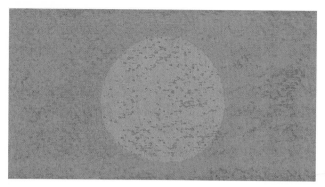

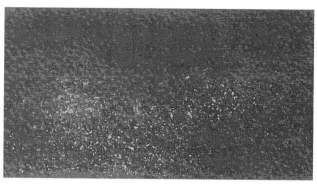

The circle in the center was masked with a template, then fixative was sprayed over the whole area. Although sometimes thought of as a negative effect, the darkening properties of fixative can actually be very useful.

To illustrate the dusting technique, particles of color were scraped off a yellow pastel stick with a single-edge razor blade onto the swatch of brown pastel. The particles were then pressed into the surface with a palette knife.

unavoidable. To correct a drawing in the early stages of work, tap the back of your painting surface lightly to remove loose pastel particles, then either erase the area with a soft kneaded eraser or just draw over it.

In later stages of a painting making corrections is riskier, because the dense buildup of pigment may prevent a new layer from adhering. Don't try to rub a mistake away directly with an eraser; this will only smear the colors and flatten out your surface. Instead, scrub the offending area with a dry, stiff bristle brush. Or, scrape color off with a single-edge razor blade, holding it flat against the surface and passing it gently downward once or twice. Remove the scrapings with a palette knife so they don't dirty other areas. You can then work right over the scraped area, though you might need to spray it with fixative first. If you need to remove more color after scraping, do so with a clean kneaded eraser.

After removing unwanted pigment, you can go over the area with a brush dipped in turpentine or liquid fixative to turn it into an underpainting that when dry will take more pastel work beautifully.

A BASIC APPROACH TO PASTEL PAINTING

Most of the paintings in this book were executed in a fairly direct manner. From the beginning, the artist knew what he was after, and developed all parts of the painting simultaneously. The following guidelines summarize his basic approach.

Choose your support carefully, determining what color, tone, and texture will best serve your subject. Begin by sketching the scene with vine charcoal or, for more detailed subjects, charcoal pencil. Spray on a fixative to preserve your drawing. Next, block in the overall value and color scheme of the composition. Hard pastels are good for this stage. Then begin to build color in soft pastel. Try to avoid much blending at this stage. Most important, move all over the surface of the painting. Don't get caught fussing in one area.

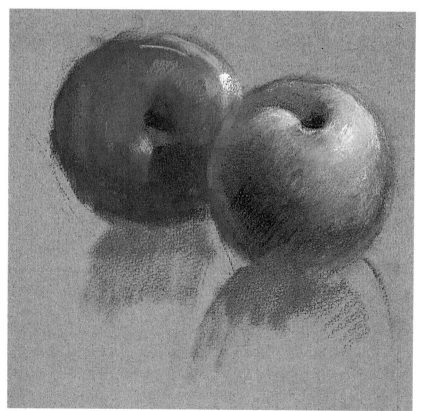

Both of these apples were begun with an oil underpainting executed in the drybrush technique. Much of the oil color shows through in the left-hand example; the apple at right has been completely painted over with pastel.

Apply color in layers, and don't blend all your strokes together. Use a fixative whenever you need to isolate a layer of pastel and restore surface tooth so you can add more color. Go from general shapes to more definite ones. Keep an eye on the overall value structure. Toward the end, define edges and add details. Remember, a few details can suggest many—don't try to paint every leaf and twig.

WASHES AND UNDERPAINTINGS

Some of the paintings employ wash effects created by brushing over a layer of pastel with water, turpentine, mineral spirits, or rubbing alcohol, all of which turn the pastel into a paintlike consistency. Pastel washes are very useful in the early stages of a painting because they let you block in the basic color and value structure quickly. In later stages, brushing into the pastel with solvent makes it easy to create very painterly passages. It also lets you sharpen edges of forms most effectively.

Some paintings in this book were begun with an underpainting of oil color diluted with turpentine to the consistency of a thin wash. Oil underpaintings are used to establish a composition's color and value structure and serve as a guide for subsequent pastel work. They are valuable for complex subjects, especially ones that call for broad color coverage. Oil underpaintings provide deep, rich tones you can't get from pastel alone, and help avoid an overworked look. Applied over an oil wash, pastel looks fresh and vibrant.

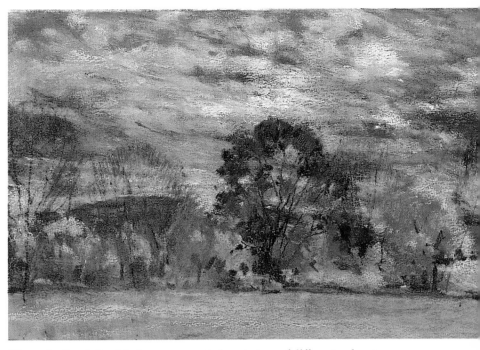

These similar fall subjects were executed on papers of different colors to illustrate the influence ground color has on the look of a finished painting. The dark gray paper used for the painting above lends dramatic contrast to the subject. The yellow paper used for the painting below contributes its warmth to the scene. The very painterly wash effects in this example were created by brushing into the pastel with alcohol.

Developing Structure in a Colorful Composition

PROBLEM

These brilliant flowers immediately catch the eye, but to give the scene some structure, you need to pay careful attention to how you develop the lush green foliage that sets off individual blossoms and provides a sense of depth.

SOLUTION

Start with a dark-hued paper, laying in the dark patterns beneath the foliage first. Build color slowly in layers, treating the flowers as masses until the last stages, when you can define them by adding darks.

☐ Since the foliage is such a key element of this composition, a deep-green paper, such as Canson Mi-Teintes ivy, is a good choice. Here, the smooth side of the paper has been used. Begin by drawing the patterns of the subject in vine charcoal, which is so soft that you can easily change your drawing by simply wiping it off and starting over.

Once you have established your composition, using a deep bluish black, begin to lay in the darks that underlie the foliage. Continue to build color, adding deep greens, bright greens, even some touches of violet. Use a fixative between stages to adhere each layer of pastel to the surface before going on to the next.

Treat the flowers as masses at first, defining only a few of the larger ones in any detail. For the petals of the black-eyed susans, use a deep yellow or light orange, highlighted with light yellow and touches of bright orange; use yellow ocher for some of the darker blossoms. The two day lilies are obvious focal points in the composition, so don't be afraid to paint them with bold strokes, making their bright vermilion hue contrast strongly with the greens of the background. Gradually, as the painting progresses, break up large, massed shapes into smaller and smaller areas. Be sure to add highlights to the deep-brown centers of the black-eyed susans; this will help make them look three-dimensional. Simply suggest the fleabane blossoms with small, carefully placed strokes of white and pale gray. Finally, use darks around the flower and leaf shapes to sharpen their edges and make them stand out against the background.

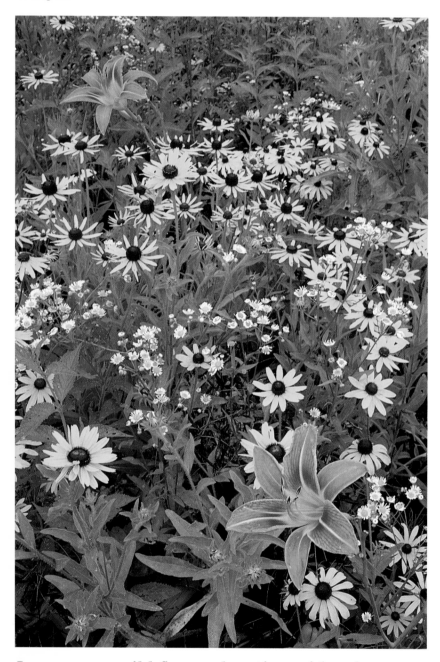

In summer, wild flowers bursting with color illuminate a lush green field.

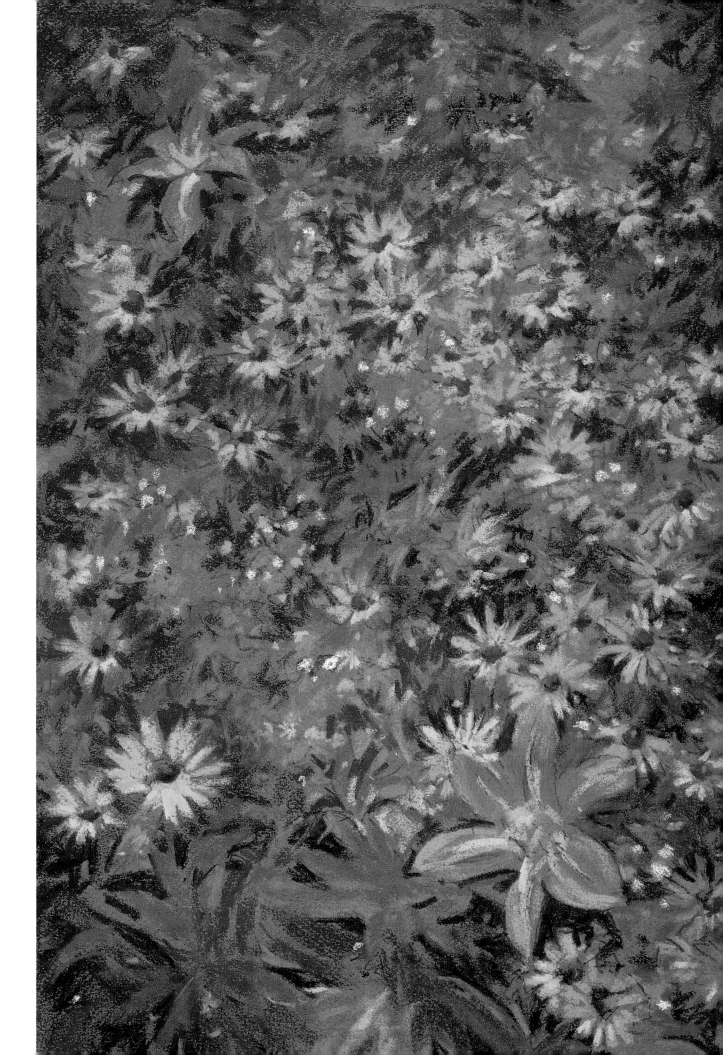

Dusting to Create Delicate Texture

PROBLEM

The main challenge here is to convey the soft fuzziness of the globe-shaped dandelion seed heads, a quality that would be difficult to achieve in most any medium.

SOLUTION

A special technique that relies on one of pastel's unique qualities is dusting, in which you shave pastel particles from the stick onto your paper and press them gently into place to create a soft haze.

NOTE

Before you use the dusting technique, experiment with it on scraps of paper. For greater control, you can prepare pastel dust away from your painting, then just sprinkle it on with your fingers.

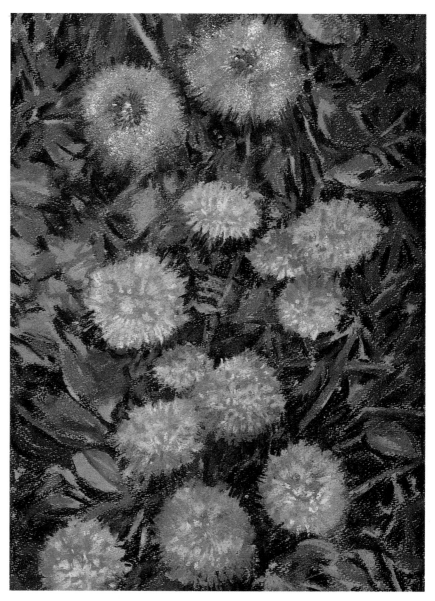

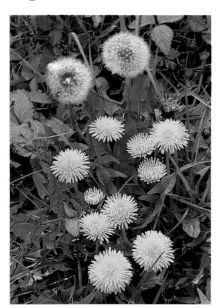

Golden dandelions in full vigor contrast with fuzzy, globe-shaped seed heads.

☐ Paint the light, positive shapes—the flowers—first, then paint the dark, negative shapes of the foliage into them to ensure sharp definition. Prepare the area of the background where the seed heads are to appear with a soft gray tonal underpainting, blending the pastel completely. Keeping your paper flat, hold a light gray pastel stick close to this area of the painting and carefully rub it against a piece of fine-grit sandpaper or scrape it gently with a single-edge razor blade to deposit powdered color where needed. Repeat with another, lighter gray. Then, to set the pastel dust, press the particles into the paper with a smooth, clean palette knife.

Establish the positive shapes of the dandelion blossoms with vivid oranges, golds, and yellows using short, bold strokes in layers to describe their tufted texture. Now, with crisp, sharp strokes that contrast with the fuzziness of the seed heads, paint the dark foliage against the light flowers.

Letting the Paper Work as Middle Value

PROBLEM

The juniper tree's gnarled roots have a wonderful linear and textural quality, while the rocky soil supplies contrasting texture and subtle color. But because the roots and soil are of almost equal middle value, the brightness of the flowers draws attention away from these features.

SOLUTION

Work on paper whose color is of medium-dark value (here, a burgundy), thus establishing your middle-to-dark value range and allowing you to place your lights in the composition right away. You can then work lights and darks alternately as the composition demands.

☐ Start with a charcoal drawing, defining the flowers as masses for now rather than as individual blossoms with articulated petals. Begin to add the light colors of the sunflowers, layering bright orange, deep yellow, light yellow, yellow ocher, and burnt sienna, but still keeping things general; you can redraw or redefine their shapes later when you add some darks. Suggest the grasses and foliage with quick, linear strokes of various greens layered one over the other.

Now that you have established the major light values, concentrate on the medium and dark ones. Pay special attention to the darks of the tree trunk; they are what best help articulate the bark's deep grooves, the curving lines that give this composition its simple grace and movement. Stroke on burnt umber, dark grays, and a dark bluish black in linear fashion, following the shapes of the trunk and its texture. Also use your darks around some of the sunflowers to help articulate them.

To suggest depth and distance in the composition, paint the top part of the ground behind the tree trunk in cooler colors—light blue, gray, and violet, but with touches of the soil's ruddy hue—and use warmer earth colors such as raw sienna, burnt umber, ocher, and Indian red in the foreground.

As your painting nears completion, stand back from it to see what values might need adjusting and where edges need sharpening. Emphasize the linear pattern of the bark and roots, and add a few highlights to the flowers.

Nestled at the base of a weathered old juniper tree, tiny, bright yellow sunflowers flourish.

Expressing a Broad Sweep of Space

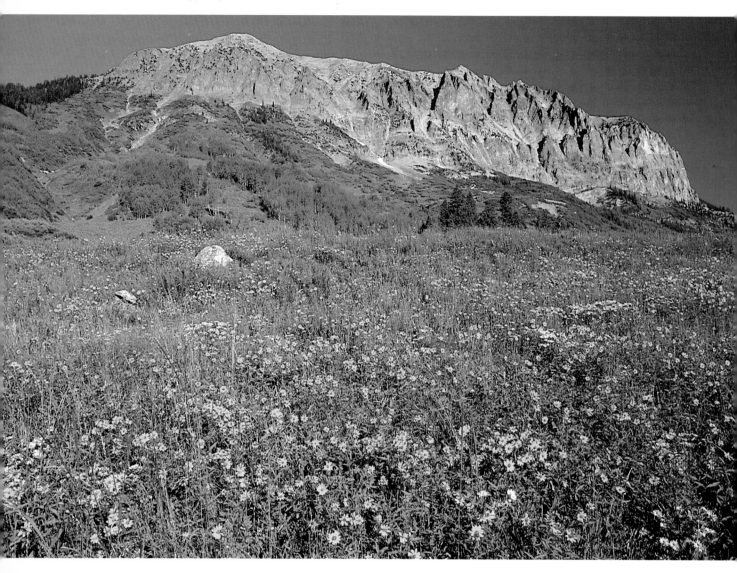

PROBLEM

Set off in sharp profile by an intense blue sky, the stark, light-colored mountain commands attention toward the background almost immediately, while the bright yellow flowers bring the eye back toward the foreground. Conveying the land's dramatic sweep is made difficult here because everything is in a high key.

SOLUTION

Keep the mountain crisply defined against the sky and use small areas of dark value to help frame it. Exaggerate dark values in the foreground to make the eye stop there briefly before moving on to the sun-bathed meadow. As the meadow recedes toward the mountain, suggest the flowers more sketchily.

Set against a clear, deep blue sky, a mountain in Colorado's Elk Range lords over a flower-strewn meadow.

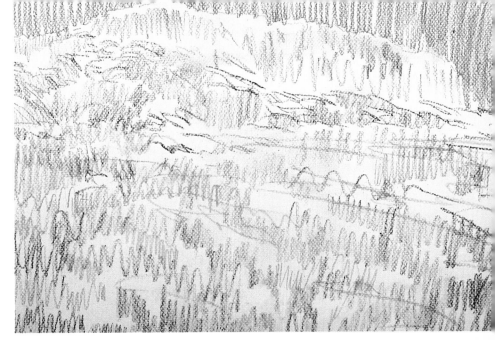

STEP ONE

Don't bother with a charcoal drawing. Instead, using the rough side of white pastel paper, quickly block in the general color and value patterns overall using very loose, vertical, linear strokes of blue, dark and light greens, brown, yellow, and ocher.

STEP TWO

With a soft-haired watercolor brush dipped in rubbing alcohol, brush over the pastel strokes you have just laid down, turning the dry pigment into washes of color. Rinse your brush every time you switch colors, or use a different brush for each hue. Alcohol dries fast, so it doesn't wet the paper enough to cause buckling and leaves no residue when it evaporates. And although alcohol fixes the pastel to the surface, the color does not completely fill the grain of the paper but leaves its texture visible. Add more pastel to areas that call for denser color, and brush over them again with alcohol.

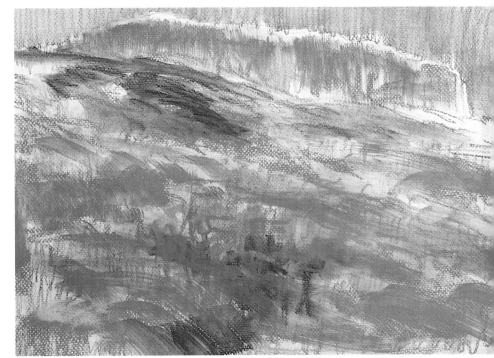

STEP THREE

Work back over the washes with pastel. To capture the sky's intensity, apply broad strokes of color—cobalt blue, plus a light turquoise blue—using the flat side of the pastel stick and blending with your finger. Articulate the mountain's texture with short, vertical gray strokes. Elsewhere, build color in layers of progressively smaller strokes. Play down the flowers' individual shapes, but make them larger in the foreground and set them off with darks to create the illusion of near space. Keep middle-ground values light, and foreground values dark (fixative can help).

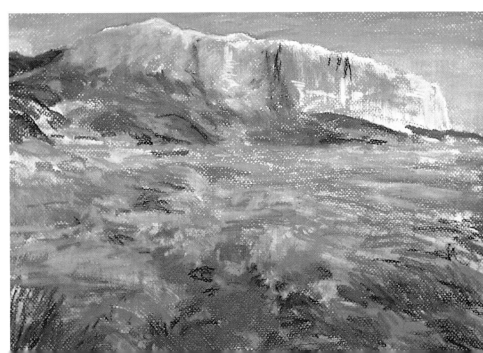

FINISHED PAINTING

Add final accents, including dark greens behind the yellow flowers and framing the mountain. To make the mountain really stand out, dip your paintbrush in alcohol again and paint the blue pastel color of the sky right up to the mountain, creating a sharp edge. Then, when this is dry, add just a few precise linear strokes of very light peach color to the top of the mountain ridge to sharpen it against the saturated blue sky.

Subtle strokes of light color along the top of the mountain underscore the dramatic contrast between this majestic rock formation and the intense sky.

Keeping the middle ground fairly simple helps create the sense of sweeping distance.

Using subtle dark values in the foreground helps create the feeling of near distance. Greater detail in the flowers and grasses also brings this area forward.

ASSIGNMENT

Experiment with using rubbing alcohol to produce soft washes of color that can work as underpainting. On a sheet of pastel paper, stroke in pastel color quickly and loosely. Then dip a pointed watercolor brush in alcohol and go over the pastel strokes, spreading the color. Note how rapidly the alcohol dries. Leave some areas alone after a single wash, and go over others with more dry pastel. Compare the way they look. With more alcohol, brush over areas where you have applied a second layer of pastel and compare the results with areas where just one layer of pastel was used. Try this technique using a range of pastel colors on a variety of colored grounds. Play with different amounts of pastel and alcohol to see what effects you get.

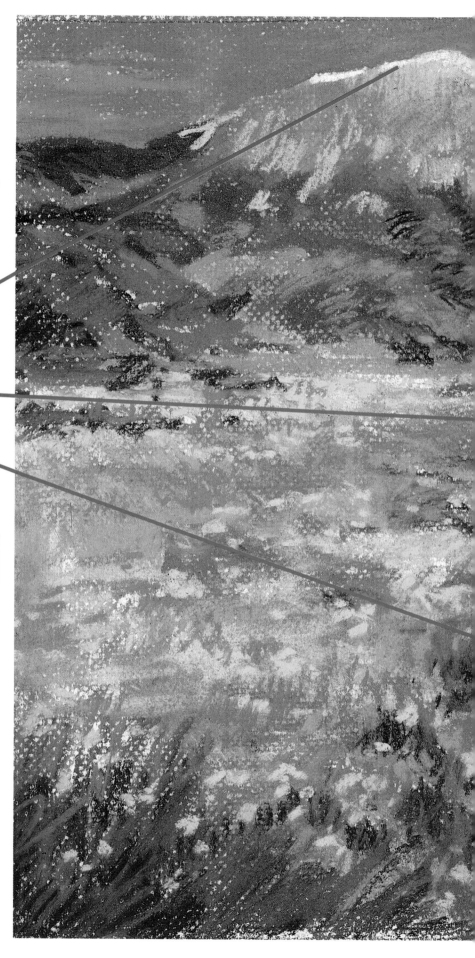

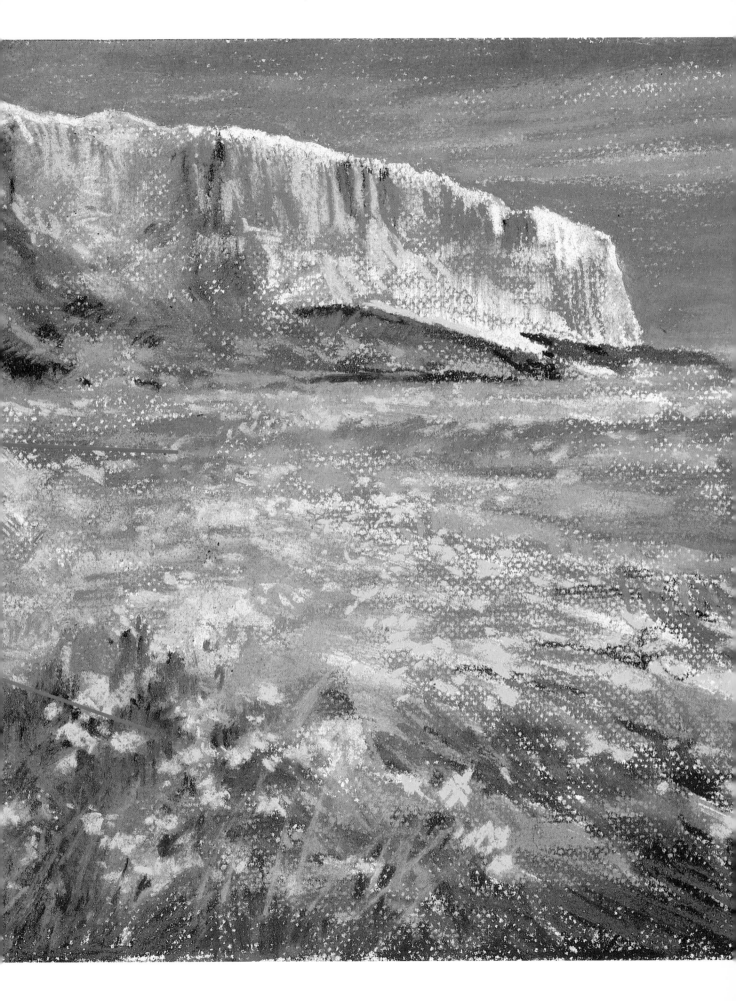

Working with Strong, Simple Shapes

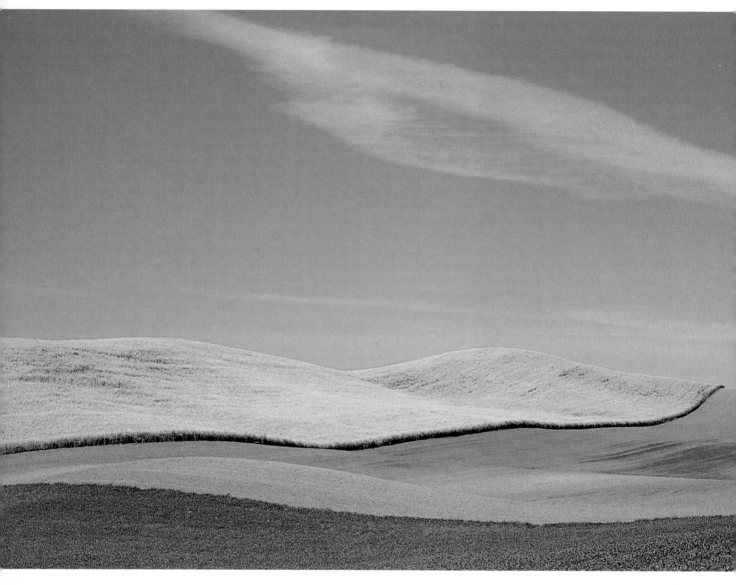

PROBLEM
This scene is composed of such bold, straightforward shapes that attempting to paint it realistically could well invite failure. Yet the subject is too compelling to ignore.

SOLUTION
Treat the scene as an almost pure abstraction, and use it as an opportunity to explore the ways deft, broad strokes of color can express the sinuous contours of the land.

☐ Work on a textured surface. Here, the rough side of a sheet of black Crescent paper, which has a distinctive, almost ropelike grain, affords textural interest without distracting from the simplicity of the land's shapes. Draw the outlines of each shape, then begin to add color, starting with the yellows and ochers of the mustard field and moving on to the narrower bands of burnt umber and burnt sienna. Don't overlap the edges of these areas, and for now, leave the foreground land shape unpainted.

Golden mustard plants spread ribbonlike across the rolling contours of a Midwestern field.

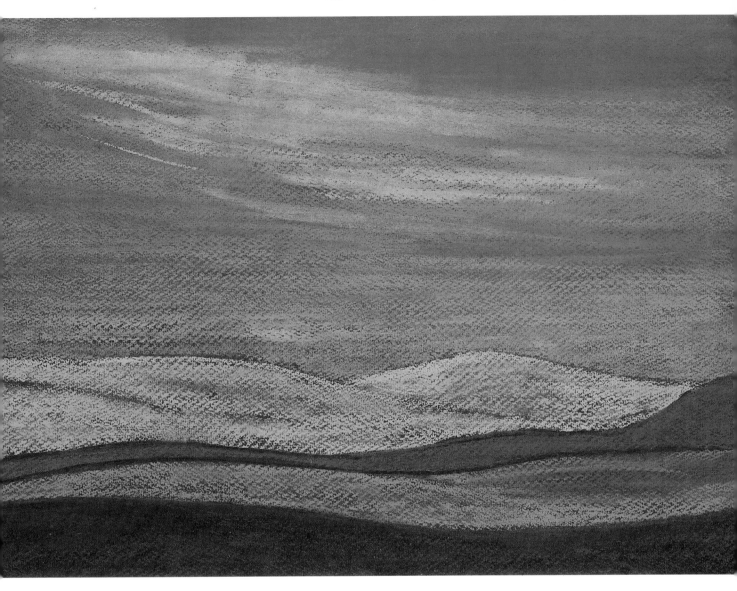

To deposit a broad swath of color, use a half or smaller piece of a pastel stick, holding it on its side and sweeping it horizontally across the paper to follow the contour of the shape you are painting. Try to stay within the outlines of your preliminary drawing.

As you paint the sky, let the blues meet the golden-yellow hills, but don't overlap them; to maintain the abstract quality of the composition, these shapes should remain discrete. The sky calls for subtle color variations

and a smoother application. The blues supply a dramatic, near-complementary color contrast with the golden-yellows, ochers, and warm, earthy oranges and browns of the landmasses. To achieve the saturated color of the upper part of the sky, use ultramarine blue, overlaid with cobalt blue and blended together somewhat. Closer to the horizon, introduce some bluish green. Add horizontal strokes of light gray for the cloud shapes, softening them with your fingers. Now for your

darkest darks. Instead of the green that appears in the photograph, use black pastel in the foreground. This provides needed balance for the light blues and yellows and helps emphasize the abstract quality of the painting. Also, to heighten contrast, add a thin stroke of black along either side of the dark brown land form.

Finally, add subtle strokes of yellow to the outer edges of the mustard field, and a few strokes of a darker-value yellow to suggest changes in its contour.

Painting Color as Pattern

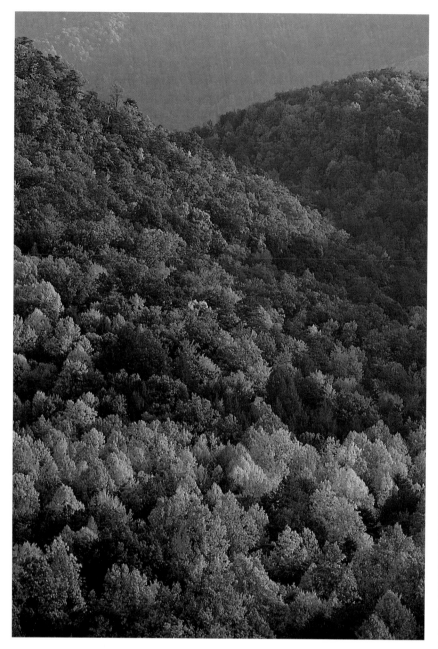

In autumn, the Great Smoky Mountains are awash with beautiful color.

PROBLEM
Autumn foliage can be difficult to paint well, especially when seen from afar as in this mountain landscape. You need to find a way to make the colors relate to the forms that underlie them, yet at the same time play down detail to preserve the feeling of distance.

SOLUTION
Identify the main, large shapes of the subject first; then, within the framework of these shapes, paint the overall pattern the trees' colors and shadows form.

STEP ONE
A dark blue paper suits the hues and dominant values of this subject. Because the scene is essentially very simple, you can forgo any preliminary charcoal drawing and, working on the rough side of the paper, sketch directly with pastel color. Start by drawing in the two hill shapes, followed by the pattern of the shadows and light-value half-round tree shapes—in yellow, orange-yellow, orange, and yellow-green—that cover the foreground hill.

STEP TWO

With dark-value greens and blues, develop the shadow patterns as they cross the foreground hillside and, with vivid, light-value hues, strengthen the suggestions of individual tree shapes. Keep the background hillside relatively dark to make it recede, using blues and greens there and only touches of the brighter autumnal hues.

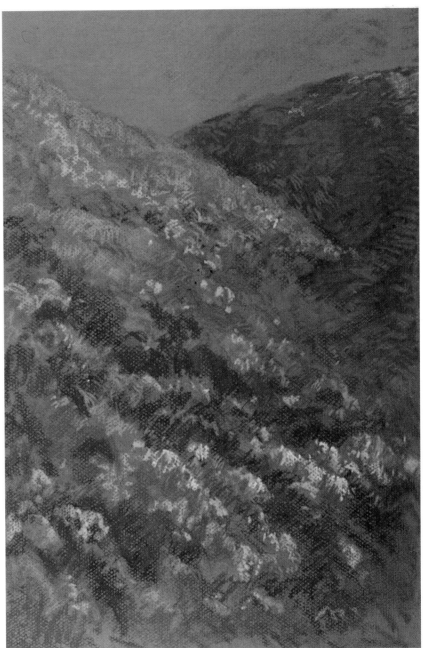

STEP THREE

Further define individual trees with layers of short, unblended half-round strokes. Layering color this way, without any physical blending, gives the elements in the pattern a needed crispness without creating the feeling of fussy detail. Thus, you can suggest form while really emphasizing overall pattern. Don't forget the sky; to keep it lively, lay down some rapid diagonal strokes of rosy pink plus violet, and over this add a layer of cobalt or cerulean blue, blending only slightly so that some of the paper's dark blue shows through.

FINISHED PAINTING (OVERLEAF)

As finishing touches, heighten the contrast between light and dark values in the foreground to make it come forward. To do this, darken some of the shadows and accent some individual tree shapes with touches of brighter color.

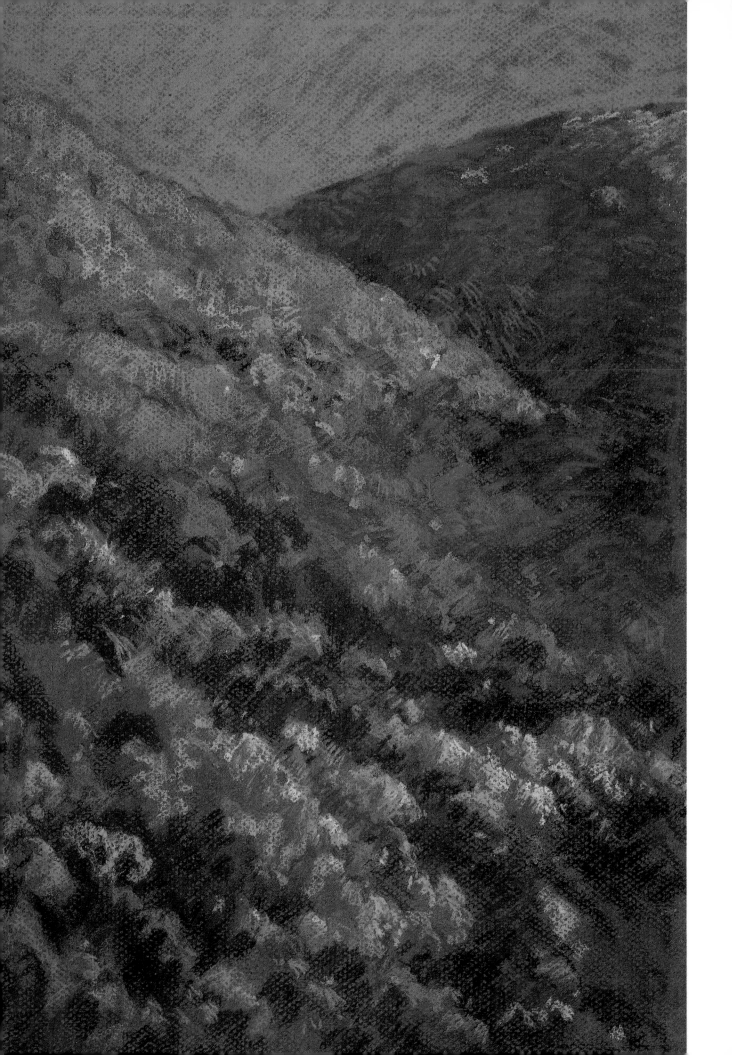

Balancing Darks and Lights in a Closeup

PROBLEM

Here you must choose what to emphasize, the aging tree or the exuberant growth of the leafy spurge. Your painting needs a definite focus if it is to work.

SOLUTION

Look carefully at what you see and determine what compels you the most. What about the subject is distinctive or exciting? Here the texture and gestural quality of the apple tree trunk and branches seem to stand out against the more abstract mass of the flowers.

☐ Given the high key of the subject, a light green paper is a good choice as a support; for this demonstration, the smooth side has been used. Start with a charcoal drawing to locate the tree and establish the abstract pattern of the surrounding landscape.

With a range of earth colors, articulate the trunk and branches of the apple tree, aiming to capture the texture of its crackled bark, its deep scars, and its almost human gestural qualities. Pay special attention to the darkest values here, which can delineate the most dramatic statements. But leave some spaces open where you'll indicate yellow flowers against the trunk.

Using medium- to light-value greens and yellows in alternation, fill in the basic pattern of flowers and foliage, blending to soften edges, especially toward the background to express distance.

Working back over the softened pattern of greens and yellows, add spots of lighter yellow throughout the landscape in rapid strokes to suggest more spurge blossoms. Then refine their edges and adjust their shapes by painting dark green and brown values around them, particularly in the foreground, where the contrast will help it project toward the viewer.

Finally, add some violet, maroon, and very light green to the tree. These colors, which complement the yellows, oranges, and greens of the flower- and foliage-bedecked field, make the tree stand out all the more from its surrounding landscape.

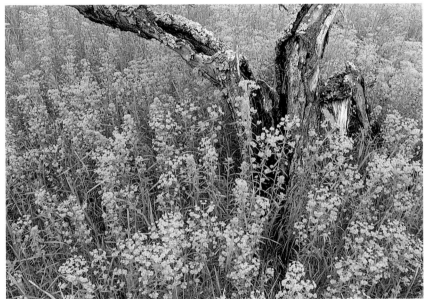

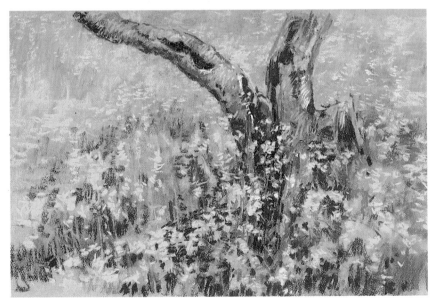

The arms of a weathered old apple tree reach out to embrace a dense cushion of leafy spurge.

Describing the Quality of Light

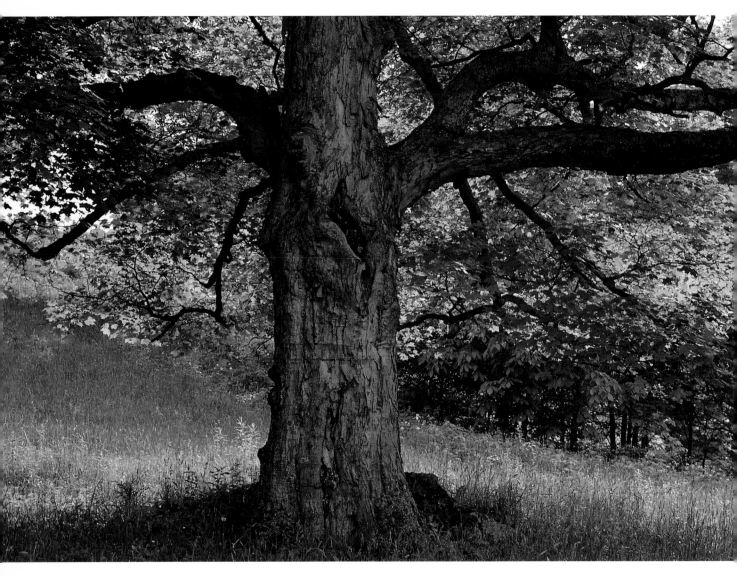

PROBLEM

Capturing the sparkling feel of light filtering through the tree's leaves is a challenge. In a backlit scene like this one, you need strong shadows to make the lights work, but too much emphasis on this contrast can deaden your painting.

SOLUTION

Look at the overall pattern of lights and darks, as if the scene were an abstraction. Then pay careful attention to the way the light affects the colors and values of the leaves and grass. You need to capture those subtleties.

☐ Working on the rough side of a bright yellow paper (such as the Crescent 902 yellow used here), lay in pastel color so that the texture and color of this ground remain visible in the finished painting, suffusing the scene with the effect of warm, sparkling sunlight.

On this light surface, paint your darks first. Remember, pastel is an opaque medium, meaning that you can paint light over dark. Establish the tree trunk

In midsummer a stately sugar maple spreads its branches,
light filtering through the canopy of its dense foliage.

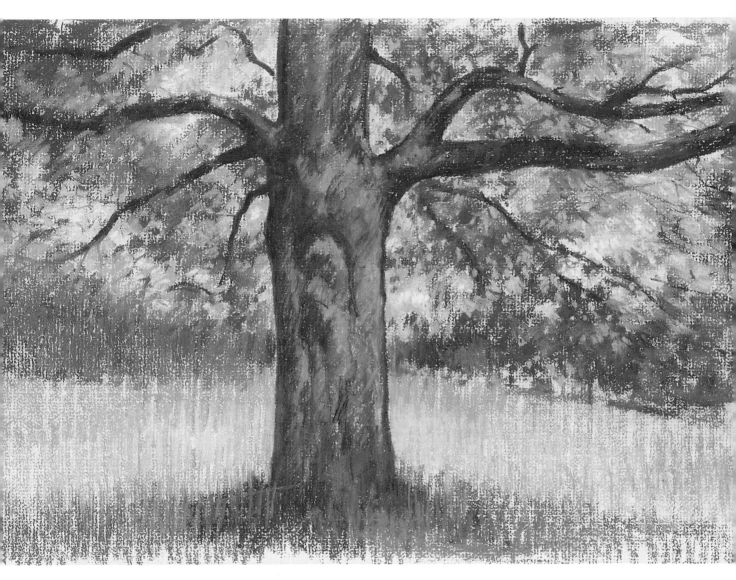

and branches with a variety of browns, black, dark gray, and touches of violet and a dark red-violet, building color in layers and subtle tonalities to create a sense of its volume and bark texture. Avoid too much detail, since the tree is in silhouette, but don't succumb to using pure black or solid brown. That would make the contrast between the tree and its surroundings too harsh. Establish the tree's cast shadow in the foreground.

Now, working from dark to light with a variety of greens, paint the foliage. Study once again the shadow-and-light pattern; do you see any large areas of solid color? No; even the line of trees to the right in the background is variegated. To create the feeling of dappled light, use the side of your pastel sticks to make short, broken strokes that glide over the surface, just touching the high points and letting the paper's texture show through.

To paint the grass, use most of the same colors you did for the foliage, this time making vertical strokes to express its texture. Merge some of the grass strokes with the tree's cast shadow.

Finally, place some yellows here and there where more light may be needed; a few strokes of a pale yellow that is lighter than the value of the paper will add sparkle.

Focusing In on a Delicate Subject

PROBLEM

This scene is a microcosm of fascinating textures, from the tufts of green undergrowth to the smooth arrow-shaped leaf to the fringe of tiny moisture droplets on the cluster of lupine leaves. But you can't depict each texture too literally, or your painting will lack organization.

SOLUTION

Treat the background as an abstract, confettilike tapestry that will set off the strong, simple forms of the leaves.

Droplets of moisture frame lupine leaves emerging from a carpet of greenery.

STEP ONE

Black paper is a good choice for this subject. With pastel pencil of a color that will show up on the dark paper, make a simple drawing to locate the basic leaf shapes. Then, making sure your paper is perfectly flat, begin to add background colors—greens and oranges—by rubbing soft pastel sticks on a piece of fine-grit sandpaper, allowing the dust to settle on your painting. You may want to make masks to cover up the leaf shapes while you do this. Lay one color over another, then press the particles into place with a large, flat palette knife to fix them to the surface.

STEP TWO

Redraw the leaves, defining them in various greens against the now-mottled background. The local color of the leaf at left should lean toward a medium yellow-green, while those at right should lean toward blue-green. Using very short, quick strokes of white or a very pale gray, suggest the fringe of droplets on the lupine leaves. Sand more color off for the background as needed. Then draw in some larger spots of orange and green color; for this, use the tip of your pastel sticks.

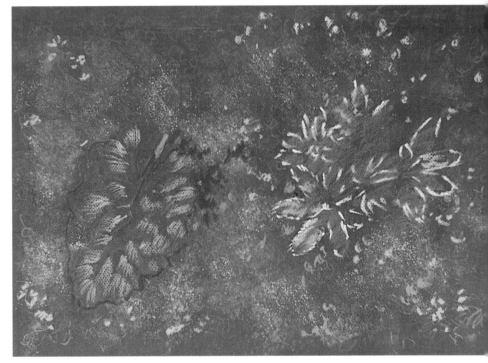

STEP THREE

Add more definition to the leaf forms to give them some volume and make them stand out more. Continue to punctuate the background with more spots of color. Then, taking care not to muddy the painting, use some black around the leaves to further define their edges. Surround some of the bright spots of background color with black as well, to strengthen contrast and enhance the confetti-like effect.

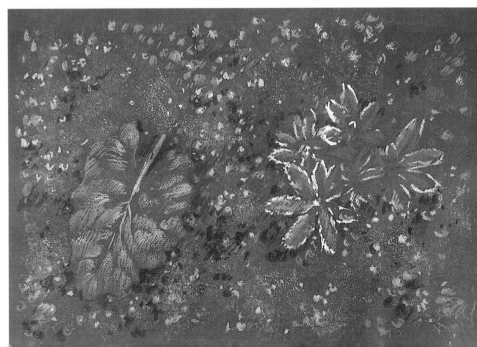

FINISHED PAINTING

Firm up any edges that need sharpening. Stand back from your work and squint at it. The background color should glitter, the spots creating an overall pattern that is lively yet does not distract from the larger leaf forms.

Note the subtle effects of dusting, the minute particles of pastel contributing soft, delicate hazes of color.

You might not think to use black pastel on black paper, but its rich, velvety dark comes through and adds the extra degree of contrast that makes this painting work.

ASSIGNMENT

To take advantage of one of pastel's unique characteristics, try experimenting with the dusting technique on different scraps of paper. First practice on dry paper to gain some control over depositing the colored dust particles where you want them. Use the technique with and without masks. Get a feel for the motion—either straight downward or slightly circular—and the amount of pressure you need when you press the particles into place. Make sure the tool you use is very clean and smooth, or it may catch and move bits of the dust instead of flattening them.

Next, see what happens when you use the dusting technique on wet paper. As they land on the damp surface, the specks of color spread and float, resulting in accidental shapes.

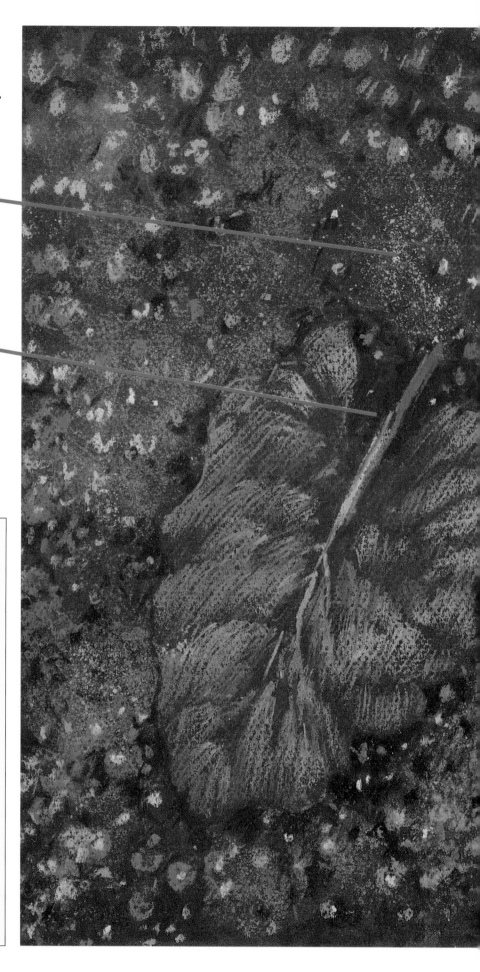

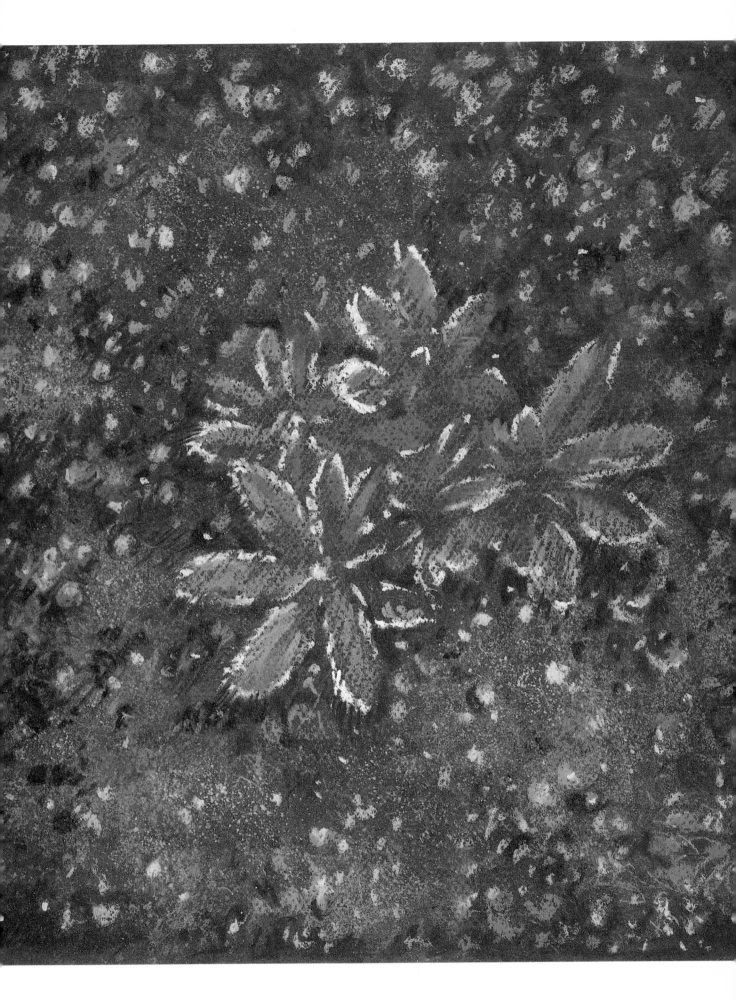

41

Handling a Detailed Closeup

PROBLEM

This is a very detailed subject that calls for skillful drawing. The dramatic backlighting adds to the challenge, since it gives the seeds and leaf a translucent quality that could easily get lost.

SOLUTION

Approach the subject not so much as a painting but as a botanical illustration. To execute as crisp and accurate a rendering as possible, use hard pastels and pastel pencils instead of soft pastels.

☐ Because the drawing itself is so detailed, it's best to keep the background extremely simple so it won't compete. The tobacco color of the pastel paper used for this demonstration is a neutral, fairly close match for the background in the photograph, so it can be left untouched. Work on the smooth side; if you work on the rough side, the paper's open texture will break up the details of the image. Keep your pastel pencils and hard pastels sharpened as you work.

With a pastel pencil, carefully draw the basic outlines of the branch, leaves, and winglike keys. Take the time to get the drawing right. When you are satisfied, begin to add color with hard pastels and, for the stems and branch, pastel pencils, working in linear strokes to maintain control. Aim to capture the feeling of light shining through the papery wings of the keys and pale green new leaves. For the local color of the keys, use subtle strokes of light orange, plus burnt sienna for shadows and light yellow for highlights. Model the seeds carefully, expressing their volume with dark and light values of green. For the leaves, use a variety of greens and yellow, articulating their vein pattern and texture. Add just a few bright yellow highlights to the keys and the leaves, and some small touches of deep red to a couple of the seed stems. Finally, reestablish your original drawing where some sharpening of detail may be needed.

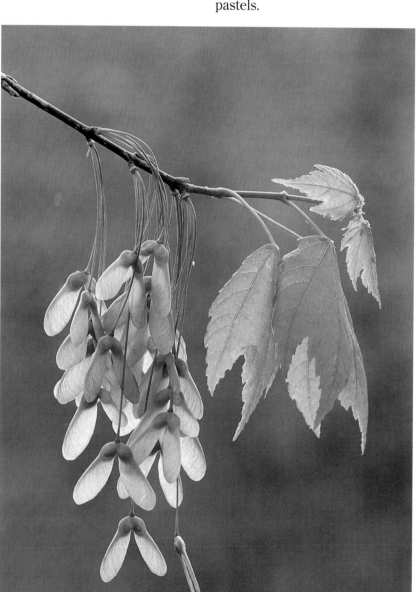

Clusters of delicate red maple keys and new leaf growth are made translucent by gentle spring sunlight.

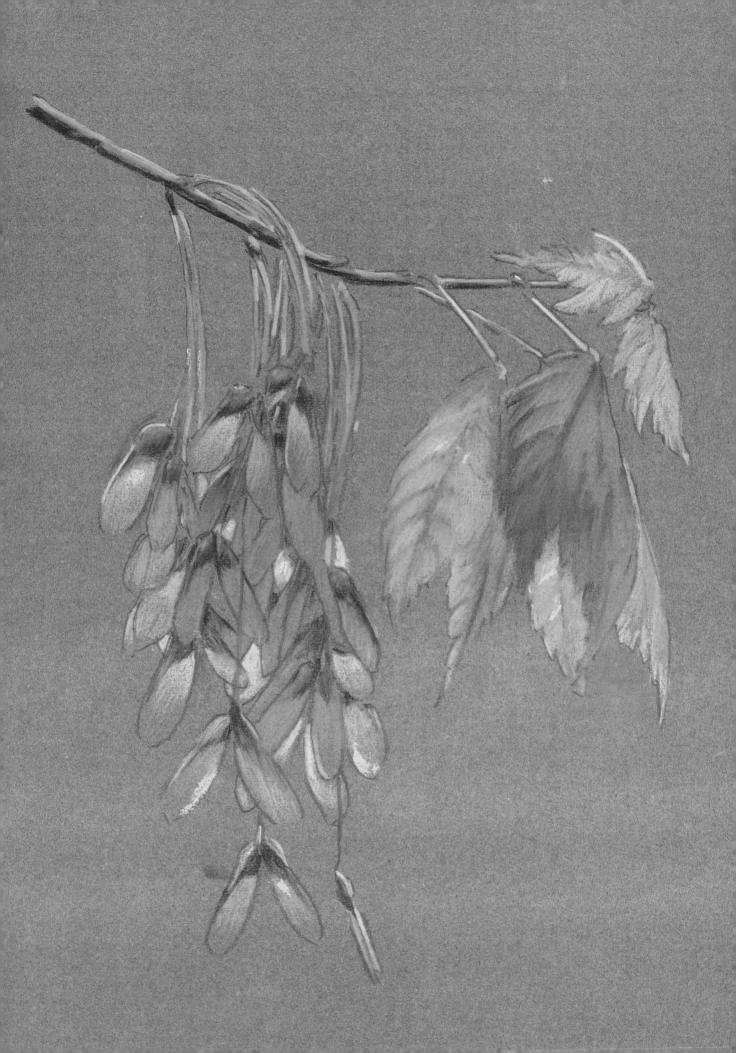

Capturing the Character of a Young Deer

PROBLEM

The fawn is obviously the focus of this scene, and is going to demand some careful drawing. The real problem, though, lies in figuring out how to make the deer relate convincingly to his surroundings so he doesn't become just a vignette; you need to think about the whole composition.

SOLUTION

Render the fawn in detail, concentrating on modeling his form and depicting the texture of his fur. Make the foliage more abstract, but don't let it go flat; it needs to have some depth or the fawn will look like a cutout that has been pasted down on a green background.

☐ On a sheet of amber-colored paper, make a finished drawing of the deer with charcoal pencil, then spray it with fixative.

Next, paint the foliage. Working around the fawn, lay in medium-dark green color in broad strokes using the side of your pastel sticks. Then, dip a pointed watercolor brush in mineral spirits or alcohol and work back into this color, brushing the pigment already on the paper as if you were painting in watercolor. Alternate layers of various greens with brushstrokes of mineral spirits until the foliage is complete.

Now for the fawn. Let the color of the paper serve as a middle value, and work with a range of related browns and earth hues. Establish the dark and light patterns using long, thin pastel strokes that follow the form of the animal's body and the direction in which his fur grows. Add color in layers, letting the strokes blend themselves as they build up. Aim to preserve the texture of the deer's fur, which should not appear overly smooth. Using fixative between layers will help. For the spotted pattern on the fawn's coat, use white, gray, and touches of a light ultramarine. Define the animal's eyes and nose with black.

Check to see that the deer really stands out from the foliage. His head needs to be in sharp focus so it will come forward in the picture, so make edges precise and contrast with the background greenery strong here. To do this, dip your pointed brush in mineral spirits and paint up to the edge of the deer. Handle the foreground loosely, just suggesting the fawn's legs and adding a few quick strokes to represent grass.

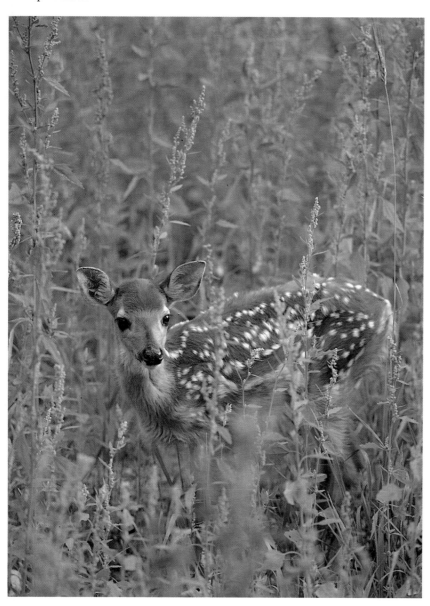

In spring, a young white-tailed fawn hides among the weeds in a Michigan meadow.

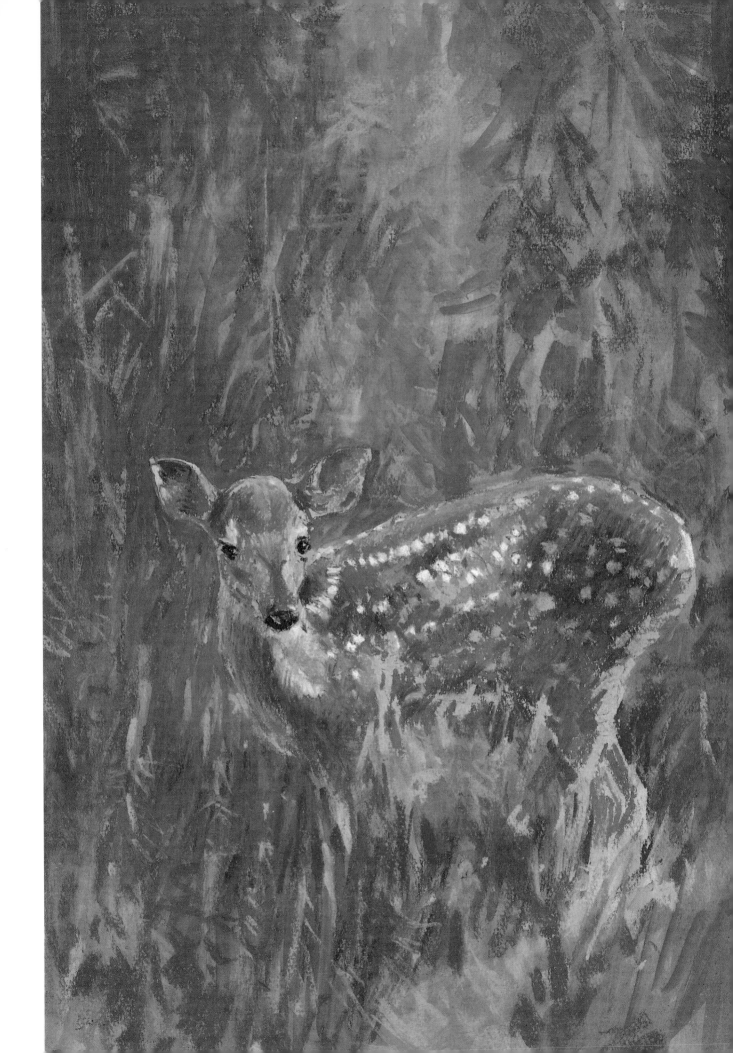

Exploring the Effects of Fog

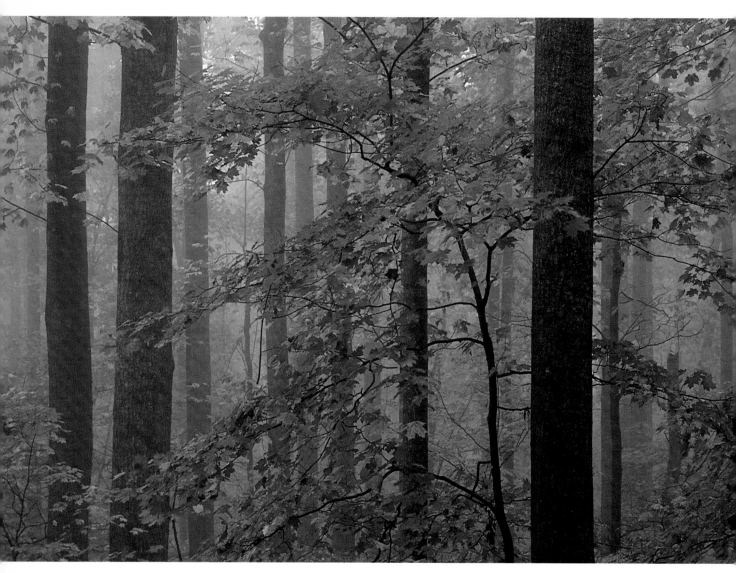

PROBLEM

Fog softens the edges of objects, mutes their colors, and narrows the range of values, making it hard to grab onto what you see. This scene also poses another challenge: With strong, repetitive vertical elements like these trees, how can you avoid a monotonous composition?

SOLUTION

Use atmospheric perspective to capture the moody depths of the woods, and keep all edges and colors soft and subdued with neutrals to convey the mist that envelops the scene. Create a subtle interplay between the positive tree forms and the negative spaces between them.

☐ Make your initial drawing on paper whose color and value relate to the overall look of the subject. Here a green was used, to reflect the landscape's pervasive gray-green tonality. As you draw the trees, it is crucial that you aim for variation in their placement, sizes, shapes, and the spaces between them, since it is easy with a subject like this one to end up with a repetitious pattern. Use dark browns and grays to lay in the trees; those in

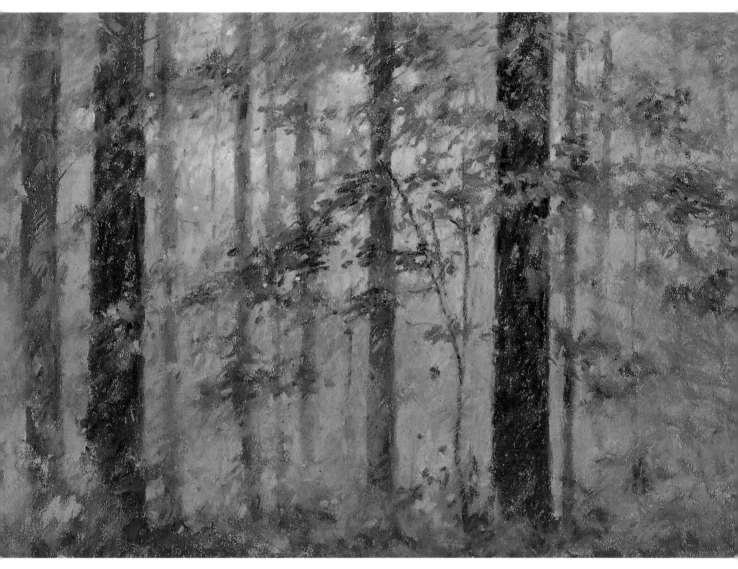

the foreground should be darkest, while those that recede into the middle distance and background should be rendered in progressively lighter values of gray. When you are satisfied with the drawing, apply fixative so you won't lose your way as you concentrate on capturing the foggy atmosphere.

Define the delicate green foliage of the young tree in the foreground, dappling the color onto the surface. Then, to develop the quality of the fog, apply very light strokes of neutral color—warm grays, bluish grays, and violets—throughout the painting.

As you continue to work, alternate between the trees and the foggy distance. Pay close attention to the negative spaces between the trees, where you'll want to create the sense of light filtering through to add color and life to the scene. Here, add touches of orange and yellow-orange in medium to pale tints, as well as touches of palest blue. Reiterate the neutrals to further soften edges and subdue value and color.

Thanks to the absence of sharp edges and strong contrasts, these woods really do appear to be enveloped in a soft fog. Yet the painting is not without a focus; the sense of space and depth that has been created keeps the eye engaged in an exploration of the scene.

Contrasting Sharp Focus with Soft

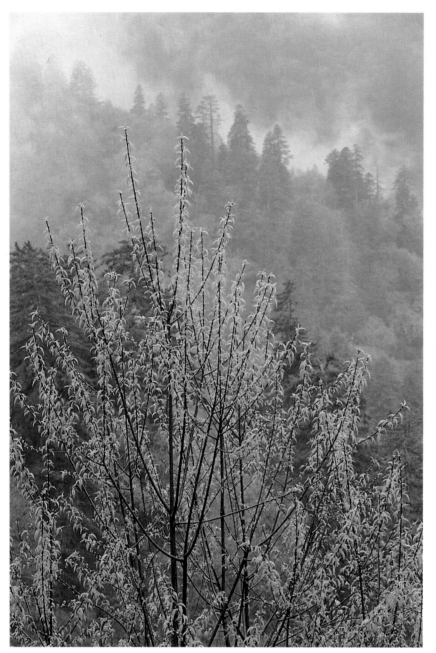

PROBLEM

To convey the essence and depth of this scene, you need to concentrate on how to handle the silhouette of the young cherry tree against the misty mountainside.

SOLUTION

State all major values right from the beginning, and alternate your work in the different value areas as the painting progresses. To make the cherry tree come forward and keep it in focus, use bright colors with little or no blending. For the background use dense, softly blended neutral color.

STEP ONE

Make your initial drawing on light green paper using pastel pencils, distinguishing foreground, middle ground, and background in the appropriate colors.

Viewed from a mountain overlook, a young cherry tree is silhouetted against a backdrop of tall conifers veiled in a blue-gray mist.

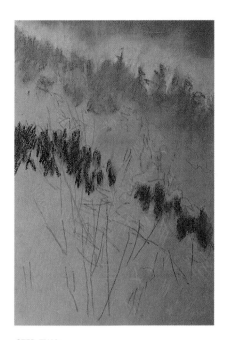

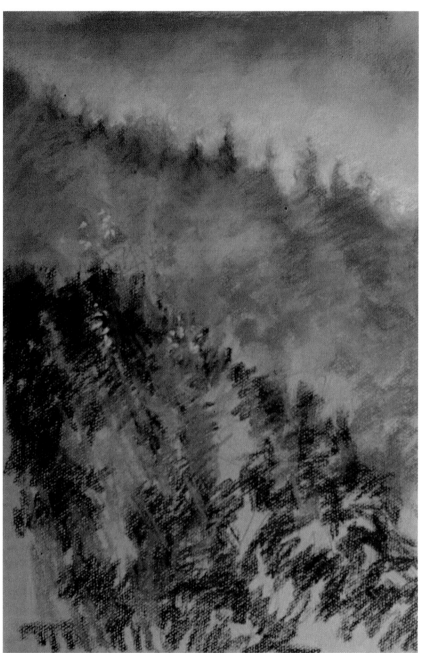

STEP TWO

Working in soft pastel, begin
to define the background mist
and middle-ground trees. Blend
these colors into the paper by
rubbing with a stomp or your
finger. When you have finished
blending, redefine here and
there the edge between the
middle ground and background.
Start to develop the dark greens
of the foreground. Leave spaces
open for the light greens and
yellows of the cherry leaves; this
way you don't have to paint your
lights over the darks.

STEP THREE

Further develop the soft,
blended shapes of the back-
ground and middle ground,
adding subtle nuances of color,
blending, and accenting edges.
Go back to the dark green of the
foreground, applying color in
short, crisp strokes that contrast
with the softness of the distant
tones. Begin to establish the
light green and yellow cherry
leaves. By now you should be
able to visualize how the fin-
ished painting will look.

FINISHED PAINTING (OVERLEAF)

Add the trunks of the cherry
branches with deft strokes of
burnt sienna (you should use a
pastel pencil for this). Heighten
contrast between the light
greens and yellows and the dark
greens. To emphasize the spatial
depth of this scene, sharpen
the edges that mark changes in
plane—the bright yellow and
light green cherry leaves should
stand out clearly against the
moody grays of the mid-dis-
tance, while the tree line silhou-
etted against the background
mist should be soft but definite.

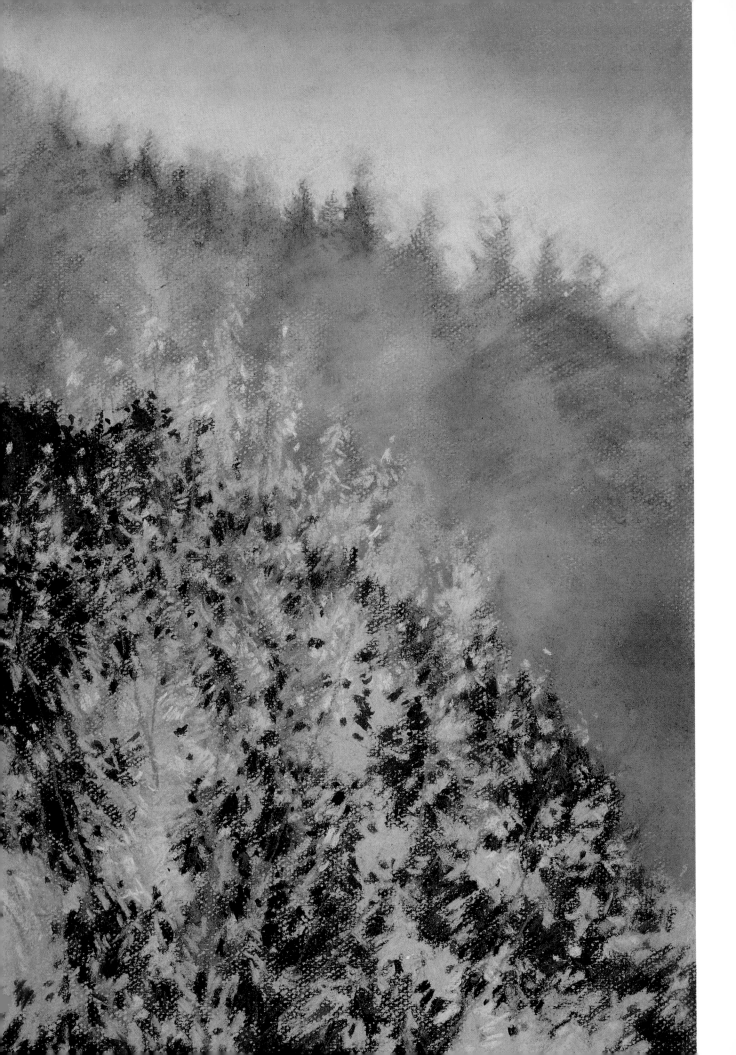

Portraying the Intricacy of Bare Tree Branches

PROBLEM
The oak tree's graceful silhouette and fine network of twigs form the heart of this composition. But how can you keep the details of the tree from becoming too fussy or too soft against the cool, neutral background?

SOLUTION
Start with a very careful charcoal pencil drawing of the tree, and then reinforce it with a black ink drawing executed with a small, pointed brush.

☐ Execute your charcoal sketch on gray paper that approximates the blue-gray tone of the background. Dip a small, pointed brush in black drawing ink and go over the main branches. Render the smaller terminal branches in a drybrush technique. (Drybrush means you have very little liquid on the brush.) This scriptlike brushstroke makes drawing the fine twigs much easier.

Treat the sky, hills, and grass as flat areas of color. For each, apply two or three hues in layers using short, broken strokes made with the side of the pastel sticks to express hints of texture. Here, dark and light values of chrome green were used for the grass, and dark blue-green for the shadow area under the tree. Suggest the middle-ground row of trees with a dark greenish blue and dark green-gray. For the large, tree-covered hill in the background, don't try to describe any detail; simply go over the area lightly with a medium gray and a very pale burnt umber. This conveys the scene's soft, hazy atmosphere.

As you apply color, work right over your ink drawing of the tree, since the ink will show through the pastel. Wherever you want more branches and twigs to appear, just lightly rub off pastel color and reinforce your drawing with a sharpened hard pastel or pastel pencil.

Here, the tree represents the darkest value and the grass and hills the medium values. To add some life to the composition, paint the sky a light value: Use a layer of deep yellow with some pale orange and pale Mars violet over it. This will also draw the eye upward so it takes in the tracery of the oak's topmost branches.

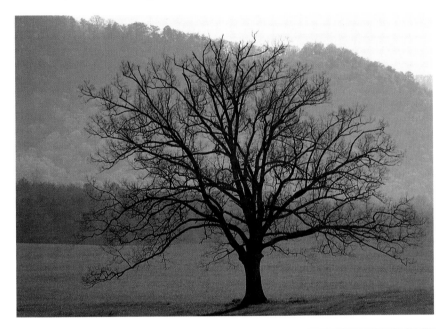

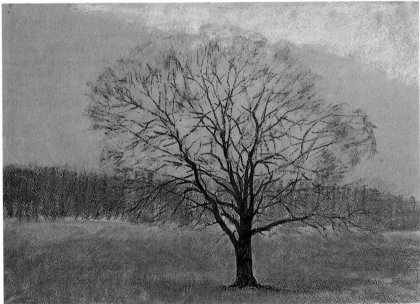

Standing alone in a field, a leafless old oak proudly etches the intricate network of its branches against haze-covered hills.

Balancing Strong Blues and Greens

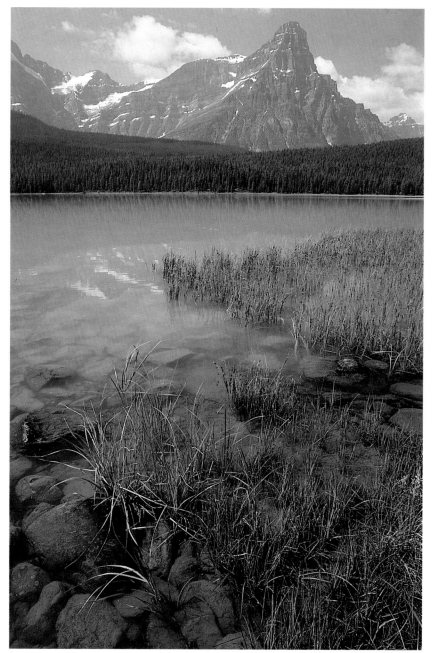

PROBLEM

Framed by a brilliant blue sky and deep green conifers, this lake is an almost unbelievable turquoise color. If you depict exactly what you see, your painting could easily look artificial.

SOLUTION

Don't compromise the beautiful blues and greens by dimming their intensity. Instead, balance them by using warmer earth tones in the foreground than you actually see.

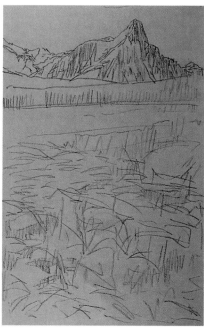

STEP ONE

On a neutral-colored paper, make a very loose charcoal drawing to establish the compositional patterns. Exaggerate the pattern of the foreground so it leads the eye back toward the mountains.

High in the Canadian Rockies, craggy peaks overlook a pristine lake fringed by stately conifers.

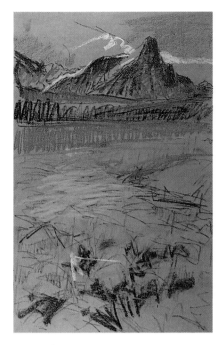

STEP TWO
Lay in simple fields of color that clearly define each of the various compositional areas. You need to establish all of the painting's basic colors and values simultaneously, working over the entire surface. This will help you balance things in the next stage.

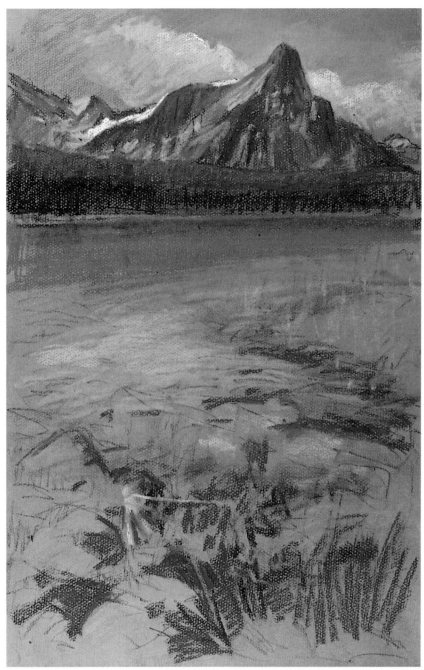

STEP THREE
Once you have covered the paper, work back over the whole painting, adding more color and adjusting values in relation to one another. Develop the cool but intense blues and greens of the distant areas in alternation with the immediate foreground; there, concentrate on building up warm, rich earth colors that will pull the eye forward. To unite the two main compositional areas (foreground vs. distance) and color schemes (blues and greens vs. browns and oranges), develop a transitional area using colors that borrow from both sections—strokes of pale blue and violet mingled with strokes of pale orange, blending them loosely to let the neutral color of the paper show through.

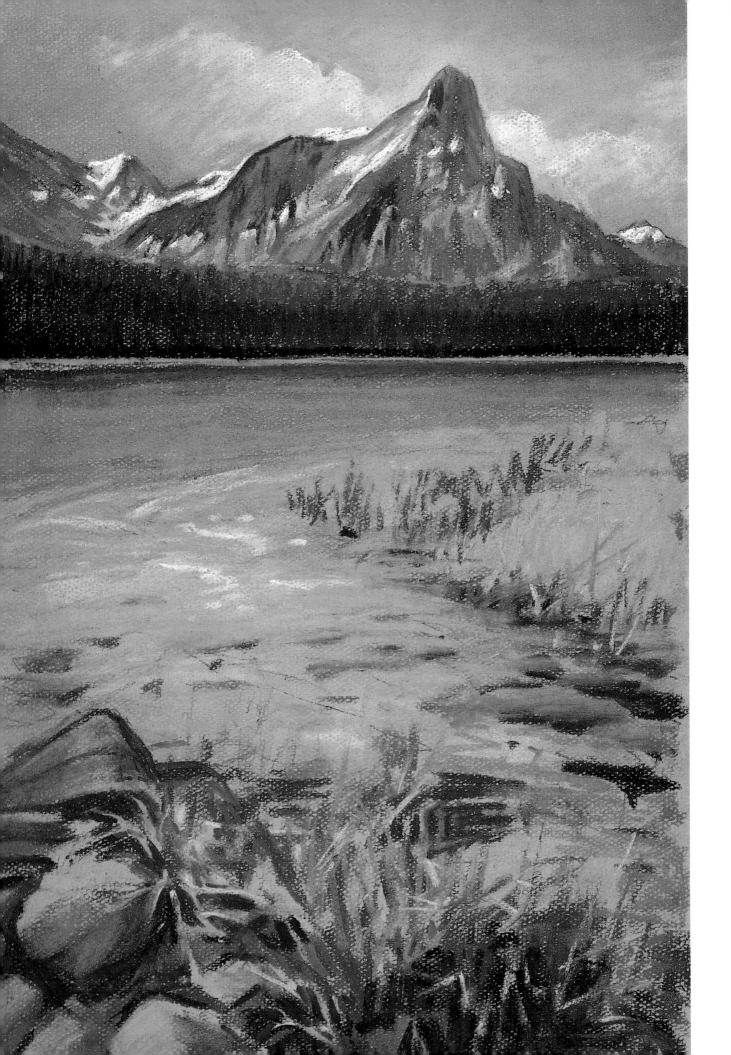

FINISHED PAINTING

When you are painting a scene as dramatic as this one, working fairly loosely prevents your composition from becoming lifeless and unnatural. At this stage, with all colors and values in place, let the painting tell you where redrawing and subtle touches of color might be needed. Add strokes of yellow-orange in the foreground to make it come forward, and perhaps additional touches of white snow to further define the sharp ridges of the mountains.

DETAIL

The colors of the mountains, trees, and lake are rich and saturated, and the mountains stand out beautifully against the white clouds and crisp blue sky. The fairly thick application and intensity of color in these areas, as well as the detailing of the mountains' facets and profile, compel the eye back into the composition and hold it there.

DETAIL

The warm, earthy browns and oranges of the foreground attract and hold the viewer's attention, but because the specifics of this area have been so loosely rendered, the eye is then free to seek the more sharply rendered, highly dramatic elements in the distance. It is the visual push and pull created by the contrast between warm and cool colors and between detail and suggestion that makes this composition succeed.

Rendering Contrasting Textures Convincingly

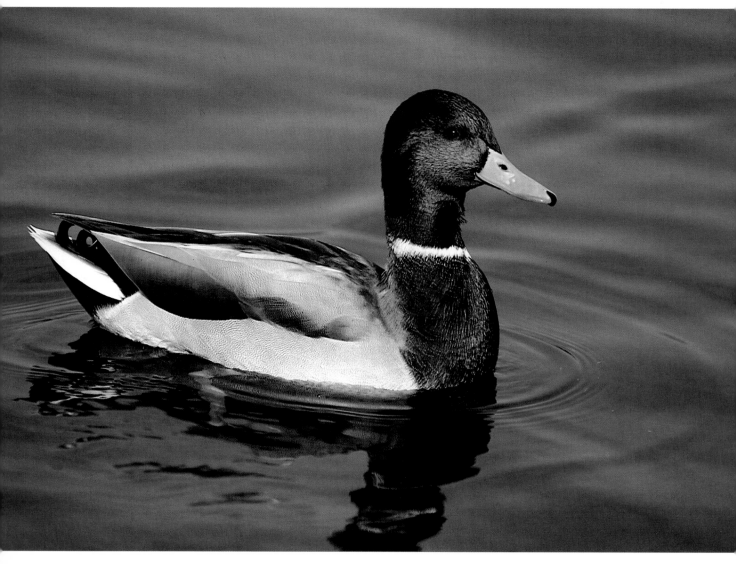

PROBLEM

This subject seems simple—a single form, the mallard, silhouetted against calm blue water. But under closer scrutiny, the artistic challenge becomes obvious. You need to distinguish between the water's smooth but gently rippled surface and the texture of the duck's feathers, as well as capture the iridescent green of his head.

SOLUTION

Use the smooth side of a warm-hued paper, such as Canson Mi-Teintes tobacco, to echo the smooth surface of the water and to add some warmth to it. Then, use one kind of stroke to render the water and another for the duck's feathers.

☐ Besides working on a smooth surface, the key is to make a careful drawing of the mallard, aiming for accuracy of proportion and detail. Then you can begin to paint the water.

To create the water's flowing shapes, make long, sweeping strokes with the side of the pastel stick, overlapping one color with another and following the water's motion as you paint. Use a variety of blues in a range of values. Define the gentle ripples with subtle strokes of a lighter blue, blending gently. Take special care in rendering the ringlike pattern of ripples around

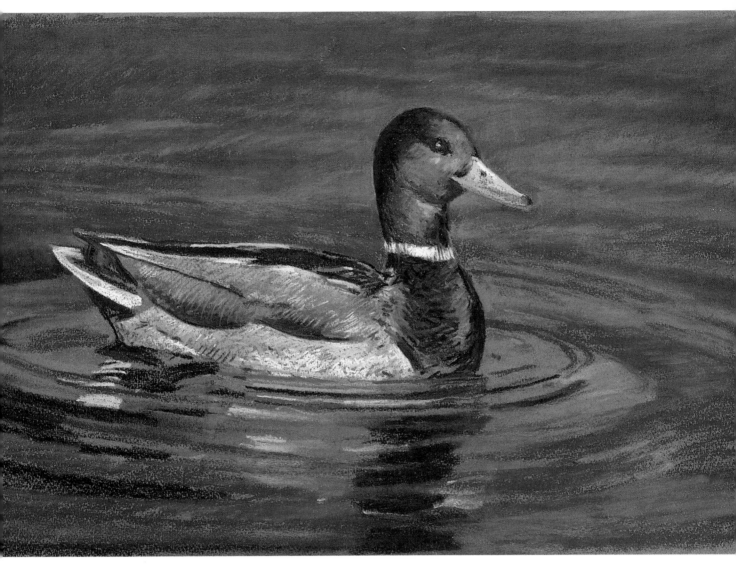

the duck; the ripples form a series of concentric ellipses.

Paint the mallard in short, crisp linear strokes that follow the direction of the feather growth and the contour of the duck's body; some individual feathers should be discernible. To capture the iridescent green of the duck's head, use a medium-value phthalo green as the local color, modeling form carefully with a dark blue-green and black for darker areas and, for highlights, a very light phthalo green tint and yellow-green. A few subtle strokes of ultramarine blue will really add shimmer.

Above all, maintain the sharpness of the duck's profile against the water.

If you want to create the illusion of three-dimensional space, it's important to render the mallard's reflection in the water carefully. In the photograph, note which parts of the duck's body actually appear in the reflection. Because of the ripples, it is chiefly the neck and breast, which reflect in the blue water as black. On either side of this dark area, suggest the sky's reflection in the water with a bright cobalt blue. Reflected too are the tail feathers—at an angle

opposite to and in a value slightly darker than the tail itself. The animal's bright orange leg is visible partly through the transparent water and partly as a reflection in it; observe and record its appearance.

Using black as a contrast to the brown paper and blues of the water, exaggerate the concentric elliptical ripples around the duck in broken, not continuous, strokes. And, to reinforce the illusion that the duck sits on top of the water, add a thin stroke of red-violet and another of orange, plus a dark gray, to separate the bird from the lake.

Using an Oil Underpainting

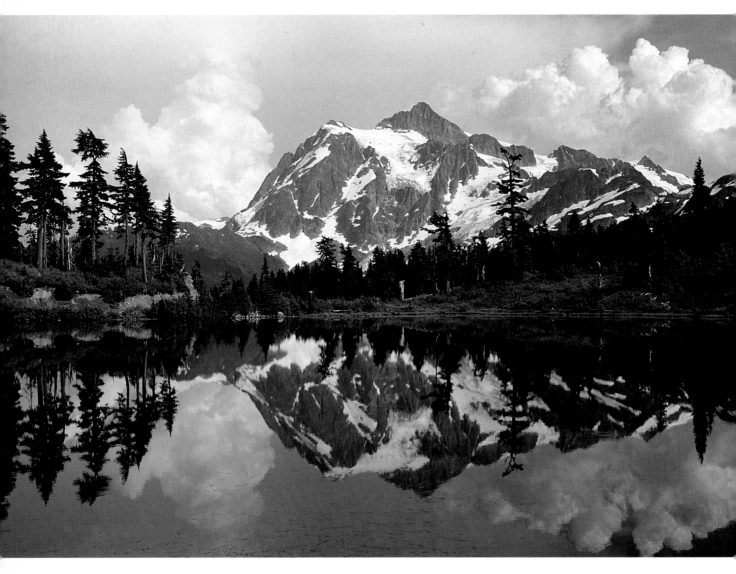

PROBLEM
To adequately capture this breathtakingly beautiful landscape in pastel, you need to reckon with two dominant features of the scene early in your painting: its symmetry and its very strong value pattern.

SOLUTION
Look at the scene not so much as a mountain landscape mirrored in a pristine lake, but as an almost abstract pattern of lights and darks. Then construct a solid underpainting in thin oil washes, establishing the scene's value pattern and color range as a guide for your subsequent work in pastel.

In Washington's North Cascades National Park, Mount Shuksan is reflected perfectly in Picture Lake.

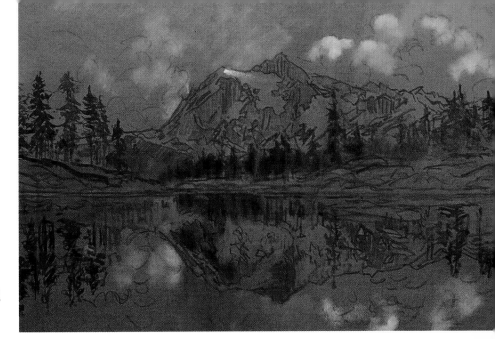

STEP ONE

Make a careful drawing in charcoal and reinforce it with oil color thinned with mineral spirits. Then, using a stiff bristle brush and very little pigment, lay in large areas of opaque color in a drybrush technique. This allows you to cover large areas of the painting very quickly, and without filling in the texture of the paper. Continue building the pattern of darks and lights this way until you have laid in the entire underpainting.

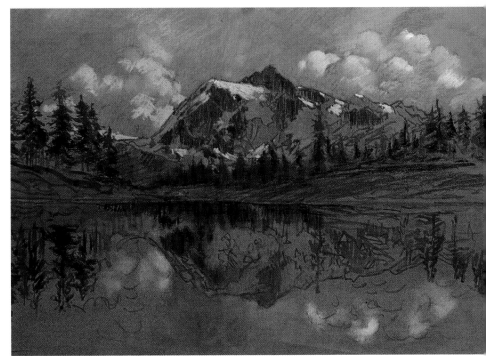

STEP TWO

Now begin to apply both hard and soft pastels over the underpainting, building upon the basic value and color scheme you have already set up.

STEP THREE

The shapes and colors of the mountain and its reflection may be symmetrical, but their values are not identical. The reflection of an object in water is always darker than the object itself. So, to make the reflection believable, keep values there somewhat darker and details slightly less sharp than in the upper half of the composition. The pressure with which you apply color contributes to this effect. For example, to make the snow on the mountain sparkle, apply strokes of pure white with fairly heavy pressure; conversely, in the reflection, apply pure white sparingly and lightly and the snow there will look darker.

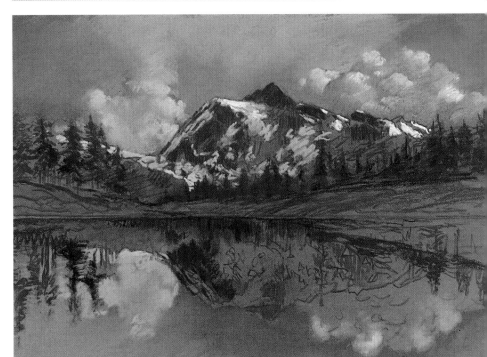

FINISHED PAINTING

Adjust values and colors where needed, particularly your darkest darks and lightest lights. Softly blend areas of the sky and parts of the clouds, as well as their counterparts in the reflection. Add further definition of texture, especially to the trees and the jagged edges of the mountain. Finally, add a subtle stroke of burnt sienna to separate the landmass from its reflection.

The one area of intense blue in the sky puts this cloud mass into sharp profile, creating interest in the upper right part of the composition.

Details that work beautifully in a photograph sometimes prove distracting in a painting. Thus, the interesting scallop shapes of soil at left in the photograph have been eliminated from the painting to tighten the composition and focus the viewer's attention on an already strong value pattern.

ASSIGNMENT

Oil underpaintings help keep your pastels from looking overworked, and let you create deep, rich tones you can't achieve with pastel alone. They're especially advantageous when your subject is complex or calls for color coverage over a large area.

Dilute a variety of oil colors with turpentine and apply the thinned paints to swatches of different colored grounds. When the swatches are dry, apply various pastel colors over them and see how they look. Keep these swatches handy for reference so you can duplicate the effects later in your pastel paintings.

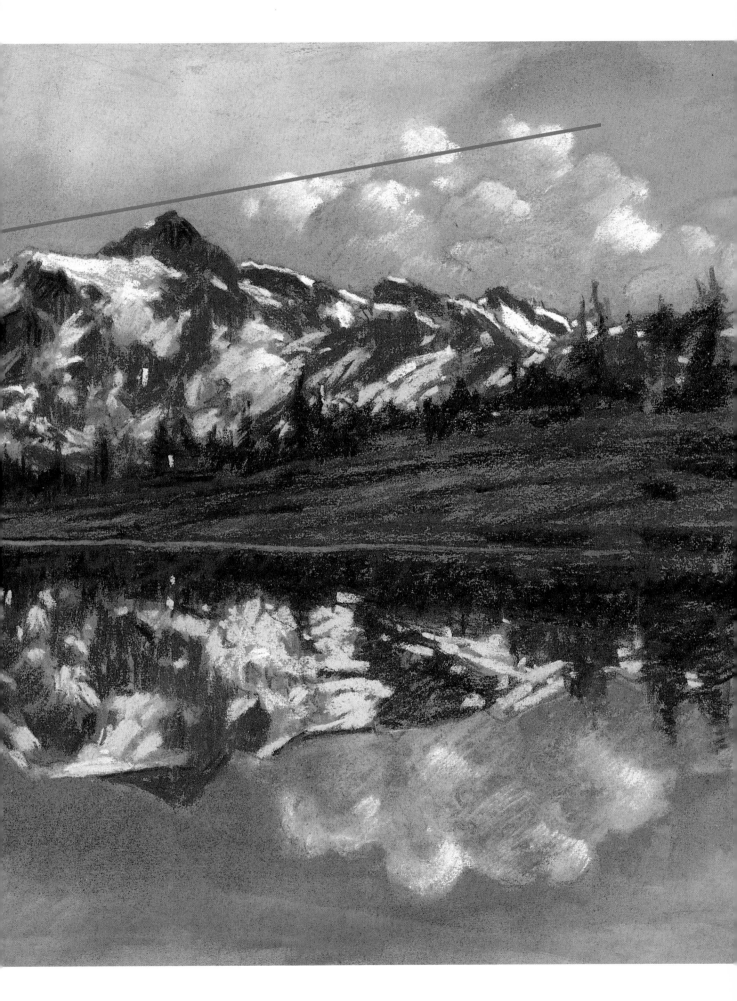

Learning to Depict Dramatic Cloud Formations

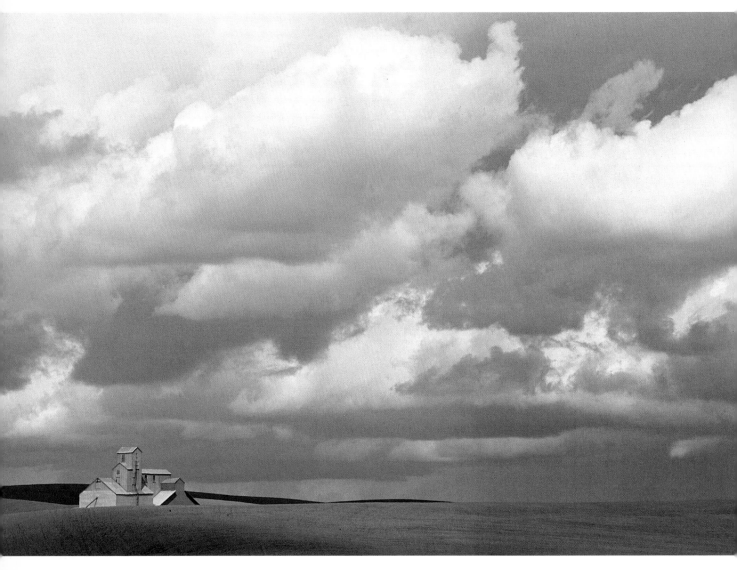

PROBLEM

The large, low-lying cloud masses are the subject of this scene, the land and grain elevator serving as anchors. For your painting to succeed, you not only have to give the clouds definite three-dimensional form, but also must convey a sense of receding space.

SOLUTION

Treat the clouds as solid shapes that can be modeled with value like any other solid shape. As you begin to paint, pay close attention to highlights and shadows, the keys that will help you sculpt the clouds' forms.

Thick clouds heavy with rain lower over a grain field in eastern Washington State.

STEP ONE

A support with a slightly abrasive surface that can withstand dense color application is needed for this subject. Here, a sheet of gray La Carte Pastel, a moderately heavy board coated with finely ground vegetable fibers, is a good choice. Start by blocking in the positive cloud shapes with white and gray to establish the patterns they form in the sky. For now, let the gray of the pastel board serve as the clouds' middle value. For the negative areas—the darker sky that surrounds the clouds and defines their forms— use a dark blue, plus a lighter value of the same blue.

STEP TWO

At this stage, with your basic value structure in place, add some warmth to the light cloud values with very light orange-pink tints. Extend the value range between your darkest darks and lightest lights using various shades and tints of cobalt, cerulean, and Prussian blue, as well as various warm and cool grays. Sharpen edges in selected areas to exaggerate contrast where clouds need more sculptural definition. Also at this stage, establish the greens of the land and begin to further define the structure of the grain elevator.

STEP THREE

Now you need to pull your painting together. To do this, draw over the colors of the sky with a neutral gray, lessening the importance of its individual elements. Blend carefully. Add some cool violet to the dark underside of the cloud nearest the horizon, and paint the highlighted roofs of the grain elevator.

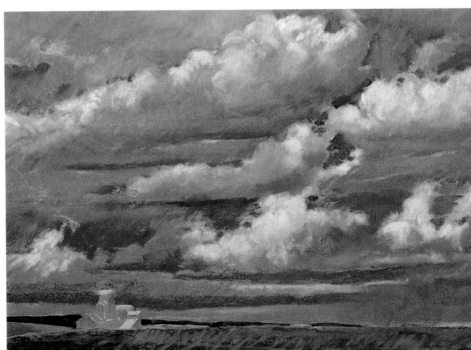

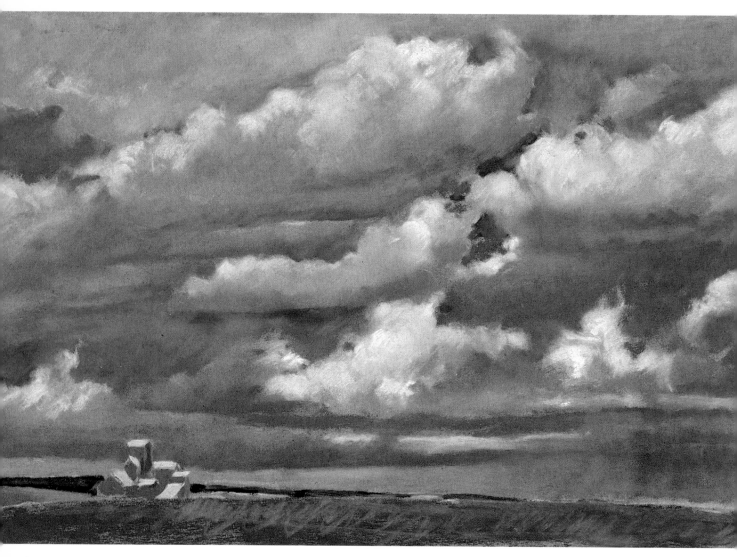

FINISHED PAINTING

Toward the end of your work, finish the details of the grain elevator. Continue to bring the painting together with judicious blending, occasional sharpening of the edges of forms, and value adjustments.

ASSIGNMENT

Pastel is an ideal medium for studying cloud patterns and formations. When you paint clouds, it helps to have a knowledge of the different types, such as thin, wispy cirrus, towering thunderheads, and fluffy cumulus. Spend some time observing the anatomy of various cloud formations in the sky. Make a series of quick, fifteen-minute studies using a gray paper and white pastel, changing the pressure as you sketch to achieve a range of values. Alternatively, use two or three gray values plus white.

Rendering a Complex Overall Cloud Pattern

PROBLEM

The biggest mistake you might make in painting this strongly patterned subject is to get too light too soon and neglect to establish a full value range.

SOLUTION

To ensure the range of values you really need here, lay in the cloud shapes first, establishing your lightest lights and darkest grays on a medium-dark gray paper that can serve for now as a middle value.

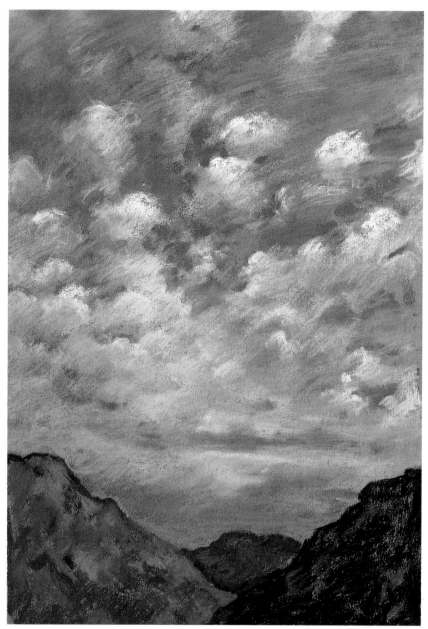

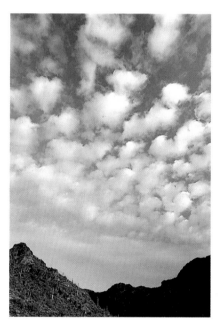

□ Indicate the browns and burnt siennas of the landmasses to anchor the scene. Paint the blue of the sky only after you've established the cloud shapes. Think in terms of aerial perspective: To make the clouds in the upper portion of the composition seem closer to the viewer, use your darkest blue—an ultramarine—there, and give some individual clouds more definition; to make the more distant clouds appear to recede toward the horizon, use progressively lighter, less vibrant blues as you work your way down to where sky meets land. Strengthen the colors of the land forms at this point.

Now work back and forth between the clouds and sky, accenting the tops of the clouds and softening their undersides. For the sake of interesting composition, don't hesitate to exaggerate the strong pattern you see.

In selected areas, indicate holes in some of the clouds with touches of blue. Small details like these will enhance the illusionist quality of your painting. Finally, stand back from your work to see whether any values need adjusting.

Puffy cotton balls of altocumulus clouds drift across an Arizona desert sky.

Using Colorful Pattern to Provide Focus

PROBLEM

The temptation here is to emphasize the beautiful flowers, but it is the cabin that provides structure to the scene, even though it occupies a much smaller portion of the composition than the colorful blossoms do.

SOLUTION

Leave the proportions of cabin to blooming prairie intact. Render the cabin in sharp focus, and exaggerate the pattern of the flowers to lead the eye back to it.

☐ Make a charcoal drawing on green pastel paper. Use the charcoal to lightly shade in darks to establish the silhouettes of the trees and cabin, as well as the pattern of the foreground flowers.

Now switch to pastel. Because the flowers occupy so much of the composition, develop them first, working from dark to light. Don't try to render them in detail or they'll compete with the cabin. Instead, treat them as groups. Lay in your darks—olive green, dark blue-green, dark brown, and a little black—in the areas between and around the flowers. Then indicate the blossoms, placing their bright reds, pinks, violets, and whites throughout the painting and leaving much of the paper's green surface showing. To give the flowers definition, work back and forth between the blossoms themselves and the dark accents around them.

Render the cabin, using grays, browns, and pale ochers for the sides illuminated by bright sun and burnt sienna values for the roof. Let the dark greens of the trees define the cabin's simple shape, and paint the sky in a light phthalo blue tint.

Strengthen the design of the flower pattern. Closely spaced strokes of warm, bright reds and pinks near the cabin attract attention to that area and suggest that the flowers are of diminishing size, creating the illusion of receding space. Conversely, the looser treatment of the flowers and foliage in the foreground, depicted mainly in cool violets, blues, and greens, gives a feeling of nearby space. What makes this scheme really work is placing a few bright red and pink blooms in the foreground to act as stepping-stones that lead to the denser mass of color near the cabin.

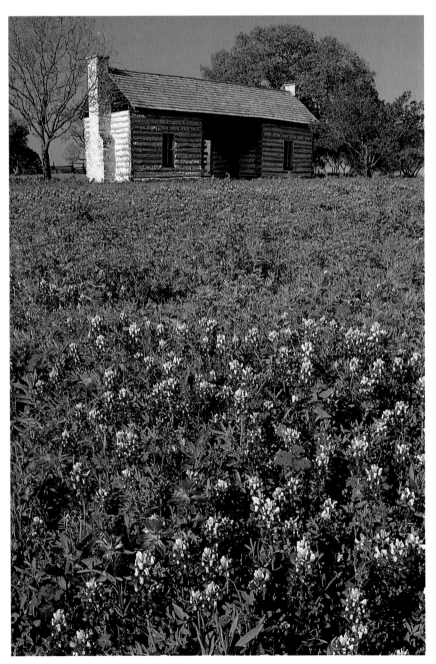

Under a brilliant sky, a carpet of spring wild flowers spreads color across a Texas prairie.

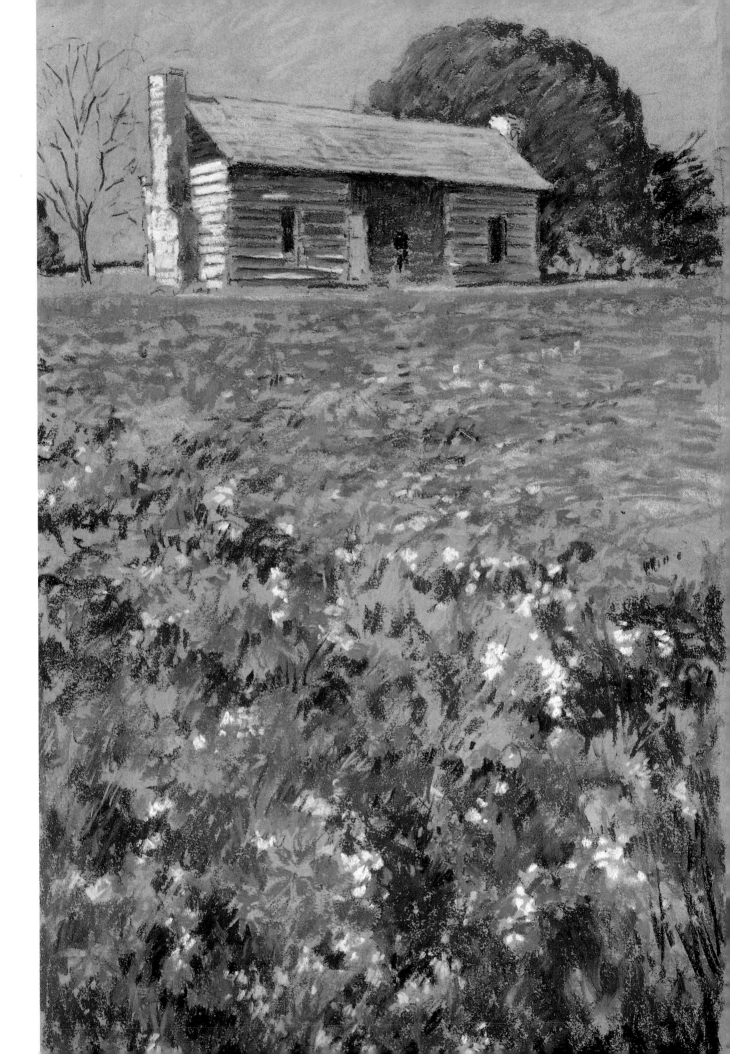

Seeing the Colors of White Against a Blue Sky

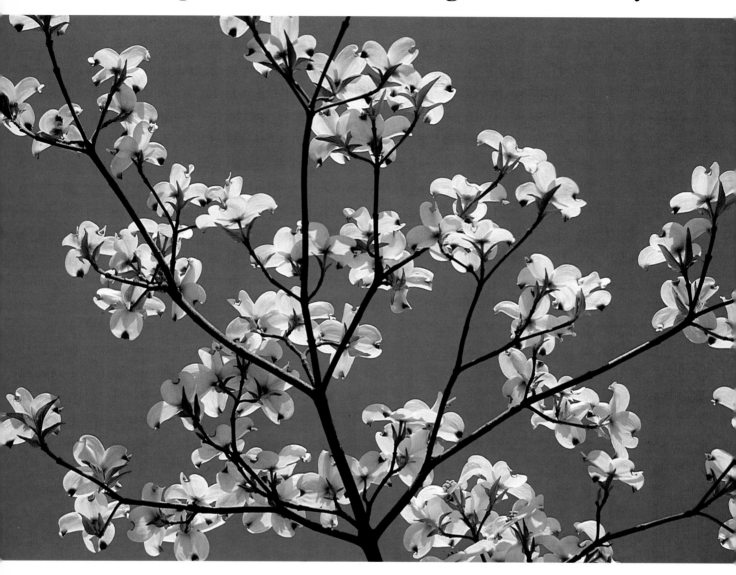

PROBLEM

Painting white flowers demands a keen awareness of subtle value shifts that can be translated into colors that will still read as white. And the white must read as the hue of your subject, not just as the highlights on it.

SOLUTION

It's best to avoid painting the sky altogether and simply choose a blue paper that can serve as the sky's hue. Not only would it be difficult to paint a broad expanse of flat, unvariegated color in pastel, but also, such a dense layer would make it hard to attain the crisp definition and bright whites you need here.

☐ When the paper serves as your background color, take extra care to keep it clean and free of unwanted marks and smudges. Here, the precise shapes of the subject call for

using hard pastels and pastel pencils, which should help keep smudging to a minimum.

Make your initial drawing with a medium gray, which will show up well but is not difficult to cover. Right away, establish the dark and light values of the flowers against the sky. Choose the colors you use more by value than by hue. For dark and middle values of the white flowers, use cool "gray" colors—light tints of bluish gray, blue-violet, grayish green, and burnt umber. Use light tints of warmer colors for the flowers' lightest white values. Carefully blend transitions

Petals of frothy dogwood blossoms silhouetted against a flawless blue sky are made luminescent by the sun's rays.

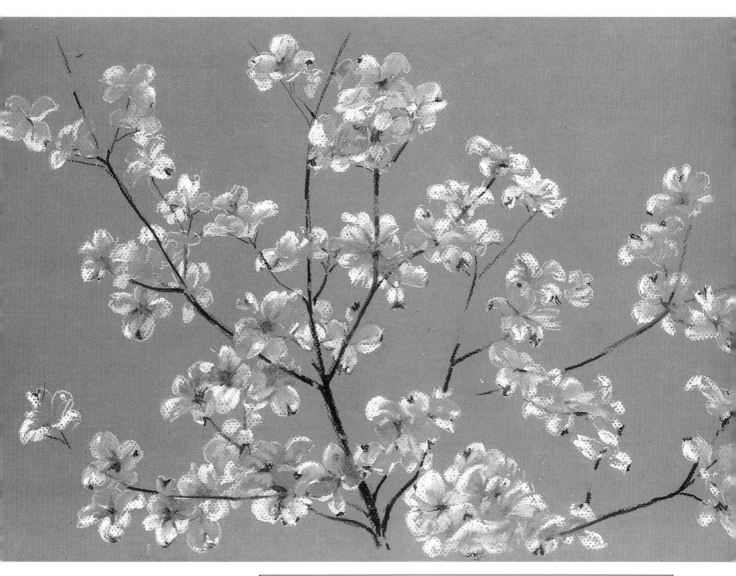

from dark to light to suggest the softness of the white petals. Articulate the branches and petal details with a dark burnt umber.

When your support serves as background color, edges of shapes and forms can only be defined with positive strokes of pastel color. So, for fine lines and crisp edges, use a sharpened hard pastel to add any last details.

In the finished painting, note the fairly wide color-value range that has been used to express the white local color of the dogwood blossoms.

ASSIGNMENT

As an alternative to using the color of your paper as the background color for your painting, you could paint a ground color on whatever support you choose using acrylic, watercolor, or any other medium that won't affect the surface adversely or add texture of its own.

It's a good idea to experiment with different mediums first to see how they affect your working surface and how even a ground tone you can achieve with them. For example, at the right consistency, acrylic lays down flat and solid, but if you thin it with too much water, you'll get streaks. On the other hand, there might be times when you want a more painterly looking ground tone showing color changes and brushstrokes.

Try creating several different colored grounds on scraps of good paper. Then apply a variety of pastel colors to them to see what effects you can get.

Balancing a Bold Shape with a Busy Background

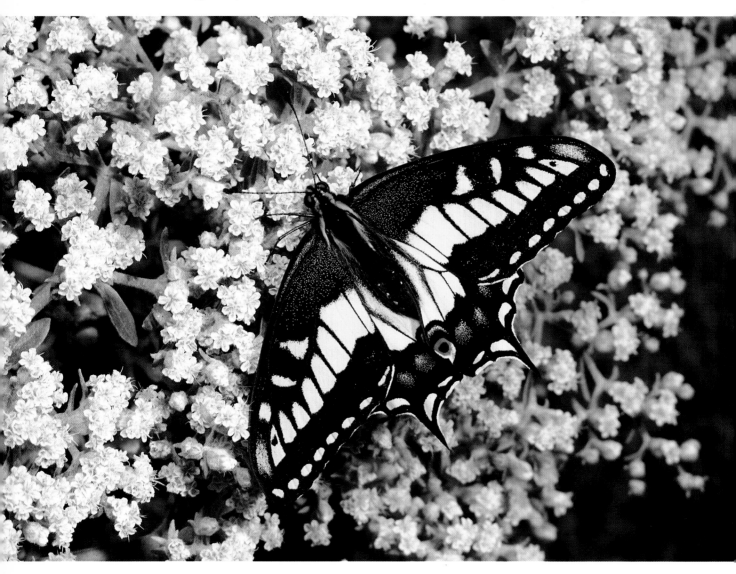

PROBLEM

The butterfly is obviously the focus of this composition, but it's not going to be easy making it stand out from the detailed white flower clusters.

SOLUTION

Play down the forms and bright whites of the flowers, painting them instead as a softly textured mass that contrasts with the strong graphic shape, pattern, and colors of the butterfly.

An anise swallowtail butterfly, its wings bearing the tracery and luminous color of stained glass, alights on a cluster of snowy white flowers.

STEP ONE
Make a charcoal drawing to
define the butterfly's silhouette
and wing pattern and indicate
the general shapes of the blos-
soms. Then, using a light gray,
lay in the flowers in a simple
manner, blending by just touch-
ing them with your finger but
leaving some of their edges
slightly defined.

STEP TWO
Now, with black and a dark
grayish blue, add the dark value
patterns of the butterfly and,
with the same blue, the areas
beneath the blossoms. At this
stage, don't yield to the tempta-
tion to give any further defini-
tion to individual flowers.

STEP THREE
With all the major dark areas
established, begin to sharpen
your rendering of the flowers,
alternating strokes of white,
which express both the flowers'
color and highlights, with
strokes of dark color to express
foliage and shadows. Define
some leaf shapes within the dark
areas of the background with
green. To the flowers in the left
foreground, add just a sprinkling
of short pink strokes; around
the butterfly's profile, add some
violet, blending it softly. Next,
fill in the tracery design of the
swallowtail's wings with glowing
yellows, blues, and, for the
eyespots, red.

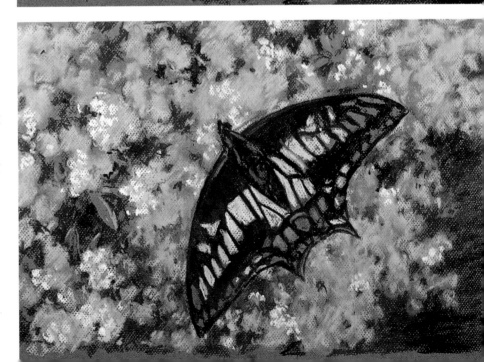

FINISHED PAINTING

Bring your painting together with a little judicious blending of grays and whites in the background, adding two or three more tiny, unblended hints of pink to the flowers to catch the eye. Fill in any remaining cells of color in the swallowtail's wings, making three or four segments of the pattern a slightly brighter yellow to represent highlights. Finally, give sharp definition to the edges of the butterfly's profile and the darks that surround the bright patches of color.

The white flowers of the background have been interpreted as an almost abstract tapestry, the individual blooms generalized and softened to provide a contrasting backdrop for the sharply focused swallowtail.

The geometric pattern of the swallowtail's bright, very distinctive colors strongly outlined in black makes a bold graphic statement that is enhanced by the soft texture and light values of the background.

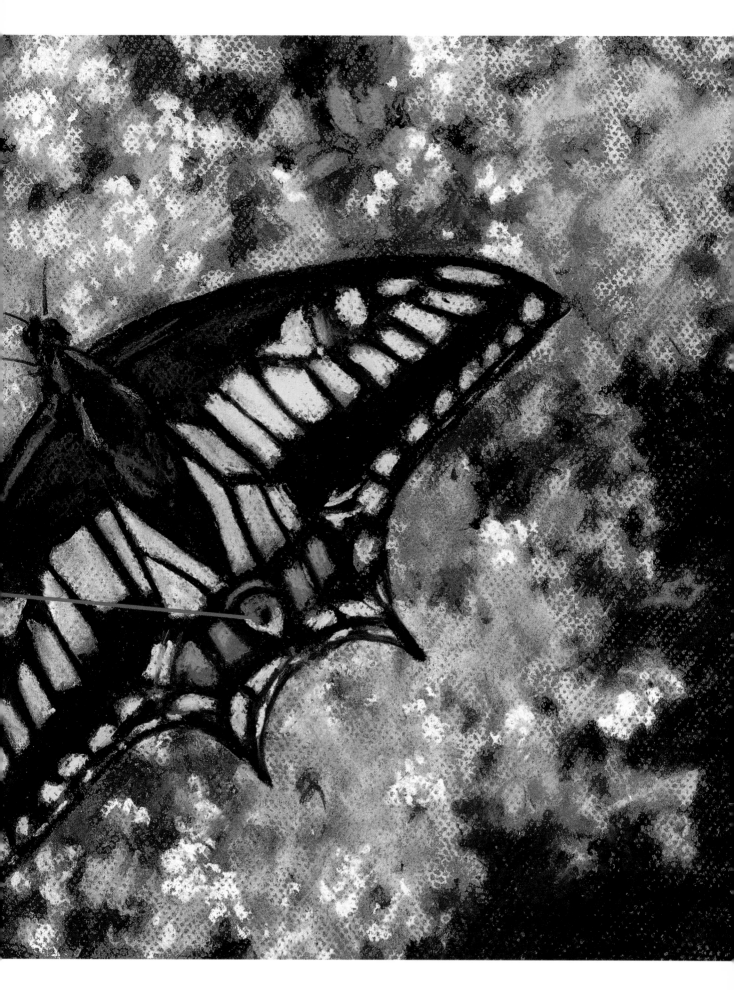

Achieving Variety in Your Whites

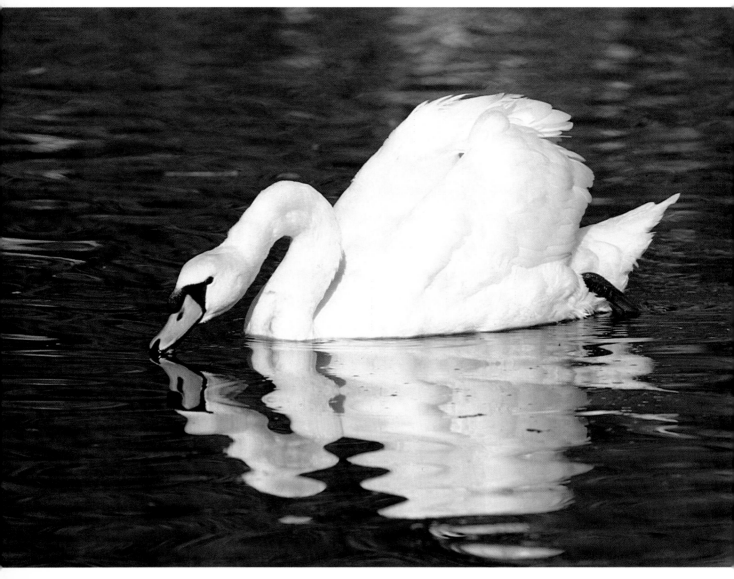

PROBLEM

To portray the swan convincingly, you have to find a way to describe the volume and changing contours of its body, as well as the texture of its feathers. But modeling form in a white subject isn't easy, and here you must consider not just the swan itself but its reflection as well.

SOLUTION

White subjects are rarely "just white." Light reflecting off the water, plus shadows and small areas of cast shadow on the bird, create subtle color and value variations in the animal's local color that you can use in describing its form.

☐ Make your initial drawing of the swan and its reflection on black paper, which will provide a contrast to bird's light form. Use a gray pastel pencil so you can see your drawing. Distinguish, then record the individual shapes of the swan's body.

Start adding pastel color to the swan. To adequately describe its form you'll need a range of dark to light gray values. Work from dark to light, saving your lightest values till last. Your strokes should follow the contours of the swan's body and the direction the feathers grow in.

Look at the photograph for hints of other colors in the white—very pale yellows, caused by light reflecting off the green water; pale orange; and blues and blue-grays on the swan's hind parts, where the

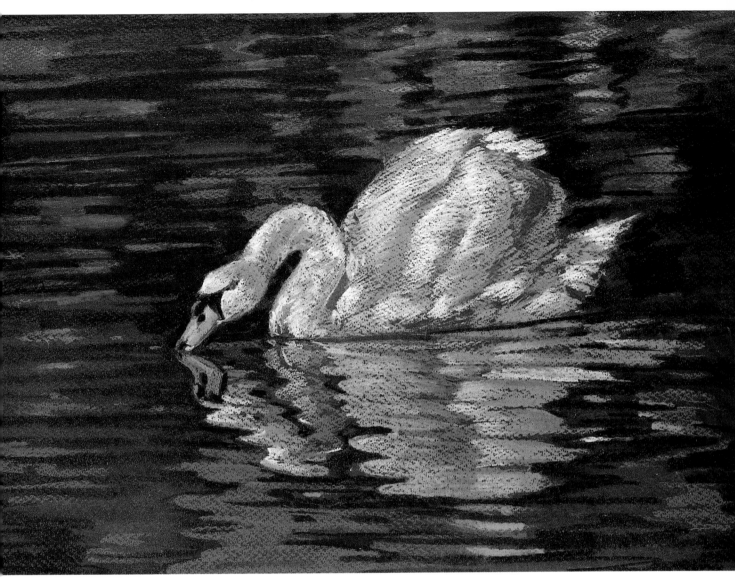

wings are lightly shadowed and cast a shadow shape on the tail feathers. Note, too, the reflections of blue in the water here.

Paint the bright orange and orange-yellow of the swan's beak and place a tiny spot of orange on the eye. Use black pastel to define the details of the beak and mask, adding a stroke of violet at the top of the mask.

As the swan begins to take shape, start painting its reflection. Just as with all reflections in water, this one is darker in value than the bird itself. Without the swan already in place as your ref-

erence, it would be easy to make the reflection too light. Translate the bird's values into slightly darker ones using grays and some strokes of blue for the body and a deeper orange for the beak. Capture the ripples of the reflection's shape.

Observe the ripple pattern in the water and follow its generally horizontal direction as you apply color. It's best to keep this simple, since the swan is the focus here. Use the swan and its reflection as a guide for judging the water's value; keeping it colorful will help it look less dark than it

really appears. Don't be too literal in your choice of colors here; use olive green, ocher, and occasional strokes of a deep green and burnt umber as medium values, and for highlights, sparing touches of orange and cerulean blue. For the darkest values in the water, use a very dark blue-black pastel, which will make the reflections stand out.

In the finished painting, note how blue-black pastel has been used near selected areas of pure white to create sharp contrast that enhances the illusion of three-dimensional form.

Working with a Limited Value Range

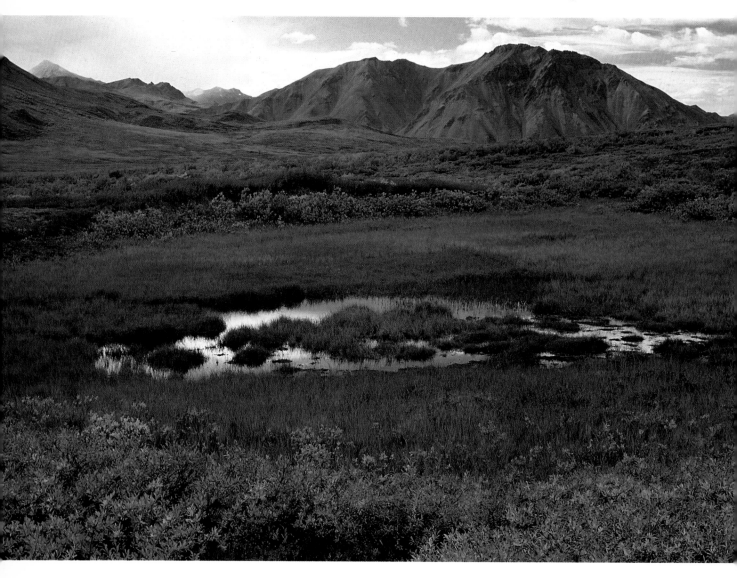

PROBLEM
The beauty of this landscape is in its subtle colors, yet there are few definite values to speak of. Your painting will stand or fall on how well you handle the colors' inherent values.

SOLUTION
Let the limited values work for you, not against you. The earthy colors of the scrubby tundra growth and mountains are medium to medium-dark values of brown, burnt sienna, and green that make for a compelling visual contrast with the bright blues and whites of the sky and its reflection in the pool.

On the Alaskan tundra, a shallow pool surrounded by scrubby autumn vegetation reflects a bright sky.

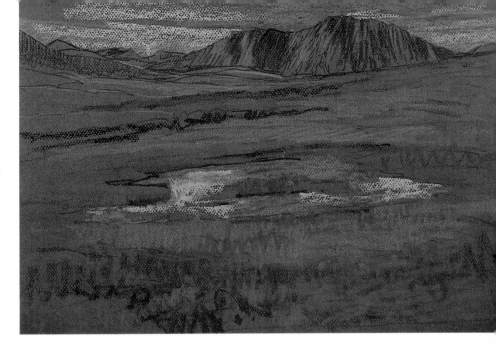

STEP ONE

Make a simple charcoal drawing of the subject on a ground compatible with the value and color scheme of the composition, such as the warm, tobacco-colored Canson Mi-Teintes pastel paper used here. To your initial drawing, add bold strokes of pastel color to suggest all the subsequent values and hues of the landscape—white, cerulean blue, ocher, burnt sienna, burnt umber, Indian red, gray, olive green, and chrome green light.

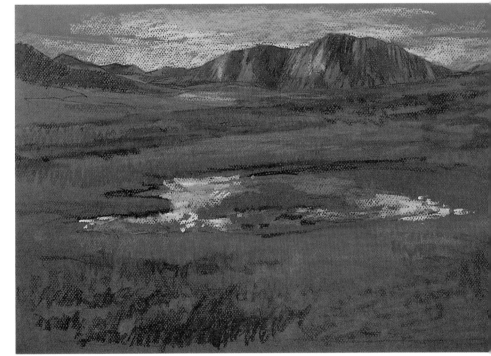

STEP TWO

Now that all major values and hues have been established, begin to articulate their nuances, working over the entire composition. Expand the variety of earth colors used to depict the vegetation and cliffs, but keep them within a very limited value range. Introduce a dark gray-blue to the land colors. Add highlights (your lightest lights) to the white clouds and sky and to their reflection in the pool.

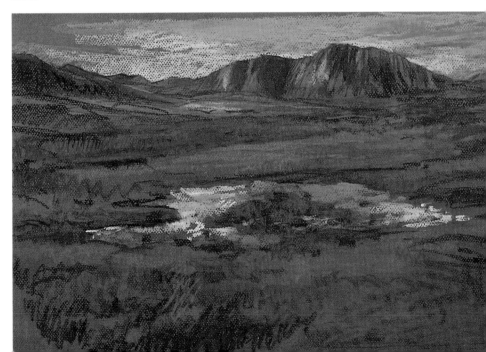

STEP THREE

Strengthen the color values, especially the extremes of light and dark. Add, with some blending, more definition to the light values—whites and blues—of sky and pool. Add, too, more articulation to the vegetation, using such medium-dark to dark-value colors as burnt umber and sepia and laying them one over the other to maintain the close value range. Some strokes of a light green, such as chrome green light, serve as medium-value highlights that cause the eye to linger briefly in the immediate foreground.

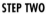

FINISHED PAINTING

To ensure that your painting
will come together, reexamine
its value and color structure.
Exaggerate the contrast between
light and dark values of the back-
ground by filling in the sky with
more light color, blending to
make it more solid and bringing
it right down to meet and sharp-
en the profile of the cliffs. Also
sharpen edges where the pool
and ground meet. Then add a
few more strokes of light green
to the grass in the foreground.
The subtle interplay of color
and value, even within a limited
range, make this a compelling
image.

*The strong contrast between
light and dark values—
between the sky and cliffs, and
between the land and the sky's
reflection in the water—really
captures and holds the eye.*

*Color contrast is at work here,
too. Note that the overall color
scheme consists largely of blues
and oranges—complements, or
opposites, on the color wheel.
There is temperature contrast
as well, the blues acting as cool
complements to the warm,
earthy oranges and browns.*

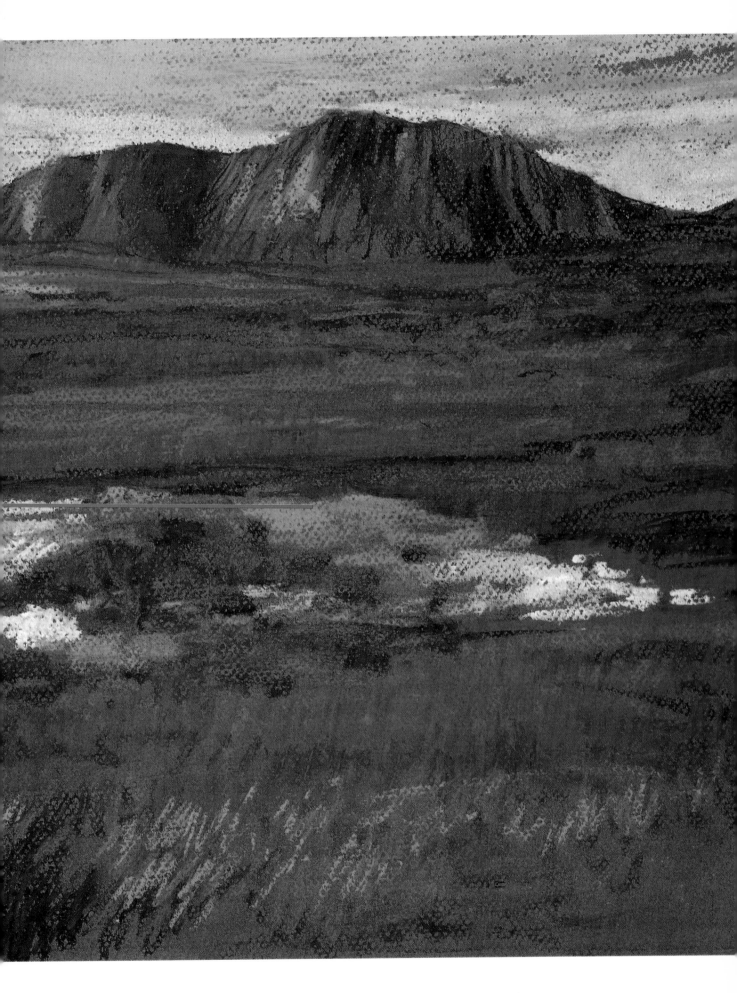

Articulating the Character of a Bold Form

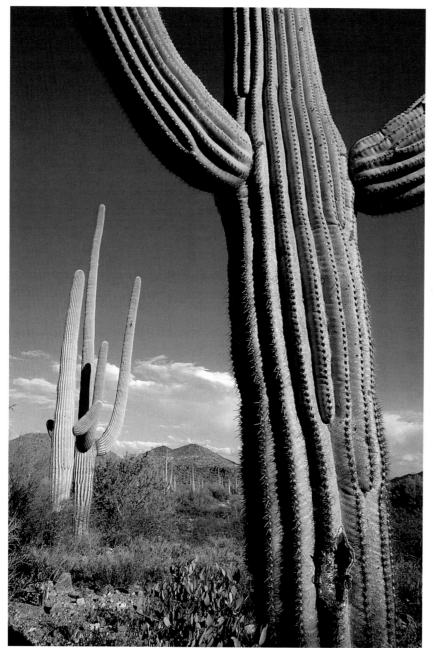

PROBLEM

With its branches reaching upward in an almost human gesture, this saguaro cactus has a lot of character. It's important that you describe its form, gestural quality, strong vertical pattern, and prickly texture carefully.

SOLUTION

Make a strong initial drawing of the subject, clearly defining the form and value pattern of the cactus from the beginning. Use the backdrop of intense sky color to silhouette and thus emphasize the saguaro's form.

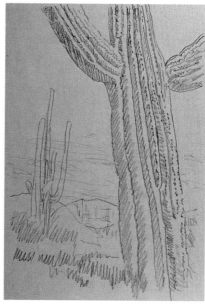

STEP ONE

Execute your drawing in charcoal pencil, articulating the strong dark values and patterns. Your drawing shouldn't be about line; concentrate instead on establishing lights and darks.

A majestic saguaro cactus raises its branches skyward, acclaiming the perfect Arizona day.

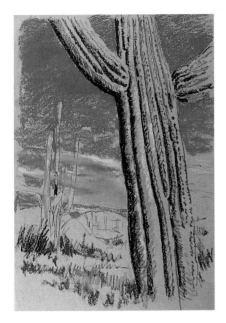

STEP TWO
Paint the deep blue sky first, bringing it almost to a finish. This will set off the cactus immediately and establish the drama of the subject. Next, place small amounts of color throughout the painting to establish the hue range.

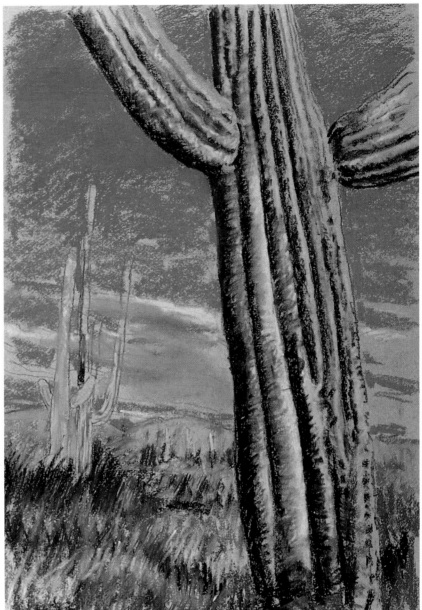

STEP THREE
Using greens, yellows, and browns, give further definition to the dark and light patterns of the cactus. Model the vertical contours carefully; you want these ridges to look three-dimensional, not like flat stripes. Strengthen edges where the cactus meets the sky, exaggerating extremes of dark and light values there to silhouette the form. As for the ground, instead of the greens in the photograph, use warm, reddish browns to describe the land; this will enhance the feeling of a desert environment. Apply color in layers of short, linear strokes.

FINISHED PAINTING (OVERLEAF)
Define the cactuses in the background, suggesting their ridged texture. Keep their profiles in focus against the sky. With a light gray, define the remaining clouds. Finally, turn your attention to the details of the foreground cactus, adding strong dark and light contrasts and, with quick, short strokes, suggesting the saguaro's prickly spines.

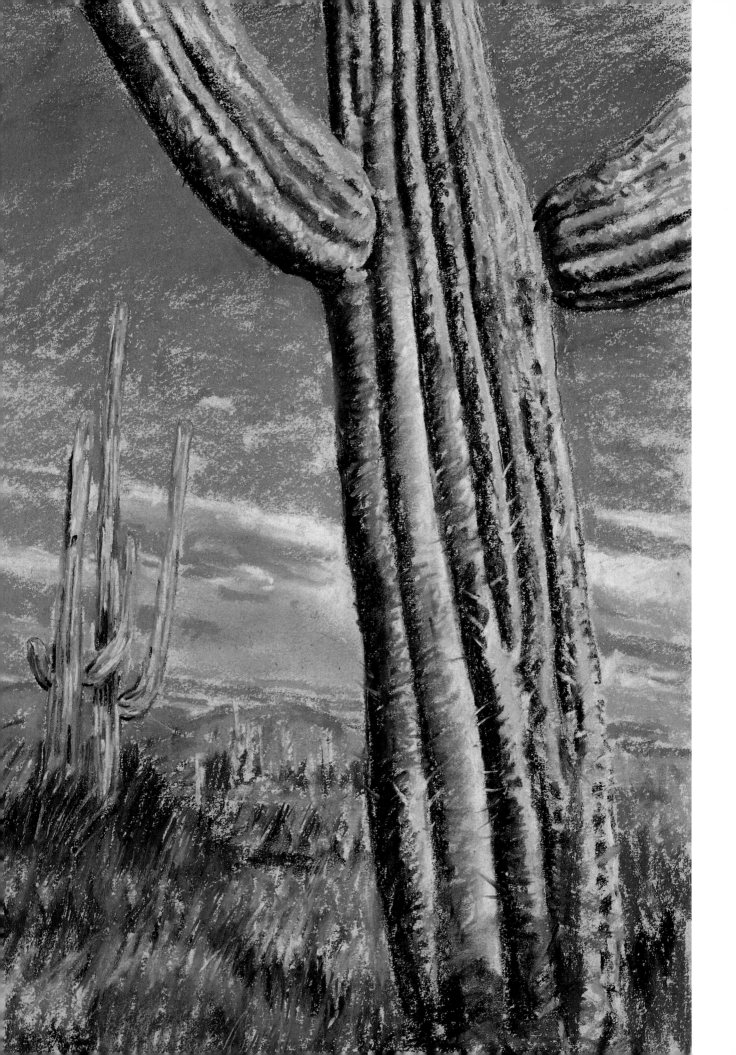

Emphasizing Interesting Texture

PROBLEM

Both the lone tree silhouetted against the sky and the intricately striated sandstone are visually compelling. But you have to choose a focus; if you give both elements equal weight, your composition will look static.

SOLUTION

Emphasize the rock's texture and play down the tree, using its graceful curving gesture as a counterpoint to the strong linear quality of the sandstone.

☐ With charcoal, draw the shape of the pinyon pine and the basic contour of the rock. Then, with a brush and black drawing ink, strengthen the tree's shape and establish the strong dark linear pattern of the sandstone's texture.

Lay in the sky color over the edges of the tree, blending the sky to a soft, smooth solid shape with your fingers. When you do this, leave as much of the tree uncovered as possible. Then block in the tree's foliage using dark greens for shadowed areas and light green for highlights. Don't overblend; leave a little of the paper showing through for sparkle. Paint the trunk using dark browns for the shaded side, with burnt sienna for areas facing the sun.

Next, paint the textured sandstone. Working with a variety of warm browns, deep yellows, and oranges in a range of values, apply color in layers of long, almost horizontal strokes following the contour of the land and the pattern you mapped out in black ink. Whenever the pastel buildup becomes too heavy for the surface to accept more, spray it with fixative, then continue to add color. Weave dark, medium, and light values together to describe texture, contour, and the play of light and shadow on the rock. Dark browns and some black will help describe deep grooves and shadows; light orange will describe highlights.

Now go back and reestablish the tree's profile, using black and dark blues amid the dark greens of the foliage to create needed contrast. Sharpen the edges between the sky and cliff and tree; to do this, you may want to use a pointed brush dipped in solvent to bring the sky right up to the profiles of the rock and tree.

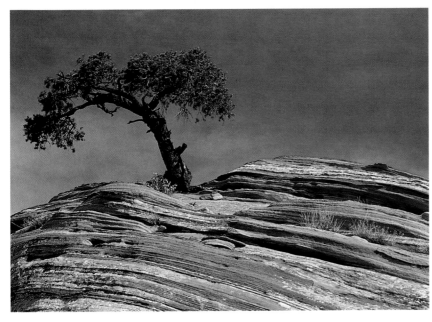

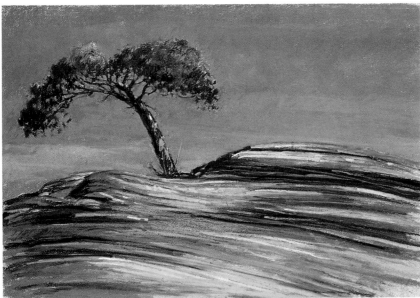

Perched atop a sandstone cliff, a pinyon pine bends gracefully over the rugged canyon wilderness.

Balancing Closely Related Colors with Strong Contrasts

PROBLEM

The natural stone arch is a very impressive shape and the focus of this composition. But the desert landscape is so brightly illuminated and the color range so narrow that the scene could end up looking flat and abstract.

SOLUTION

Use shadow and color contrasts and sharply focused elements against softer ones to "sculpt" the landscape. Select a ground that matches the overall earthy orange hue of the scene and that can serve as your middle value.

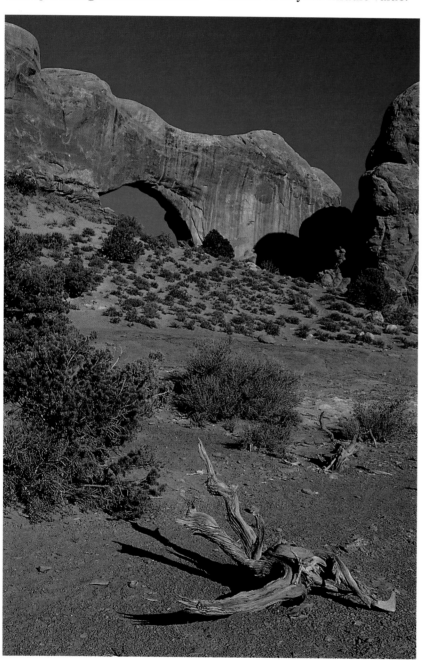

A natural stone arch serves as the gateway to a spectacular desert landscape.

☐ Make your initial drawing in charcoal pencil on amber-colored paper.

Using the paper's color as middle value, paint the sky, aiming for strong contrast with the earthy oranges of the rocks. Its color should be dense and the edge between it and the rock forms sharp. Next, with dark brown, violet, and ultramarine blue, establish the dark shadow patterns—the underside of the arch and deep cast shadows to the right. Also define the pattern of darks on the ground, using dark greens for the shrubs' cast shadows and dark brown and dark gray, with some ultramarine blue, for the shadows cast by the petrified wood.

Paint the desert soil and rock formations with earth colors of similar value—ochers, burnt siennas, and a medium red. Using the same closely related colors for these seemingly distinct areas unifies the painting.

For finishing touches, add some linear strokes of violet and rose to the face of the arch. Sharpen textural details on the petrified wood in the foreground with curvilinear strokes of gray and pale orange, plus some ocher and dark brown, adding a few small white highlights. Then define the middle-light values of the shrubbery with medium-value greens. Convey the texture of the tufts of foreground vegetation with short linear strokes of color. Finally, sharpen the definition of all contrasts and significant edges.

When you use the paper's color as your middle value, you can judge color and value relationships right from the start. This is especially helpful when you're working with closely related colors and strong contrasts.

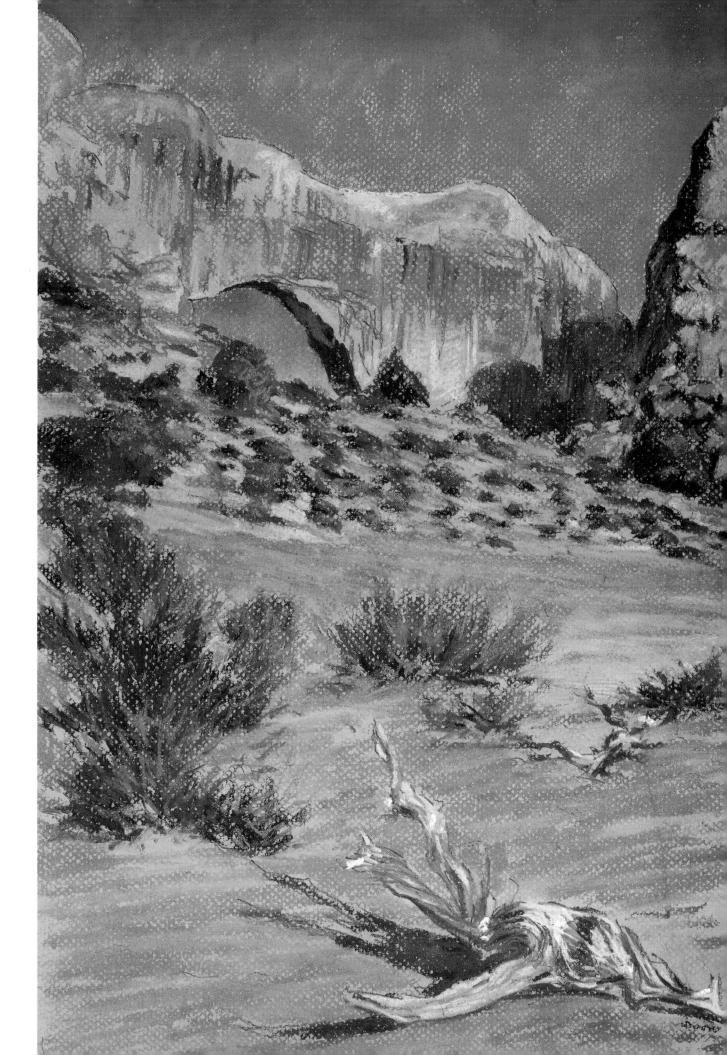

Varying Repeating Vertical Elements

PROBLEM

This stand of palm trees makes an interesting pattern of vertical lines, but the trunks are so evenly spaced that they could look static and artificial in a painting.

SOLUTION

Rearrange the palm trees and alter their sizes as needed to create a more satisfying composition. Artists working on location make these kinds of visual adjustments to the landscape all the time.

☐ For this painting a sheet of illustration board was coated with a mixture of powdered pumice, acrylic medium, and gray acrylic color, yielding a surface like sandpaper.

Draw the trees with charcoal pencil, varying their sizes and positions and making some of them overlap for greater interest. Next, using four different hues and values of blue, paint the sky, making it darkest at the top and progressively lighter toward the horizon, blending the various colors together to create a smooth, gradated sky.

Now paint the trees over the sky; the rough surface will give you a clean, crisp line. Use burnt sienna for the trunks' local color, with some subtle strokes of dark red-violet; add bright orange for the lights on the trunks closest to the foreground, indicating highlights at the top of just one or two trunks with sparing touches of yellow. For the ground, use a similar range of colors, adding burnt umber and black for the darker values and some touches of ocher, orange, and red-orange for the light values.

To paint the palm fronds, use dark shades of olive green, bluish green, and gray, adding black for further contrast and textural definition. Let your strokes emulate the fronds' shapes and the direction they grow in. As finishing touches, use some dark violet on one or two palm branches, as well as very sparing strokes of light green for highlights on a few of the fronds.

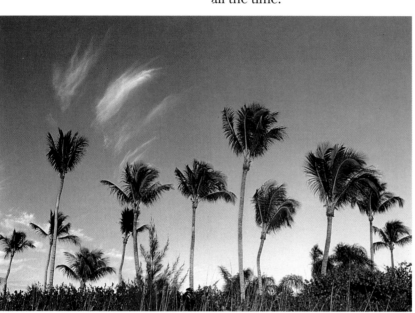

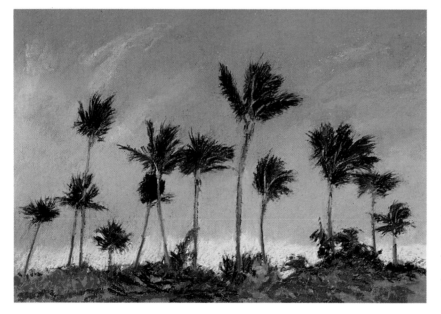

In Florida, palm tree branches swaying in the breeze echo the rhythm of cirrus clouds flitting across the sky.

Expressing the Sculptural Quality of Clouds

PROBLEM

Clouds can be confusing to paint; even when they look solid and sculptural, they should feel as light as air.

SOLUTION

Look for the very subtle shifts of value in the cloud mass that describe changes in contour, and use them to model form. Keep edges between sky and clouds relatively soft and indefinite.

☐ Here, a sheet of 400-grit, medium-dark gray wet/dry sandpaper was used as a ground.

With a middle-value gray pastel, indicate the cloud shapes, letting the darker tone of the sandpaper stand for the darker values of the clouds and sky. Then add ultramarine blue and related hues around the cloud shapes, blending softly and defining the top edges of the clouds somewhat but leaving bits of gray ground showing through. Soften the undersides of the clouds.

The earth is a simple, bold shape that contrasts nicely with the softness of the clouds. Use burnt sienna for its local color, accented with a slightly darker red and a lighter value of orange. Make sure the edge dividing land from sky is very definite.

As the painting develops, work toward the lightest values of the clouds, but don't get too light too soon. Sculpt the forms with rounded strokes, and let the gray ground provide most of the edge definition. Add subtle middle values and colors—grays and pale pinkish orange—then add your whites, blending here and there to model form. Finally, soften and pull all the tones together until the clouds have convincing volume.

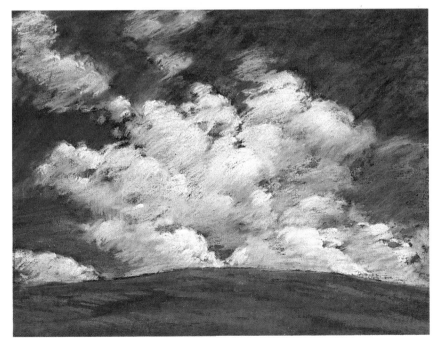

In midsummer, a bank of fluffy white cumulus clouds set against an azure sky suddenly bursts forth.

ASSIGNMENT

Don't be afraid to try unusual grounds like the 400-grit wet/dry sandpaper used for this lesson; pastel has a real affinity for slightly abrasive surfaces like this, and you may find them extraordinarily pleasing to work on. Your local hardware store is a great source for such supports. Buy a small selection of fine-grit sandpapers and see how well they take to linear techniques, color layering, blending, and washes with various solvents.

Simplifying a Dramatic Scene

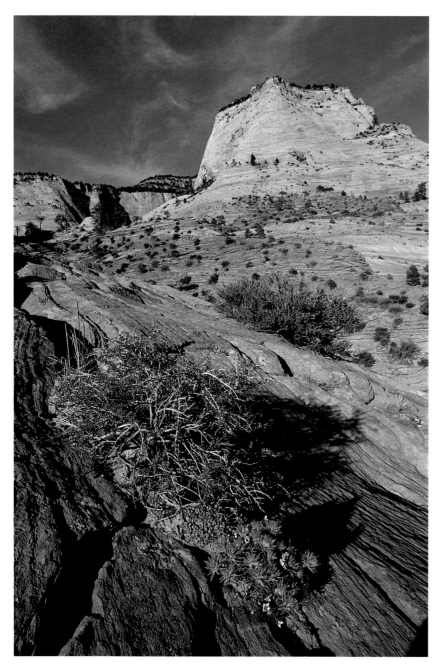

In Utah's Zion National Park, vivid red desert paintbrush blossoms contrast with the colorful striations of sandstone bedding.

PROBLEM

One of the most compelling features of this vista is its dramatic sweep of space. But with so much else going on—interesting textures, strong colors, and bold shapes—how can you capture the scene's spatial essence?

SOLUTION

The eye can't resist strong, dynamic diagonals. Simplify the colors and textures and exaggerate diagonal linear patterns as they recede into the distance.

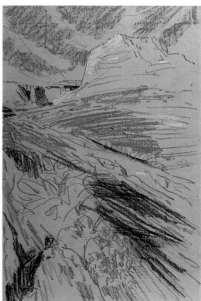

STEP ONE

With charcoal pencil, sketch in the main forms; draw the striations of the rock, exaggerating and arranging these diagonals so they converge on the horizon. (Be careful not to press too hard and emboss the paper's surface, as such grooves can be hard to cover.) Once you've established your drawing, lay in strokes of local color for the rock and sky, a few of the flowers, and the distant cliff. Simplify the sky into a pattern of diagonals so that it echoes the rock pattern.

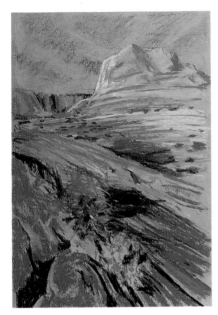

STEP TWO
Continue to build color, working over the entire painting. Your strokes should follow the contour of whatever form they are defining. Clean up edges and heighten contrasts of light and dark as you go. Concentrate on simplifying what you see and stress the scene's linear qualities, especially exaggerating the diagonals. Use fixative when the pastel color builds up, yet you need to add more.

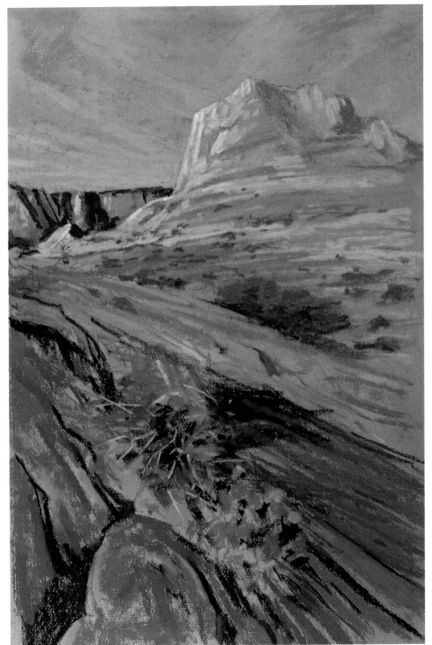

STEP THREE
Still working over the whole composition, keep adding color, but now aim to bring the painting to completion. Refine colors and values simultaneously. Alternate between creating subtleties and transitional passages of tone and hue and further exaggerating dark and light patterns that will direct the eye.

FINISHED PAINTING (OVERLEAF)
Finishing touches in the foreground include strokes of violet on the rocks, dashes of color on the flowers, and additional greens for the vegetation. Finally, add touches of pale violet and pink for the wispy clouds.

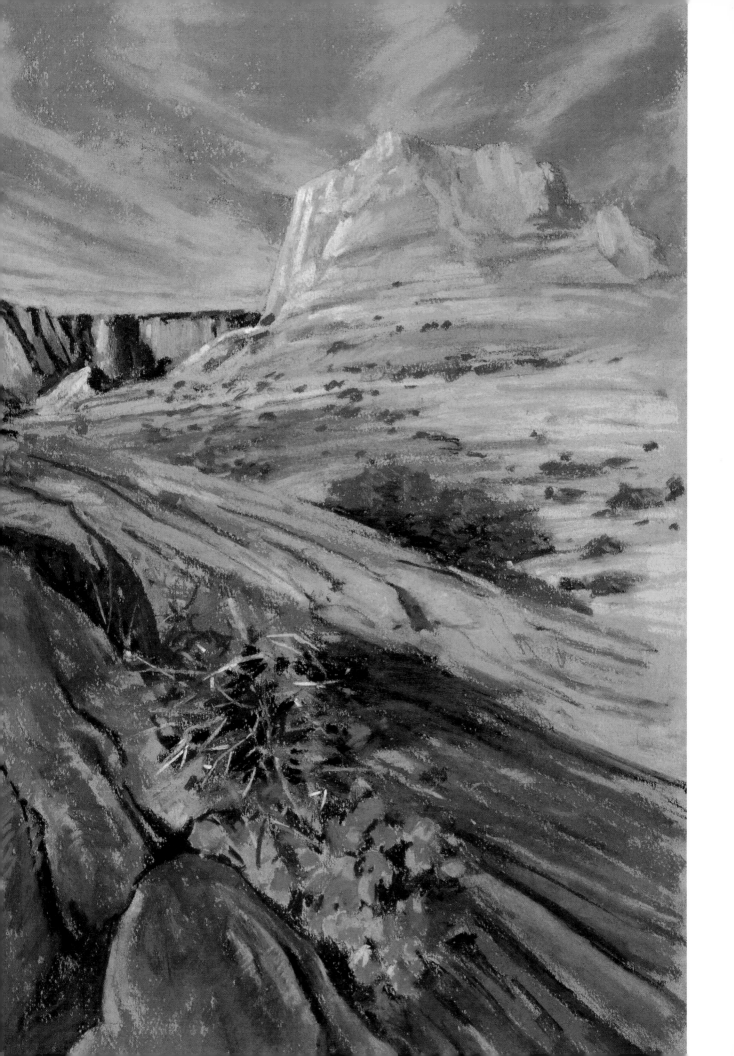

Combining Abstract Pattern with Focused Form

PROBLEM

If you treat this subject too literally, your painting will lack interest. Depicting the simple structure of the barn should be fairly easy; the challenge is in keeping the surrounding wheat field from looking flat.

SOLUTION

Keep the barn as the focal point of the composition and paint the field as an abstract pattern, but animate it by exaggerating its texture.

☐ Start with a drawing in charcoal pencil on the rough side of a sheet of deep yellow paper. Define the barn and indicate the large patterns in the field. Next, using vertical strokes, establish the darks—deep blue, green, and black—in the foreground and behind the barn. Still using a vertical stroke, add more colors over the darks, this time medium-value greens and ochers. Develop the barn further with a range of reds and analogous hues to distinguish which areas are in sunlight and which are in shadow. Shadows almost always have some blue in them; thus, because the barn's local color is red, the shadows on its left side should be violet—the color you get when blue and red are mixed. For the roof, use a light blue shaded with different grays to indicate the various planes of its pitch.

Continue layering one color over another to create the grasslike texture in the wheat field. Don't be in too much of a hurry in painting the field; it takes quite a while to build up enough strokes of different colors to make the texture rich and interesting.

The barn is the only element treated in any detail, the resulting contrast with the abstract field providing the composition with a needed compositional anchor. Even with most of the paper covered in pastel color, the textured yellow ground lends the subject an overall sparkle.

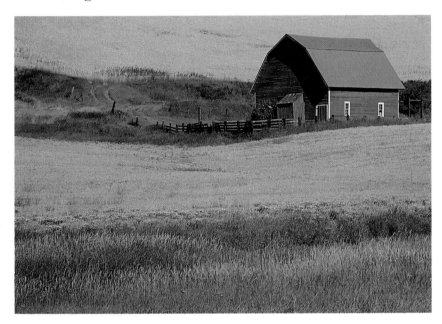

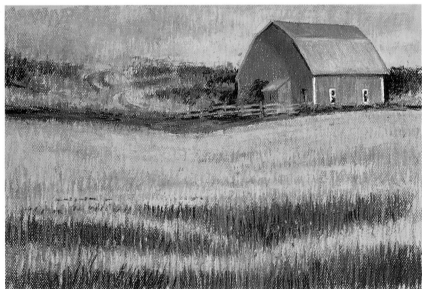

A stolid red barn holds its place amid golden fields of ripening wheat.

Using a Dark Ground for Dramatic Emphasis

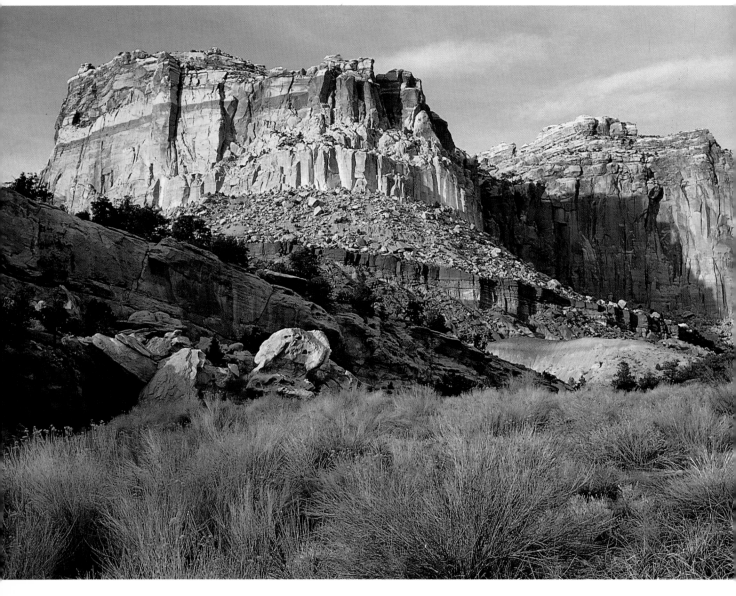

PROBLEM

Offsetting the brightly illuminated cliffs are large areas of dark shadow. You need the shadows for contrast, but must find a way to keep your darks from going dead and weakening the scene's impact.

SOLUTION

Use black paper as your ground, which relieves you of having to add a lot of dark pastel color and lets you concentrate instead on developing the important light and middle values.

☐ On a black or very dark surface, almost any color looks light by comparison, so it becomes important not to let your values get too light too soon. Build toward the lightest lights slowly. And, to focus attention on the cliffs, make the foreground simpler than it appears in the photograph—merely suggest the plant life and don't try to articulate mid-distance rocks.

Don't bother with a preliminary drawing; go right ahead and state colors and values

Warm, late afternoon sun accentuates the distinctive colors and the fortresslike structure of cliffs in a Utah desert.

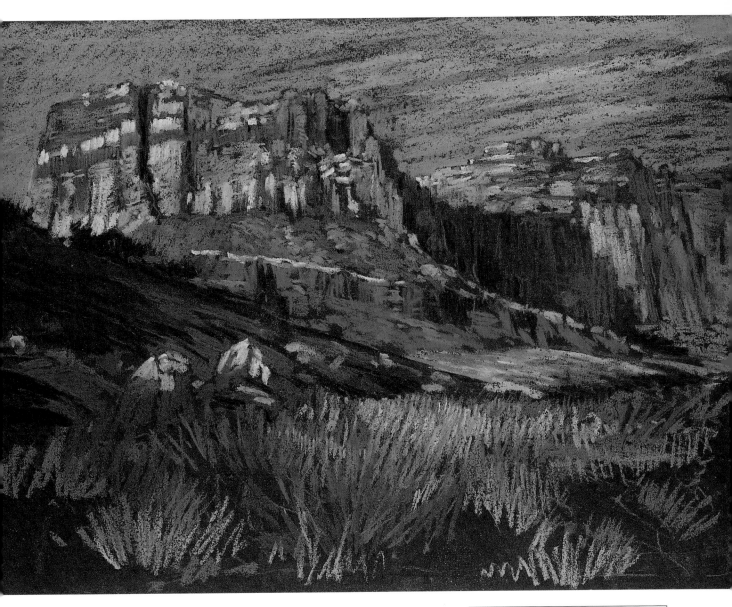

throughout the composition. Start with the cliffs, using short, vertical strokes of ocher, raw sienna, burnt sienna, burnt umber, and raw umber. Let the black paper stand in for the linear divisions between rock facets. For the foreground grasses, use the same colors that you used for the cliffs. The sky is a light cobalt tint, the clouds a pinkish gray.

Continue to layer on color, adding pale orange, scarlet, and rose for the highlights on the cliffs, dark brown and black on the rocks in the middle ground, and burnt sienna at the base of the middle cliff.

In the photograph the cloud ends at the right edge of the cliff. To enhance the feeling of depth in your painting, make the cloud appear to continue behind the cliff and extend off to the left of the composition.

Black pastel looks even darker against the black paper. Use just a few well-placed strokes where a bit more contrast and definition are needed.

ASSIGNMENT

Select four or five small sheets of different colored papers, including black. Set up a very simple still life and paint the same scene on each colored sheet using the same pastel colors and technique for all of the studies. Apply the pastel lightly so the paper's color shows through. Compare the results. Note how dramatic the subject looks on the black ground, which provides maximum color and value contrast.

Eliminating the Unnecessary

PROBLEM

For all of its interesting texture, the tree trunk takes too much attention away from the scene's real subject, the squirrel. It also has a flattening effect on the space.

SOLUTION

You don't have to record everything you see. Leave the trunk out of your painting so you can focus on the squirrel.

☐ On a ground compatible with the squirrel's color, sketch in the animal and the tree branch. Begin to paint the squirrel using a variety of ochers, umbers, and siennas. Build the animal's form and fur texture with layers of short, overlapping linear strokes that follow the contours of his body.

Turn your attention to the tree branch. Use most of the same colors you did for the squirrel, but introduce black and a dark gray to describe the bark's texture. Apply pastel more loosely here; you want the bark's texture to contrast with the squirrel's. To make the upper branching twig recede in space, paint it as a nearly solid silhouette. To define the branch further, outline some areas with a small brush dipped in rubbing alcohol.

For the sky, use a modulated blue color blended with your fingers. Treat the sky broadly, vignetting it around the outer edges of the composition but making sure the edges around the squirrel and branch are crisply defined. Use a stomp here, or move the pastel color with a brush and alcohol. To enhance the vignette effect, add some areas of burnt sienna to the upper and lower parts of the sky, and don't fill the paper to the edge; the openness will let the eye focus in on the main subject.

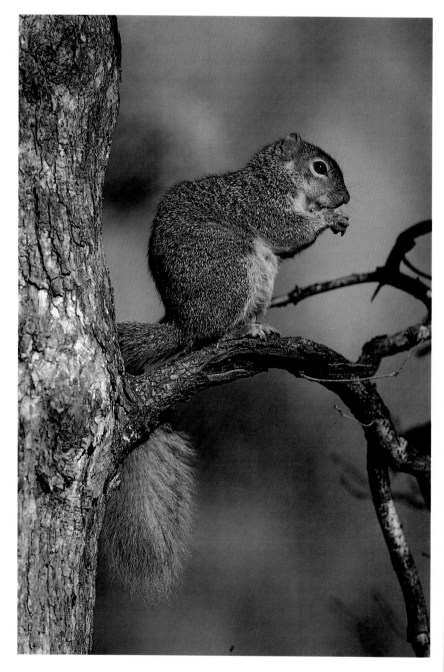

Perched on a branch, a fox squirrel pauses to nibble on a hickory nut.

ASSIGNMENT

Using scraps of variously textured pastel grounds, apply 7 or 8 swatches of both thick and thin pastel color to each, leaving space between them. Blend each swatch using a finger, a stomp, a sponge brush, rolled-up newsprint, a rag, a paper towel, and a brush dipped in alcohol. Which takes off the most color? The least? How does each tool perform on each surface?

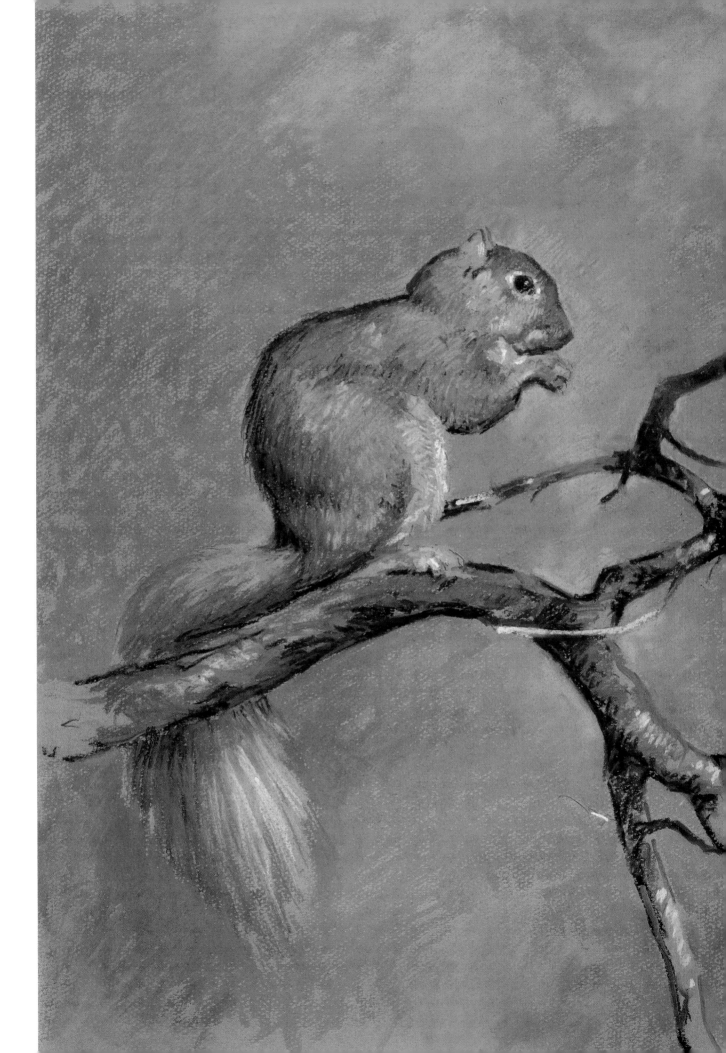

Exploring a Landscape's Curves and Contours

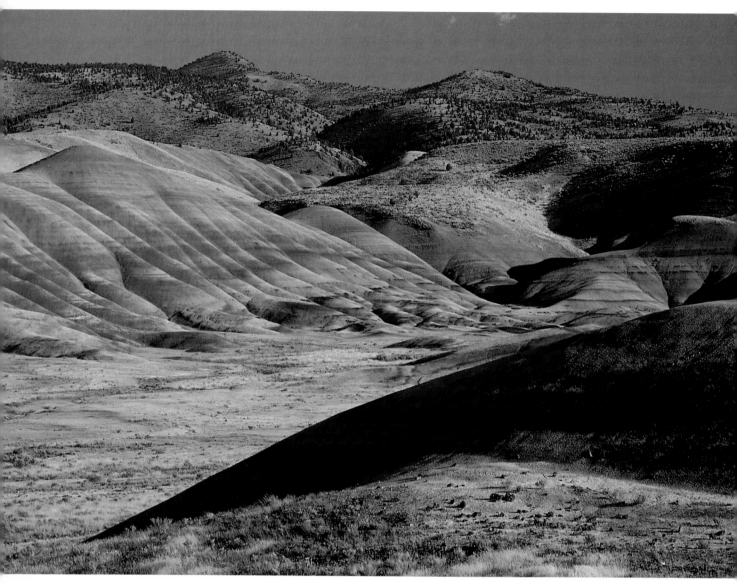

PROBLEM
Colors, textures, and interesting shapes all vie for attention here, but it's hard to find a single compositional focus.

SOLUTION
In your painting, emphasize the graceful, rounded contours and interlocking curved shapes of the land and forget about trying to record every color and detail you see.

The rolling contours and rippled surfaces of Oregon's Painted Hills are ribboned with rich color.

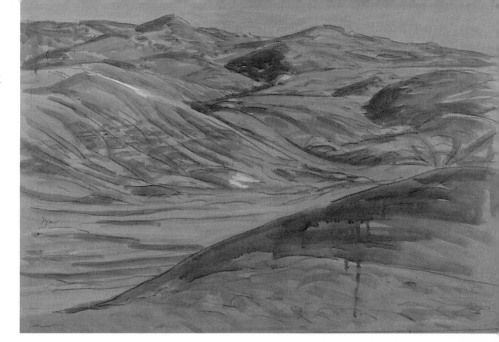

STEP ONE

Before you begin to draw, squint at the photograph so that all you can see is the value pattern of the rounded hills and shadows. Do this periodically throughout the painting so you don't get distracted by details. Make your drawing in charcoal pencil on a tan ground, paying attention to the converging outlines of the hills. Exaggerate some of these directional lines to strengthen the composition. Next, to establish the painting's overall value and color range, cover the surface quickly with thin washes of oil color in earth hues.

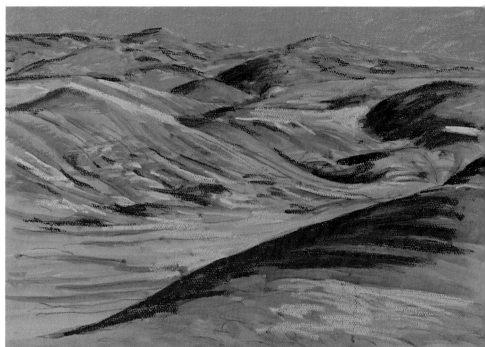

STEP TWO

When the oil washes are dry, begin to lay in pastel color over them. Alternate your work on dark, middle, and light values, continually adjusting the relationship of one to another. Apply color in long, continuous strokes that follow the contours of the hills. Lay in the basic color of the sky at this stage, bringing it right down to meet the tops of the most distant hills.

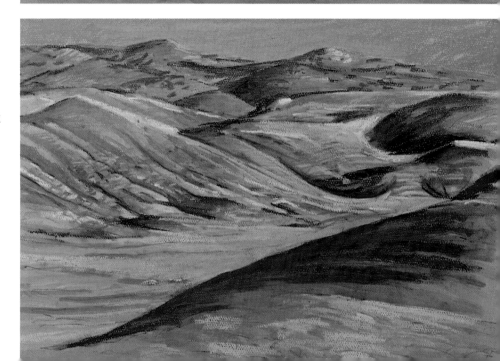

STEP THREE

Continue to add color; at this point you need to concentrate on capturing the way colors look in sunlight and how they look in shadow. Also, emphasize the difference between the colors in the foreground—warm oranges and browns, plus dark blue and brown shadow shapes accented with cool violet—and those in the background—cool greens and violets that make the hills recede in space.

FINISHED PAINTING

Work toward smoothing out the curving contours. One rounded shape should flow into the next, but your shapes should have variety. Blend to unify any areas that may still look too spotty. Sharpen edges where contrast is needed to emphasize form.

The rounded contours of the hills are pleasing to the eye, conveying a sense of calm. What keeps them from making the composition too monotonous are the dark, strongly curving shapes of the shadows.

Even though the shadow shapes are very dark, they have a lot of color in them, and thus hold our interest. Sometimes it's tricky to keep large shadow areas from going flat; here, that problem has been successfully avoided.

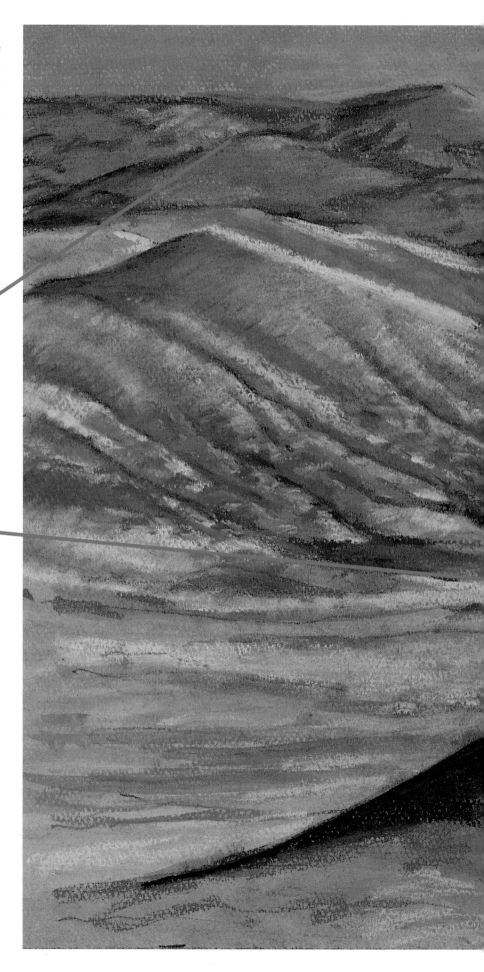

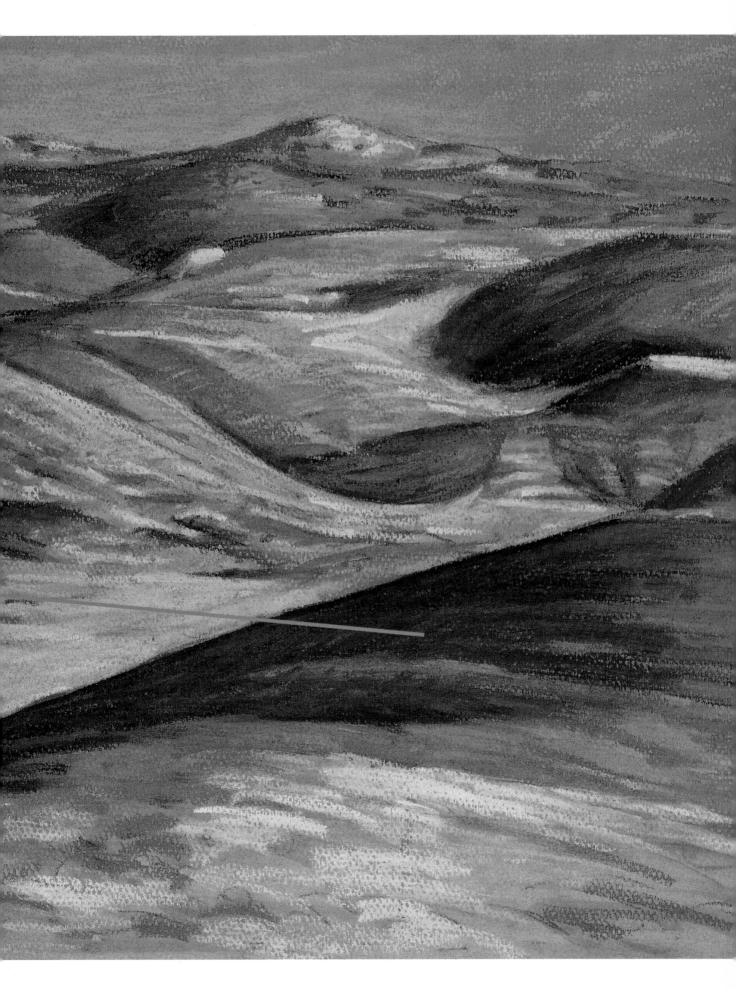

Working from Light to Dark

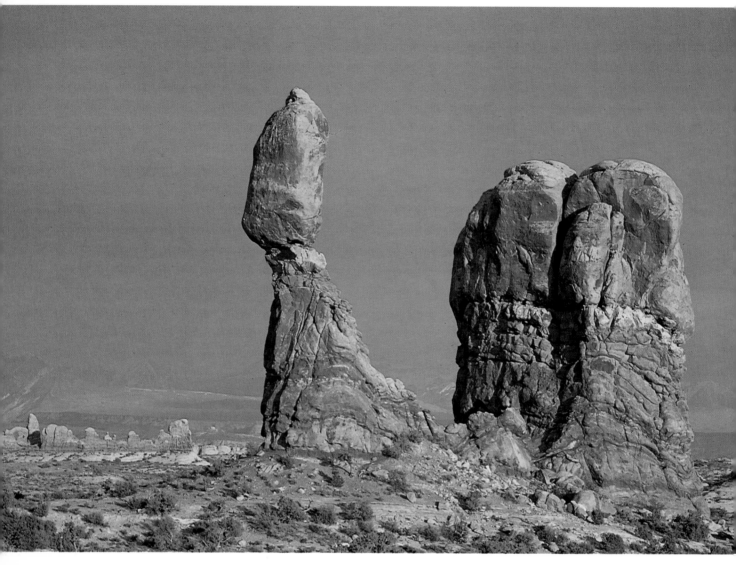

PROBLEM

These rock formations are truly unusual and distinctive: You don't want to lose any of their impact in your painting.

SOLUTION

Use black paper and lay in light values first to establish maximum contrast; this immediately sets the dramatic tone of the scene. A subject as striking as this one can stand up to and is enhanced by a very dark ground, whereas a more sedate subject would be overpowered.

☐ Make your drawing with a reddish-brown pastel pencil so you can see it against the black paper. Aim to capture not only the profiles of these rocks but also their almost anthropomorphic character.

Put down your light values first—the tan areas of the rocks and foreground, plus the blue of the sky. As you apply color, leave a lot of the black paper showing through; it's your darkest value, so let it describe the shadows as

At sunset, huge, peculiar rock formations are bathed in an eerie glow.

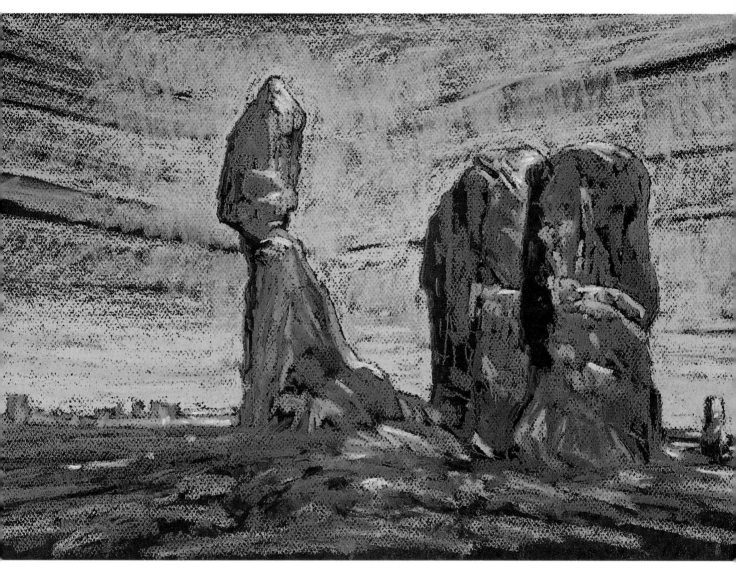

well as the cracks, crevices, and other linear details of the rocks' surfaces. The color of the rocks needs to be rich and bold. Paint them by laying short strokes or spots of pastel color side by side, with hardly any blending. Use a range of hues—burnt sienna, scarlet, ocher, Indian red, orange, rose, red-violet, and a light pinkish orange. Aim to capture the distinctive patterns and striations on the rock formations. Establish the foreground

too, using most of the same browns as in the rocks plus some olive green and a few spots of a dark blue-green.

Keep the sky simple; you don't want it to take attention away from the rock formations. Use a light value of cobalt blue, again leaving a fair amount of the paper showing through to suggest a subtle pattern. Apply color more densely toward the horizon, adding some strokes of bright pink there and blending

them into the blue, creating a lavender that hints of sunset. Blend the blue of the sky softly with your finger, taking special care to sharpen the profiles of the rocks and horizon line as you do so.

In the finished painting, the rocks really come to life; the underlying black makes their color seem more vivid, their profiles strong, their volume and texture definite.

Deciphering a Complicated Scene

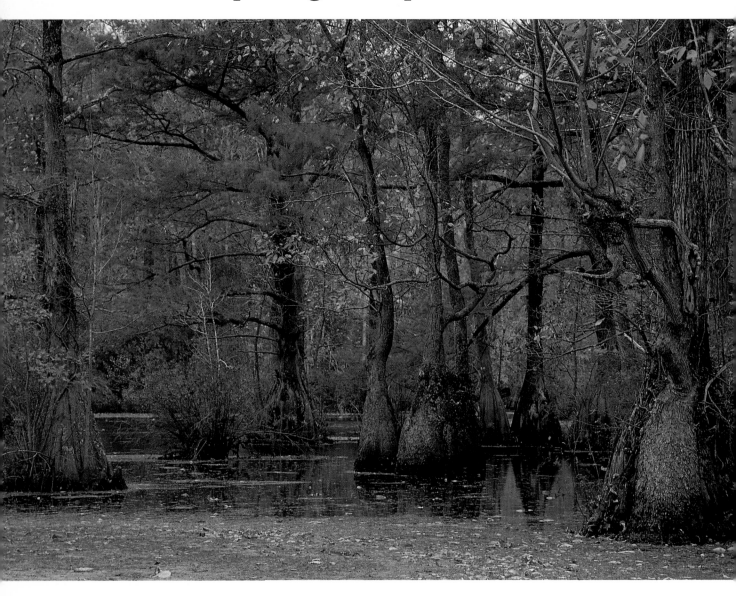

PROBLEM

Several things are happening at once here. The stand of baldcypress trees screens off our view of the background with a calligraphic tangle of branches, and light and color are so subdued that it's hard to find a way into this space.

SOLUTION

Don't try to describe what you see too literally or you'll lose the moody, mysterious feel of the scene. Use the baldcypress trees as your framework and suggest the foliage simply and abstractly.

In November, baldcypress trees rise out of a North Carolina swamp, spreading their tangled branches and displaying their bright, rust-colored needles.

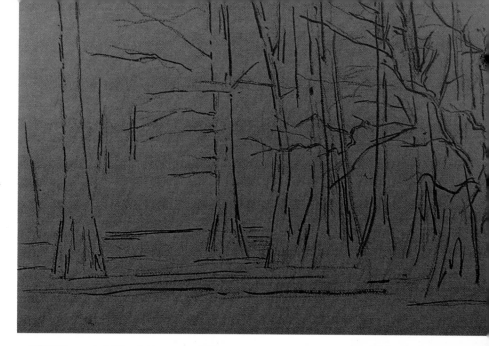

STEP ONE

A burgundy-colored paper will help to convey the feeling of deep wooded space. Make a simple line drawing to establish the placement of the baldcypress trees, then strengthen your sketch using black drawing ink applied with a small, pointed brush.

STEP TWO

Over your simple line drawing, stroke in abstract waves of reds, oranges, yellows, greens, and browns to suggest the trees' foliage and the pattern of light filtering through the upper branches. Then define the tree trunks and branches with dark browns and grays. In the immediate foreground lay in horizontal strokes of orange and yellow to describe the carpet of fallen leaves on the surface of the swamp. Suggest a few other such patches of leaves receding toward the background with single horizontal strokes of bright color, subduing them with strokes of olive green and brown.

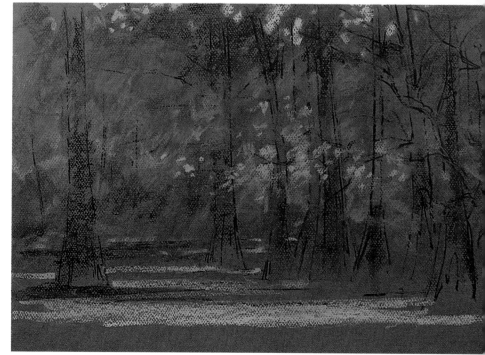

STEP THREE

Define the foliage further, building color in smaller strokes laid one over the other. Darken the tree trunks and suggest the texture of their swelling bases. With black, give further definition and life to the twisting branches. Add dark strokes to the ground to enhance the sense of receding space. Strengthen your lightest values, accenting two or three of the intertwining tree branches with thin, sinuous strokes of burnt sienna and pale gold ocher and adding a few small, confettilike spots of bright color to the foliage to make some of the leaves appear to come forward.

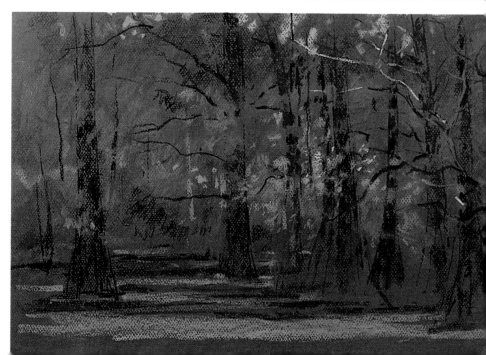

FINISHED PAINTING
In the finished painting, the baldcypress trees seem like sentries guarding an entrance to the woods, yet provoke our desire to explore its mysterious depths.

Contrasting with the dark background, bright spots of color like these capture the eye immediately.

The bright orange and yellow in the immediate foreground captures the essence of the fallen leaves and suggests sunlight coming through the tree canopy. Any attempt to describe texture in this area would have created too much of a distraction.

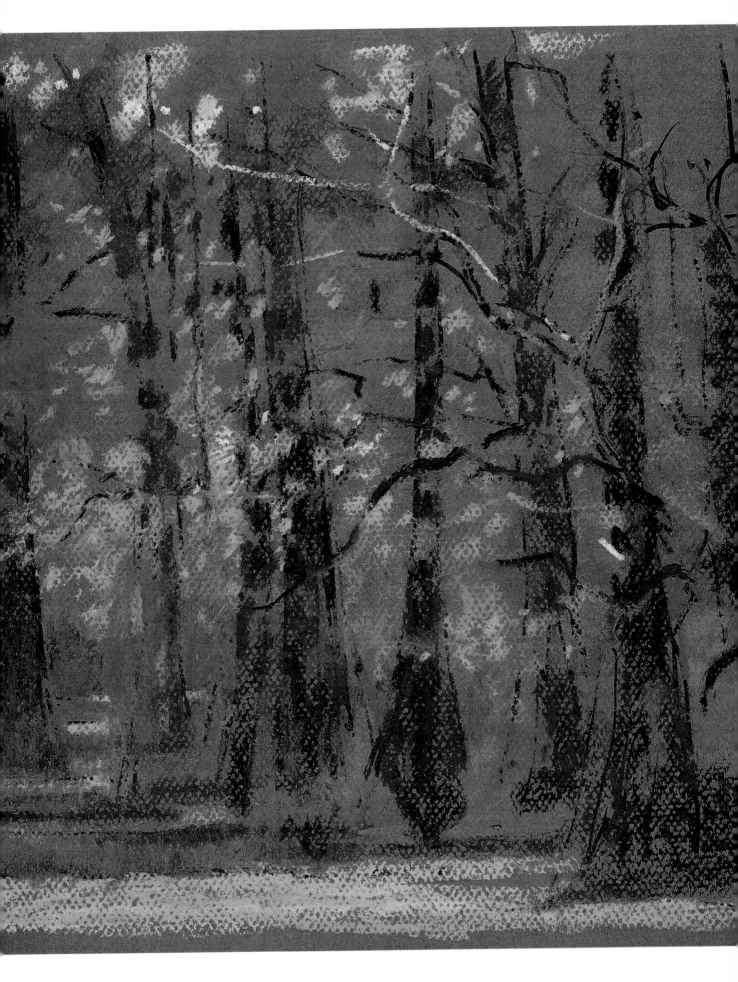

Mastering an All-over Pattern

PROBLEM

Intricate closeups, especially ones as colorful as this, seem like complicated jigsaw puzzles. It's hard to know where to begin and what to focus on.

SOLUTION

Start by establishing the overall pattern you see, then concentrate on the specifics. Don't try to record every detail; instead, aim to convey the feeling of the scene.

□ Execute your initial drawing in charcoal pencil. Include both line and tone; for this intricate subject, a line drawing alone would be too hard to follow. A warm, tobacco-colored ground harmonizes well with the colors of the scene.

With the basic linear and value structure established, begin to add color. Paint both light and dark forms at once so you can more easily follow the subject's pattern. Work over the entire painting, keeping individual leaves well defined. Your pastel strokes should follow the leaves' structure—both their inner and outer contours and their veining. Use warm earth hues: browns and deep red-browns, burnt sienna, and burnt umber, plus olive green for dark to middle values; for middle light to light values, use oranges and ochers. Blend to soften form in some areas.

Continue to develop the dark and light pattern of the leaves. Look closely at the photograph and note where there is a greater concentration of lights. Aim to capture this in your painting; you don't want all your lights and highlights evenly distributed.

Now add your darkest darks— a dark burnt umber and black— to the negative areas around the leaves, giving definition to their shapes and setting off their color. For highlights, add touches of deep yellow and lemon yellow.

Stand back and look at your painting. Are the values too evenly distributed? If so, you may want to tone down or add a few lights. Do the leaves look too uniform? If so, introduce some variation; touches of red-violet will add subtle interest. Last, is the overall pattern pleasing? Sharpen a few leaf edges and look for places to emphasize contrast, such as around some of the lighter leaves.

Early autumn's alchemy turns beech leaves to copper and gold.

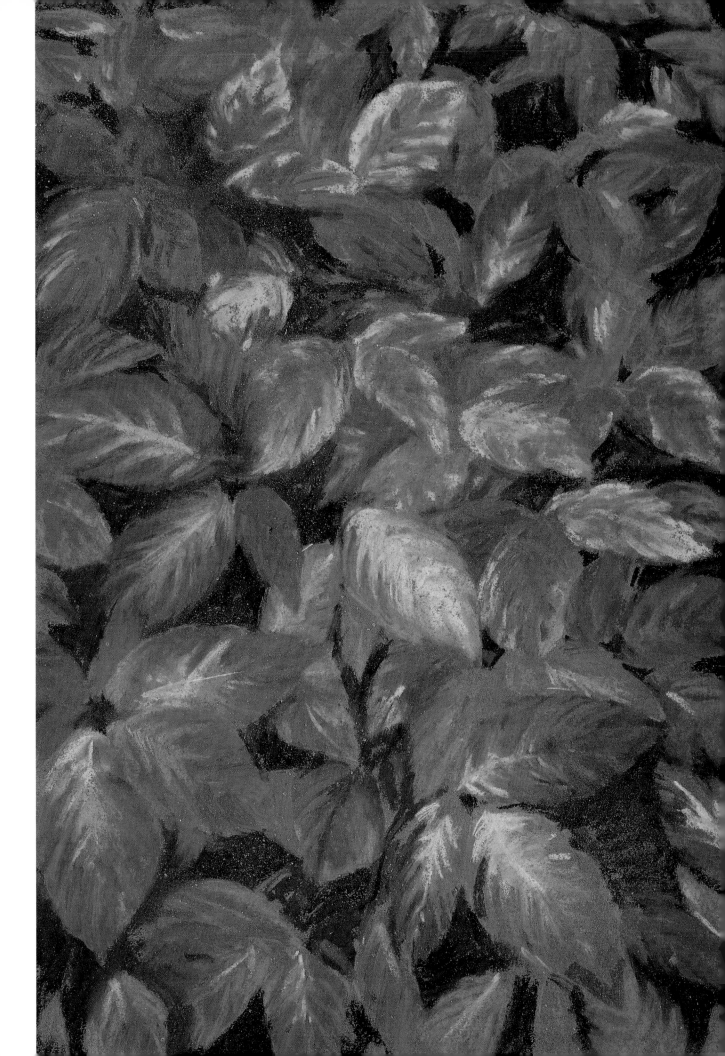

Interpreting Shimmering, Unfocused Reflections

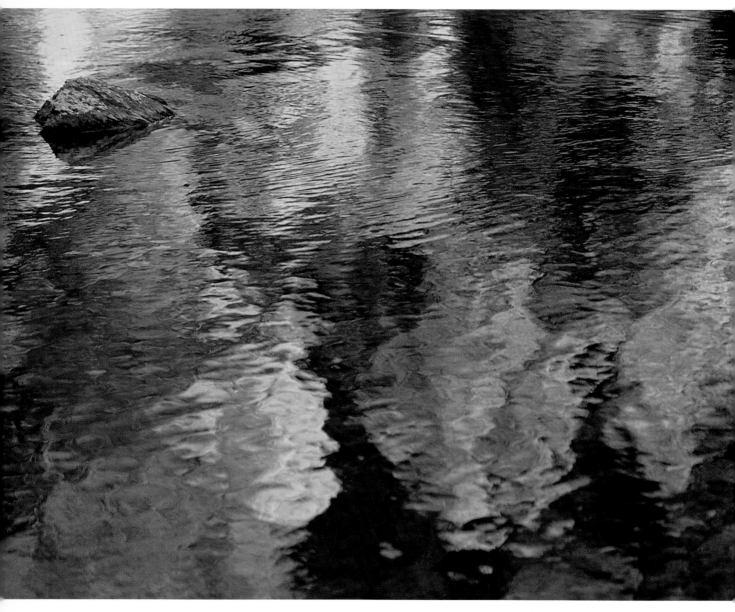

PROBLEM
Except for the lone rock, there's very little to hang onto here. The rippling pattern in the water is irregular, the shapes unfocused. Only their colors are fairly distinct.

SOLUTION
Use velour paper, whose surface imitates suede or velour. On it, pastel strokes seem to spread and blend on their own, creating a very painterly effect appropriate to the blurred, diffuse forms seen here.

☐ Because this subject is so abstract, you don't need much preliminary drawing—just enough to place the rock and the pattern of the reflection.

Use an olive-green velour paper as your ground, which will automatically establish your middle value. Then begin to paint, working in short linear strokes that imitate the rippled surface of the water. You won't find it easy to lay down sharp lines. Pay close attention to the abstract color patterns and value range of the reflections, and exaggerate the color strength as much as possible. Use deep yellow, orange, red-orange, permanent green

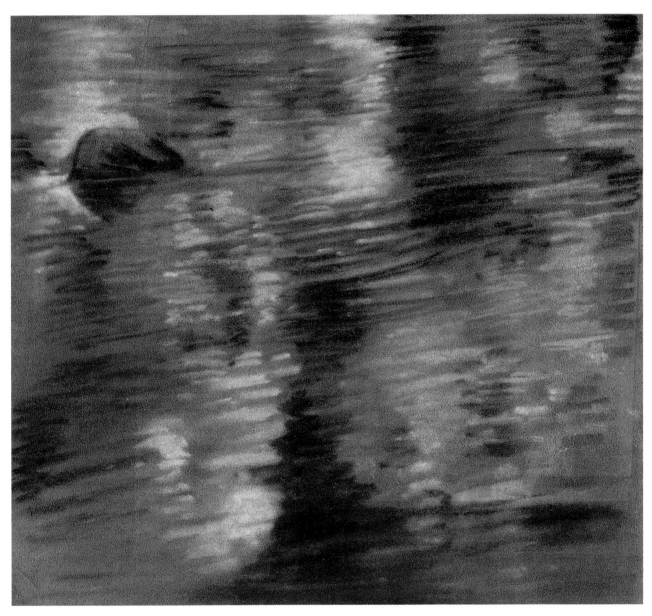

light, and a light phthalo green for the light values; permanent green deep, ocher, burnt sienna, burnt umber, and a medium gray for medium values; and chrome green deep, Prussian blue, and black for your dark values. For highlights, use a light yellow.

You'll discover that as you add one color over another on velour paper, the colors do not meld as much as they do on other surfaces, and that blending with fingers or stomps is not possible,

but that this ground stays receptive to adding color longer than many other types.

Note that the rock is the only realistic element in the painting. Use it as an anchor to the scene; it helps in creating a sense of space and depth.

When you feel you are nearly finished, stand away from the painting. The shapes of the reflections in the foreground should be larger and somewhat more distinct than those farther

back to give a sense of the autumn trees' location in relation to the water. The dark reflection in the center foreground is very important in balancing the lighter shapes, so heighten contrast there. You will probably need to strengthen your darkest values elsewhere as well to better describe the ripple pattern, especially in the middle ground, where ripples emanating outward from the rock seem more definite.

Playing Detail Against Abstraction

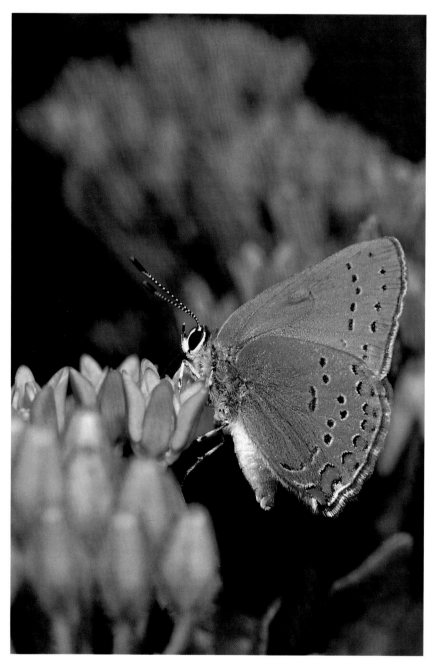

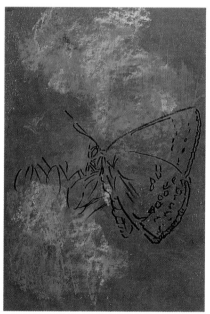

PROBLEM

Here, both the background and immediate foreground are so out of focus that you have no choice but to treat them abstractly. But the butterfly is so distinctive that you can't skimp on its detail.

SOLUTION

Take advantage of the contrast between sharp and soft focus to play up the butterfly's character. Establish the background first; then you are free to concentrate on making a careful rendering of the butterfly.

STEP ONE

Illustration board coated with a mixture of powdered pumice and gray acrylic paint is a good choice of support here; the sanded surface can hold a lot of pastel, but also permits fine detail. With no preliminary drawing, broadly stroke on deep yellow, ocher, and light green in abstract patterns to suggest masses of flowers and greenery. With a wet paper towel, wipe the color to further spread and blend it. When this is dry, make a drawing of the butterfly in charcoal pencil.

A silvery butterfly alights on a newly opened bud, the bright coral-red spots on its lower wing echoing the color of the flower.

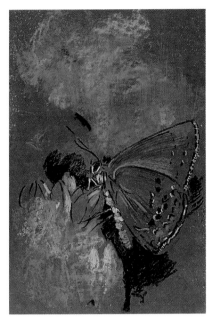

STEP TWO
Define the butterfly further,
capturing its brilliant red-orange,
black, and white wing pattern.
Paint the wings in different val-
ues of gray, stroking on the col-
ors to follow the wings' forms.
Model the body carefully with
grays and white. Then define a
few of the bright orange flower
heads with bold color to give the
butterfly a place to sit. Also at
this stage, start to add your dark-
est values around the butterfly's
form to bring it into sharp focus.
Once you have established this
extreme contrast, you'll find it
easier to develop the rest of the
painting.

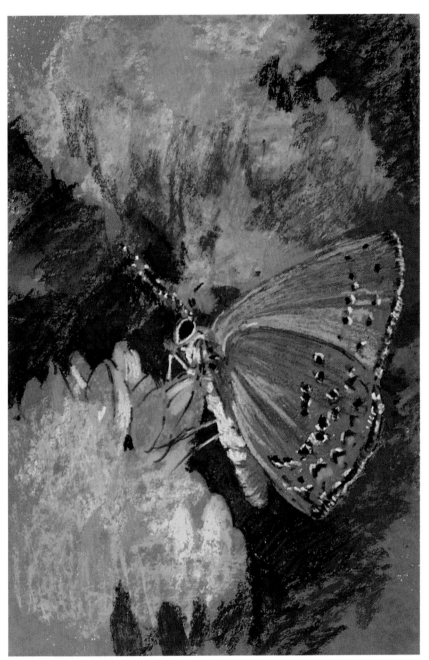

STEP THREE
Continue work on the back-
ground, adding bright orange
and red in the upper portion,
tempered with some olive green.
Add more dark values as well—
a deep bluish green and black—
to offset the brighter colors.

FINISHED PAINTING (OVERLEAF)
At the final stage, sharpen the
butterfly's wing markings using
a small, pointed round brush
dipped in a solvent (such as
rubbing alcohol) to paint around
their edges. Now look at your
work. Does the butterfly stand
out enough from the back-
ground? If not, heighten the
contrast around its edges.

111

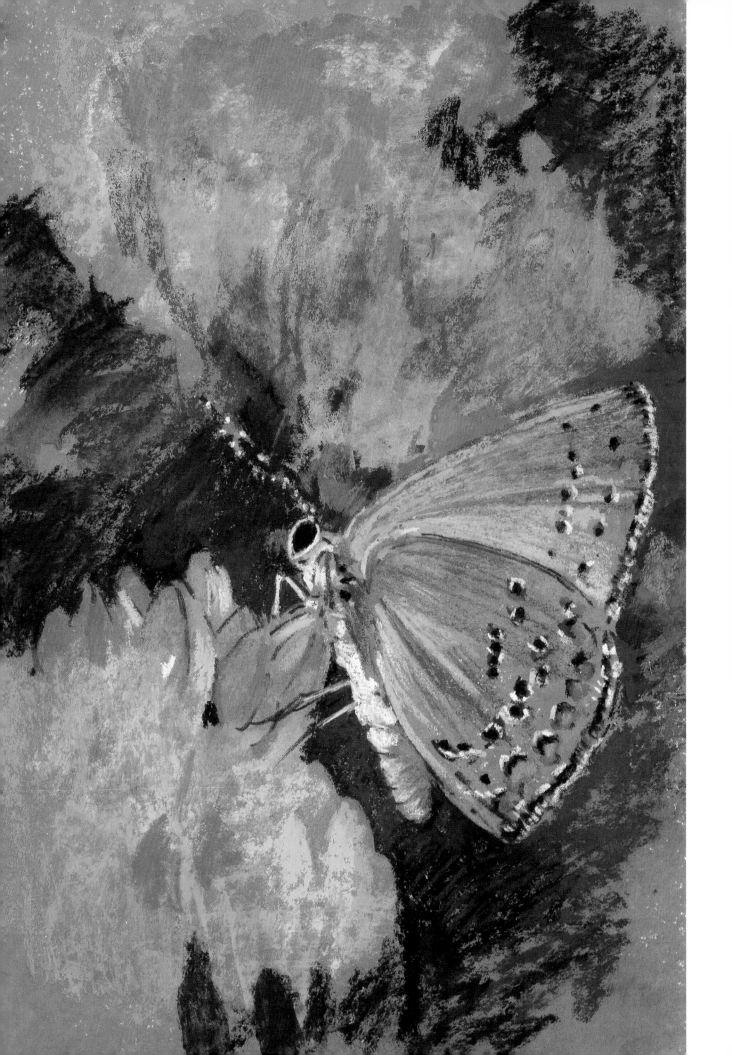

Capturing the Textures of an Autumn Landscape

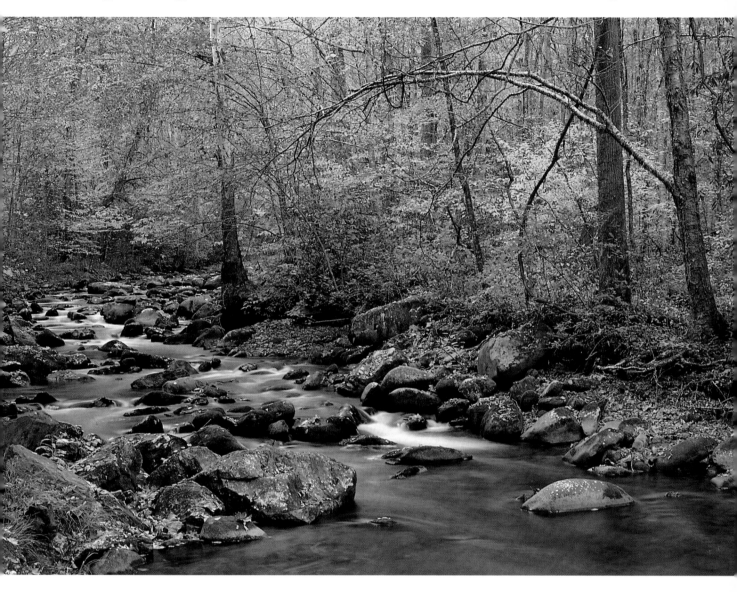

PROBLEM

There are so many different textural aspects to this intimate landscape scene—the brightly colored leaves, the gentle contours of the moss- and lichen-covered rocks, and the perpetual flow of the stream—that it's hard to know how to unify them.

SOLUTION

Block in large, general areas of color first; then you can concentrate on rendering each of the landscape's specific textures.

Strewn with moss-covered stepping-stones, a mountain stream courses through autumn woods.

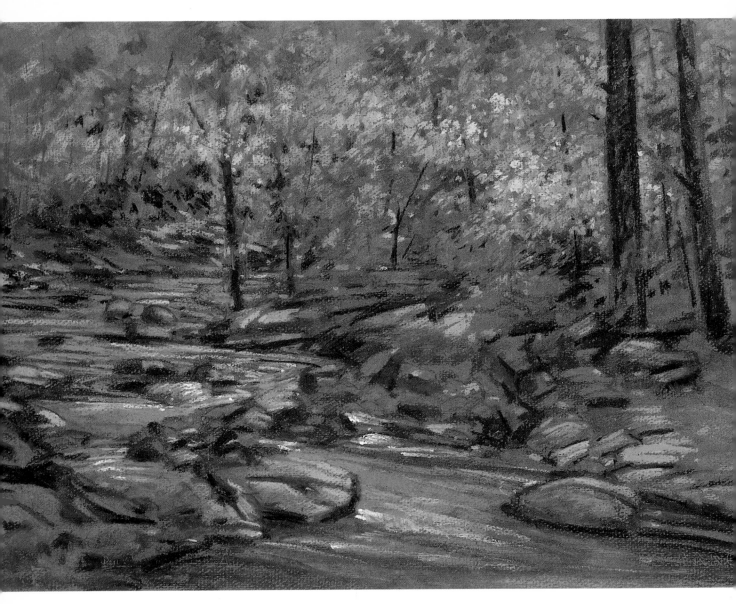

☐ Start with a charcoal drawing on a dark brown paper. Over this, lay in large areas of color—burnt siennas for the background, medium green for the middle ground, and browns for the rocks—with the flat side of your pastels. Indicate general groups of leaves, not individual ones or any details. As you apply color, work light hues over dark. Lay in dark color for only the largest tree trunks at this stage.

As the painting progresses, break up the large patterns you blocked in initially into smaller and smaller areas of detail. Paint the smaller tree trunks over the foliage; they should be very subtle, looking like thin, dark threads woven into a colorful tapestry. For the water, use long, linear strokes that describe its flow and contour around the rocks. Be sure to add some touches of white near a few of the rocks to indicate the water's rush.

Develop the foliage further with bright red, orange, deep yellow, and light green applied in many tiny, overlapping strokes that both describe the leaves' texture and follow the direction of the overhanging branches. Concentrate your lightest values in the central area of foliage to create the feeling of sunlight filtering through the trees.

In the last stage, check for textural variety and value relationships. Add some depth to the background at left with a few small touches of black, which will help set off the bright leaf colors. Sharpen edges around some of the rocks to make them look more three-dimensional.

DETAIL

Framed by the dark tree trunks that contrast with them at right, the brightly colored leaves really sparkle with life. Note how almost every stroke remains visible; there is very little blending.

ASSIGNMENT

Strong drawings help make strong paintings—they add structure to your compositions. Practice drawing with vine charcoal and charcoal pencil; both are highly compatible with pastel and are excellent for preliminary drawings. Vine charcoal lets you make changes quickly; one sweep of a rag and it's gone. When a very detailed preliminary drawing is called for, charcoal pencil gives you more control. Charcoal pencil isn't as fragile as vine charcoal; it gives a sharper line and clings to the surface longer, allowing you to lay in color without worrying too much about losing your drawing. A spray of fixative can help, of course. On very dark grounds, make your drawings with medium-gray pastel pencil so you can see what you're doing.

Making the Most of Repeating Shapes and Colors

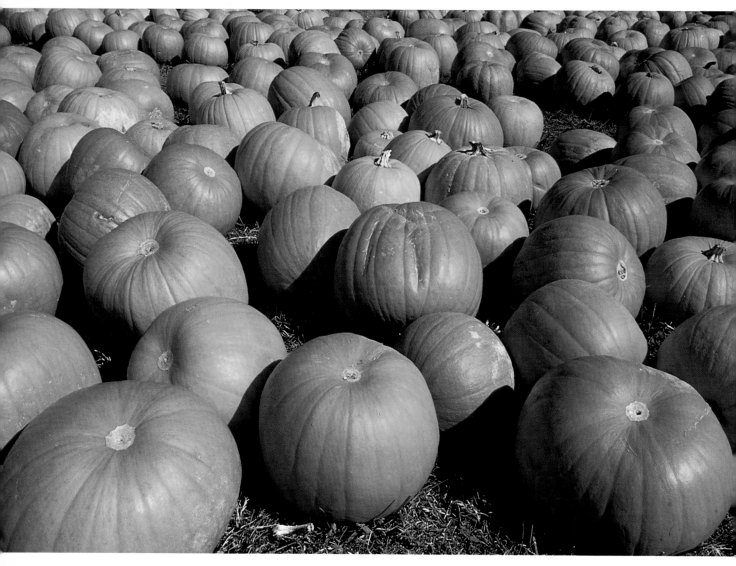

PROBLEM

This field of bright orange pumpkins is a very appealing subject, but the sameness of the shapes and colors could make for a monotonous painting.

SOLUTION

If you look carefully, you'll see that the pumpkins aren't all alike in shape or size, and that there's an interesting interplay of light and shadow that allows for a good value range. Concentrate on these aspects of the scene.

☐ Burgundy-colored paper will set off the dominant orange of the pumpkins nicely. Using the smooth side of the paper, execute your charcoal drawing, aiming for variety in the sizes and shapes of the pumpkins (avoid making them too round), as well as their placement. Remember, to create the illusion of depth, the pumpkins in the foreground should be both larger and more detailed than those that recede toward the background.

With your drawing in place,

concentrate now on the patterns of light and dark, and on adding interest through subtleties of color and value. Work from light to dark. Although the pumpkins' local color is orange, you can paint them using a wide range of analogous hues—colors adjacent to one another on the color wheel that have a primary color in common. In this case, the shared primary is red, and the color range extends from red-violet to orange-yellow and ocher.

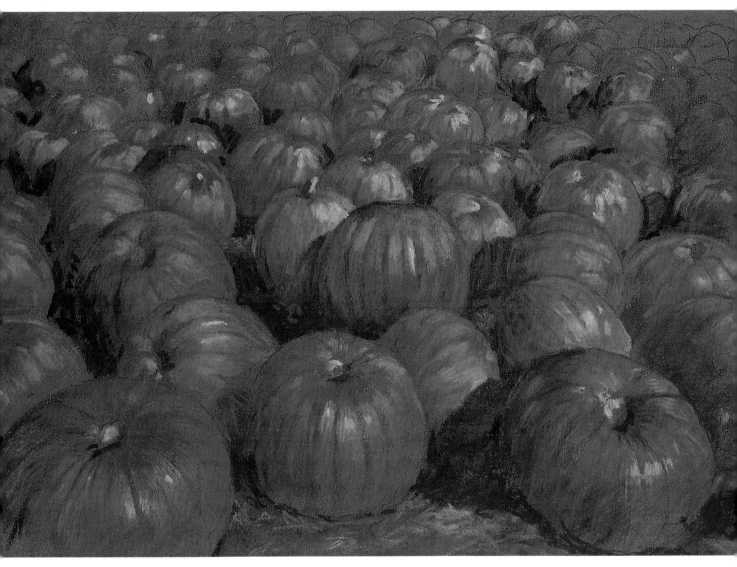

Let the burgundy color of the paper stand as your middle-dark value. Begin to define the pumpkins with bright orange, stroking the color on to follow the forms' contours and leaving paper showing through for the ridges. Paint the pumpkins in the background very loosely. Continue adding color, moving toward burnt sienna and red as you model form. For highlights, use yellow and, on some of the stem areas, yellow-green. Use red-violet for some of the lighter, warmer shadows on the pumpkins; for darker, cooler shadowed areas, use a blue-violet.

Don't forget the grassy ground the pumpkins rest on. Use an olive green or chrome green for the basic grass color, highlighting it with strokes of lighter greens. Add a sparing strokes of olive green to the shadowed sides of a few pumpkins.

Now concentrate on the negative areas—the cast shadows and spaces between the pumpkins—where your darkest darks belong. Paint these areas in dark browns and hints of dark Prussian blue with a mind toward further sculpting the pumpkins' forms, especially in the foreground and middle ground.

Finally, examine the overall value structure of your painting and adjust any areas that seem too bright or too dark. Refine edges and sharpen contrast between any individual pumpkins where form needs further definition.

Capturing the Brilliance of the Rising Sun

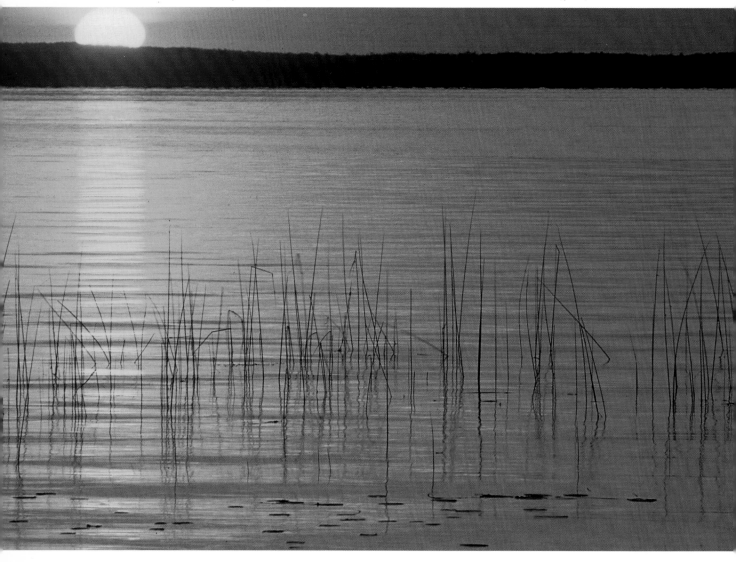

PROBLEM

The sun can be very difficult to paint. If you paint the sky too light, you can lose the contrast that makes the sun appear so brilliant.

SOLUTION

Keep everything around the sun darker than it actually appears to create the necessary contrast, building one color over another to achieve a rich, vibrant effect.

☐ Because of this scene's high-key color scheme, a compatibly keyed ground such as Canson Mi-Teintes cadmium yellow paper is a good choice. Let it work as your middle-light value, contributing an overall feeling of summery warmth; the sun's lighter yellow will appear even lighter against it. The composition is so simple that you don't need a preliminary drawing; just visualize the three divisions of sky, land, and water and begin applying color to establish each of them.

As the summer sun rises over a lake, it ignites the sky, sending fiery oranges and yellows across the water.

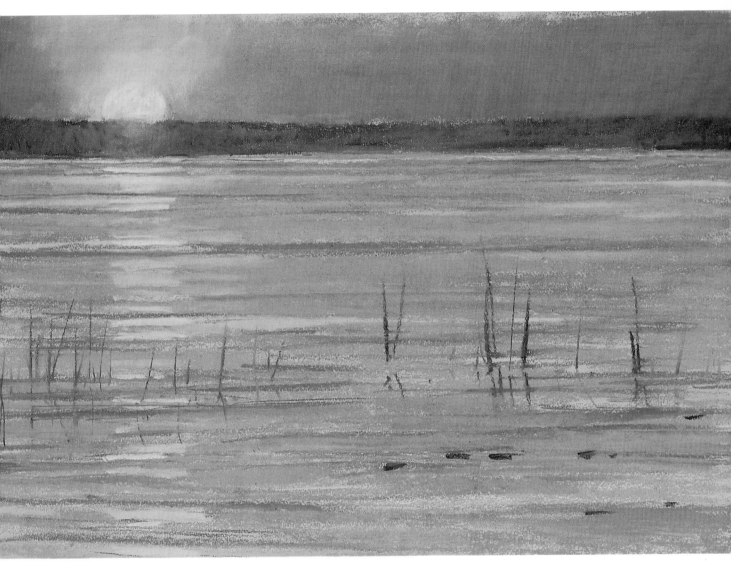

Paint the sky in overlapping, multidirectional strokes that cancel out one another's identity, resulting in a smooth field of color. Use a range of oranges, moving into reds toward deep rose, and blend with your finger. Paint the sun with deep yellow layered over with lemon yellow, blending the edge of its form with the surrounding sky slightly to create a sense of its radiating warmth.

For the narrow strip of land, use layers of vertical strokes, working with deep blue-violets and, nearer the sun, layering these with red-violet and orange. Remember, you need to exaggerate contrasts in the areas around the sun, so don't let your colors get too light there.

Paint the water in long, horizontal strokes of orange, red-orange, red, and scarlet. Indicate the ripple effects with both warm and cool colors—rose, red-violet, phthalo blue, a medium and a light blue-violet, and bluish green. For the sun's reflection in the water, apply shorter, intermittent horizontal strokes of light yellow, making sure they stand out from the predominant oranges; you want to create an almost vibrating effect here.

Finally, with a very dark blue-black, add thin, quick vertical strokes for the grasses and their shadows in the foreground. Four or five small horizontal strokes of a dark blue in the immediate right foreground suggest other vegetation. Here, in the finished painting, the sun really seems to glow in the sky, sending its warm rays out over the gentle ripples of the calm lake.

Defining Underlying Structure with Oil Washes

PROBLEM

It's not only the dazzling colors, but also the texture of the foliage that captivate the eye in this scene. But because you can't mix pastel colors the way you would oils or watercolor, hues as vivid as these can easily get out of control when you try to layer them, yielding garish, unfocused results.

SOLUTION

Lay a foundation for the major compositional elements in opaque oil washes on a moderately dark ground. Against this, the strokes of bright pastel color will really come to life, and will more easily suggest the trees' three-dimensional volume.

☐ On the rough side of a burgundy-colored paper, make a charcoal drawing to define the trees' silhouettes. Next, using thin but opaque oil washes, brush in color for the sky, then dark color for the trees. When the washes are dry, switch to pastel and concentrate on the sky. Layer grays, blues, and pinks over one another, blending and then relayering to pull all the sky colors together. This gives the sky a soft look that will contrast with the texture of the leaves.

Now begin to define the leaves. Don't worry about matching your colors exactly to those you see in the photograph; instead, try to match their brilliance and richness. Working with a variety of reds, oranges, and yellows, layer one color over another in crisp, short, unblended strokes, leaving some of the dark background showing through the leaves for contrast.

Next, establish your darkest darks—the trunk and cast shadow of the tree at left, plus shadow areas between its branches, as well as the shadow side of the tree at right. Suggest the lighter areas of the ground with ocher and a light burnt umber, leaving much of the paper's color showing through. Add a few greens here and there for variety—a dark olive to some of the foliage in shadow, touches of yellow-green to highlighted areas, and a few subtle strokes of permanent green deep to the horizon line to suggest vegetation in the distance. At this point, stand back from your work and look for any areas that may need further adjustment.

In the finished painting, with some of the dark underpainting showing through, the leaves seem to sparkle against the soft blue sky.

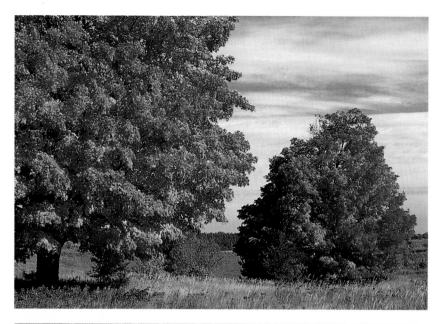

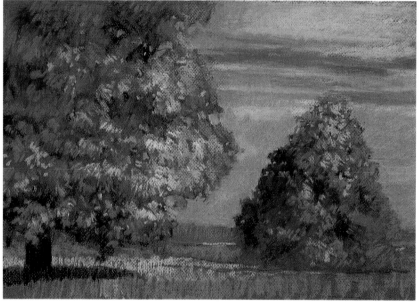

Stately sugar maples blaze with color to warm up a crisp October day.

Weaving a Colorful Tapestry

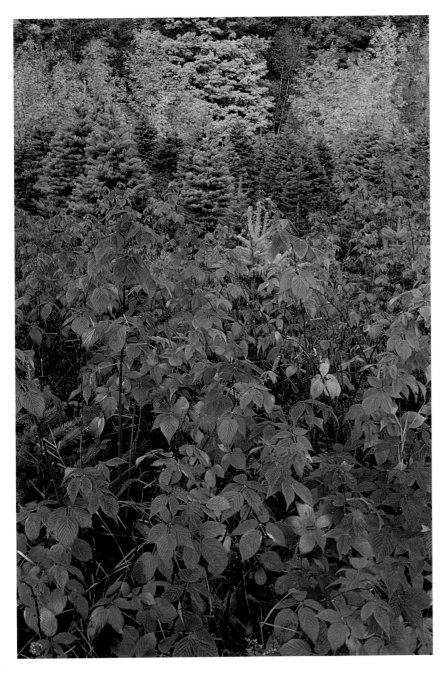

At autumn's peak, brilliant red blackberry leaves are woven into a dazzling tapestry with the colors and textures of cool blue-green spruce and golden maples .

PROBLEM
It's hard to find a way into this scene, dense as it is with the lush color and textural variety of the blackberry, spruce, and maples. Everything seems to be in closeup; any sense of depth is limited to the immediate foreground.

SOLUTION
Abandon any notions of trying to convey the illusion of spatial depth. Instead, think of what you see as an intricate, abstractly patterned tapestry.

☐ The many bright colors need the contrast of a dark ground, such as a brown paper. In your initial charcoal drawing, establish the overall pattern by simply indicating groups of leaves. Define a few individual leaves just in the foreground for focus.

Begin to apply color, starting with the reds, oranges, and red-violets of the blackberry leaves. Move on to the bluish greens of the spruce trees, making your strokes suggest the branches' growth pattern. Next, lay in the orange and yellow maple foliage.

With the basic overall color pattern in place, begin weaving the different areas together with your dark values. Work negatively all over the painting, applying dark greens, browns, and black between and around the various positive foliage shapes to help define them. Let the brown paper do some of the work for you. Don't distribute the darks too evenly; you want the viewer's eye to travel through the composition, not rest on a flat, unvaried surface.

Now work back and forth between the colorful leaves and the dark areas, redrawing occasional leaf edges for textural interest.

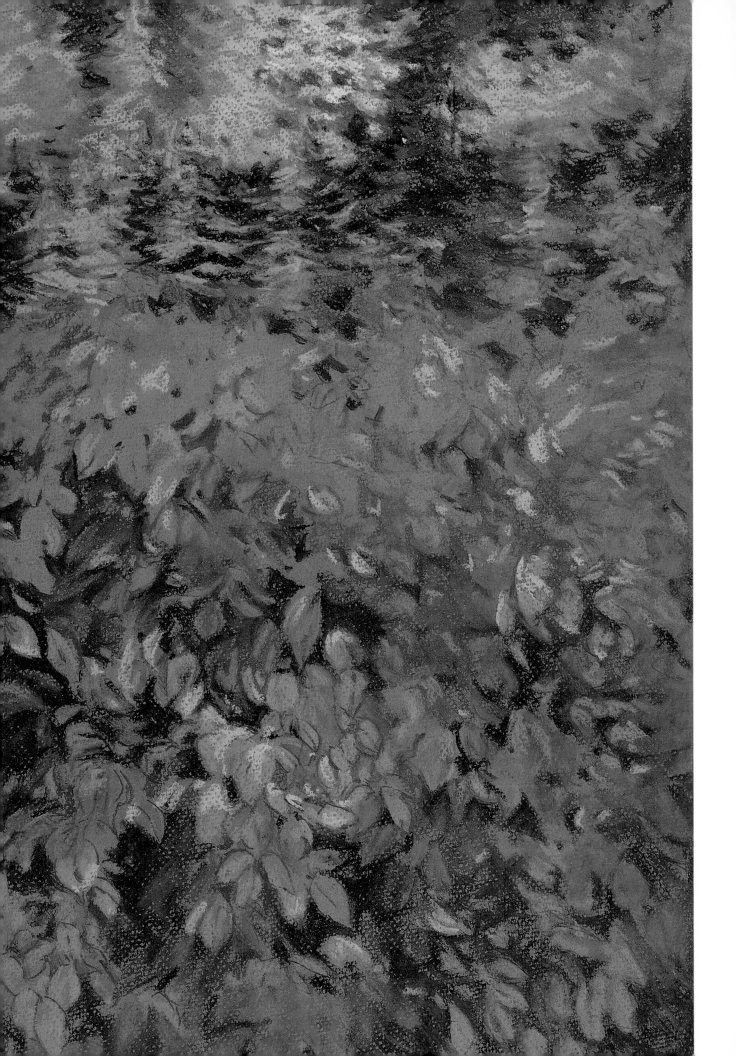

DETAIL
The dark values supply the needed structure in this overall pattern, which otherwise would seem random and chaotic.

DETAIL
Dark red-violets, in combination with the brown of the paper, support the intensity of the bright reds and oranges.

Rendering Delicate Texture in an Intimate Closeup

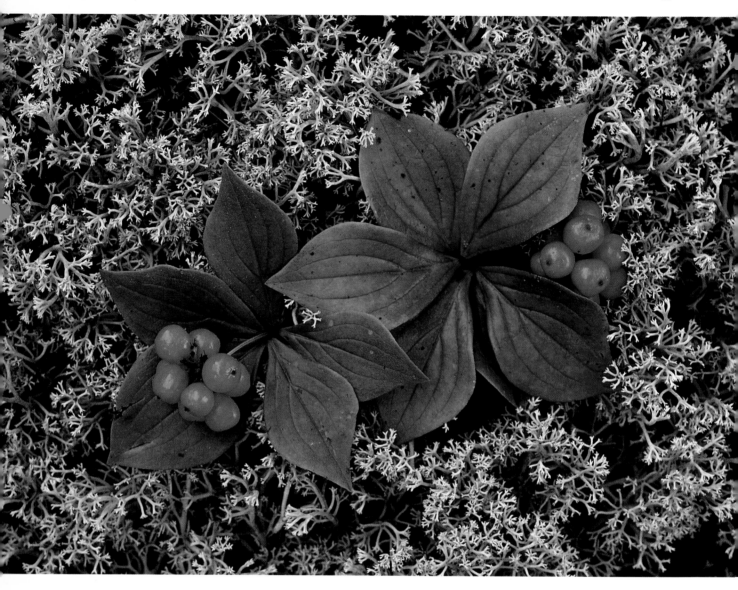

PROBLEM

This is a wonderful study of contrasting textures. Painting the smooth green bunchberry leaves and shiny red berries should pose few problems; the real challenge here lies in describing the lacy cushion of reindeer lichen without letting its intricacy overwhelm the composition.

SOLUTION

Work on a black ground, which will contribute a feeling of underlying depth to the delicate pattern of lights.

Shiny red bunchberries surrounded by smooth, pointed green leaves burst forth from a cushion of delicate reindeer lichen.

STEP ONE

Make a careful drawing with a medium-gray pastel pencil, not only defining the bunchberry leaves and berries but also filling in the surrounding overall lichen pattern.

STEP TWO

Develop the background pattern further by darkening some areas with blue-black and lightening others with a very light blue and light grays, setting up a kind of rhythm. Also at this stage, establish some green in the leaves and red in the berries so you can begin to visualize the color structure of the whole painting

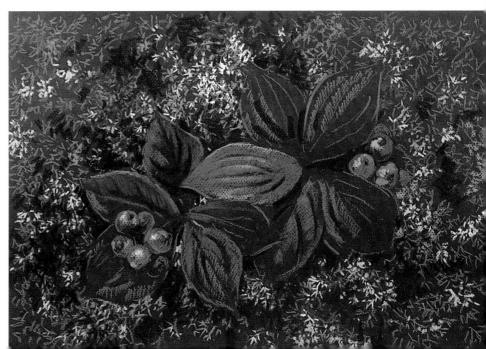

STEP THREE

Continue developing the leaves more fully. Aim for variety in your greens, letting them range in hue and value from yellow-green to blue-green and olive. Define the berries further as well, taking care to model them with a range of reds and oranges so they appear convincingly round.

FINISHED PAINTING

As the painting nears completion, redraw edges of shapes where more definition is needed with black or even a very dark blue. On black paper, black pastel provides contrast even with medium-dark to dark values.

Because of the way the lights and darks have been modulated, the intricate lichen pattern has a springy, cushiony quality.

Note how color values have been handled to model the berries so that they appear not only round but shiny. The dark paper works as deep shadow, so the highlights really pop.

ASSIGNMENT

You don't have to look far to find appealing pastel subjects—it just takes a little practice to learn to focus in on the simple things that are all around you. Go into a park, or even your own backyard, and look at the leaves and twigs that lie under the trees. Execute a detailed drawing of a foot or two of the ground. This sketch will train you to look at everything you see, from minute bits of leaf litter to pinecones and leaves. Next, pick just one detail from your drawing—like the bunchberry here—and narrow in on it. Sketch the detail, making it much larger than life size, then begin your pastel painting.

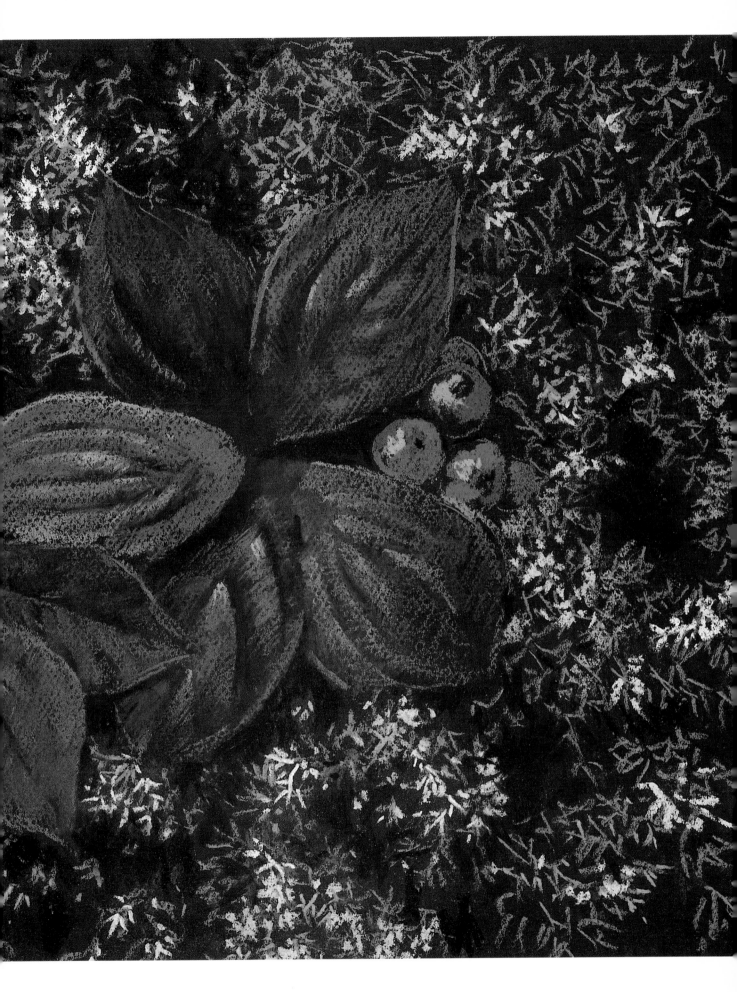

Portraying a Bird in Vignette

PROBLEM

Only the cardinal and part of the branch he sits on are in sharp focus; all else appears soft, the background simply a blur of brown and gray. Yet if you emphasize the bird and nothing else, your composition will lack balance and interest.

SOLUTION

Treat the branch, twigs, and new leaf growth as if they were also in sharp focus, but preserve the composition's vignette quality—the gradual shading of the image into its surroundings. Use the complementary contrast between the green leaves and the bird's red plumage, plus the pleasing linear curves of the twigs, to hold the viewer's attention.

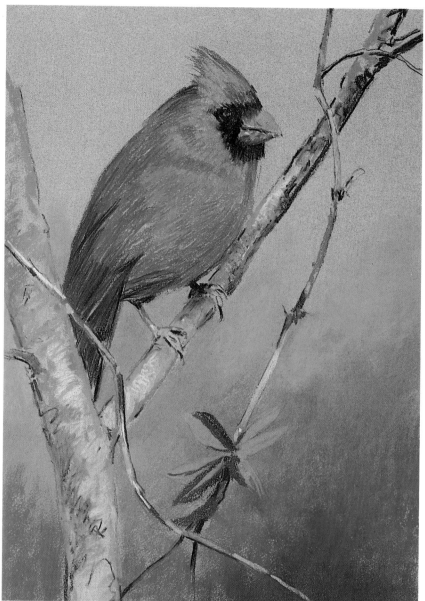

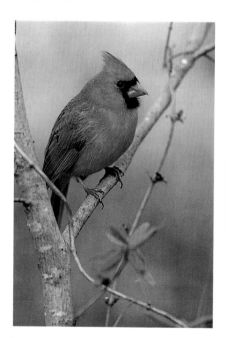

A male cardinal, ablaze with brilliant red plumage, perches on the branch of a young sapling.

☐ Make an accurate line drawing of the cardinal and branches in charcoal pencil. With these elements in place, paint the background in burnt sienna tones, blending as you go. Begin with darker values at the bottom, and work upward into progressively lighter values.

Now for the cardinal. With a wide range of reds, apply color in narrow, overlapping linear strokes that follow the direction of the feathers' growth. Use black for the bird's mask, dark back and tail feathers, and fine details. Render the delicate legs and feet in orange, burnt sienna, and black. Echo their colors and forms in the twisting twigs. For the leaf cluster, use two or three greens; these will offset the reds of the cardinal. Model the tree branch in grays, a medium brown, and touches of black and burnt umber.

The few well-placed greens and graceful linear elements are subtle counterpoints to the cardinal's form, texture, and brilliant color.

Delineating Forms on a Monochrome Background

PROBLEM

Against a virtually solid, neutral green background, the flower and the monarch seem as one, the butterfly's veined wing segments echoing the shapes of the blossom's petals. How can you capture this subtle relationship yet maintain the subject's interesting potential?

SOLUTION

Don't fight the simple background; it's an effective foil for such closely allied details of form and pattern as you see here.

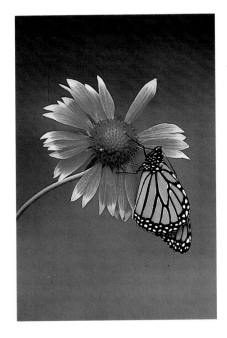

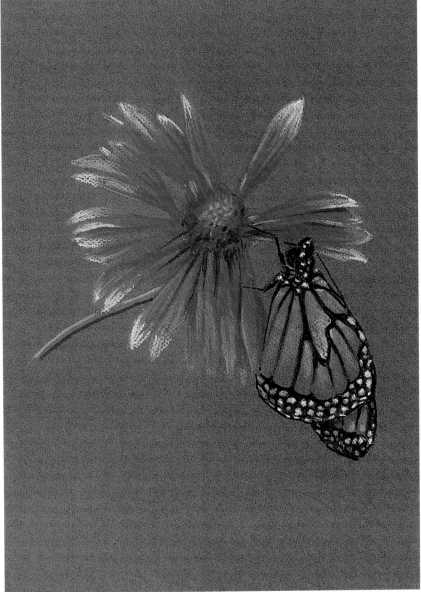

In summertime, a monarch butterfly alights on the crown of a red-and-yellow blanketflower.

☐ The color and value scheme of this composition call for an ivy-colored paper. Skip a preliminary drawing; work in hard pastel and pastel pencil. Start with the bold flower form, defining its petals and center in analogous colors that range all the way from yellow (for the petals' tips, the highlights) through red-violet and, for dark accents, deep burnt umber. Indicate the stem simply by laying three strokes, each of a different green, side by side.

Now concentrate on the butterfly. Carefully draw the outline of its form. Next, define the details of its wing pattern—the petallike cells containing orange color, and the intricate black-and-white checkerboard borders. Take your time with this. Fill in the colors carefully, letting your oranges and yellows taper off softly to suggest the diaphanous quality of the monarch's wings. Use light gray for most of the spots, and pure white for just a few of them.

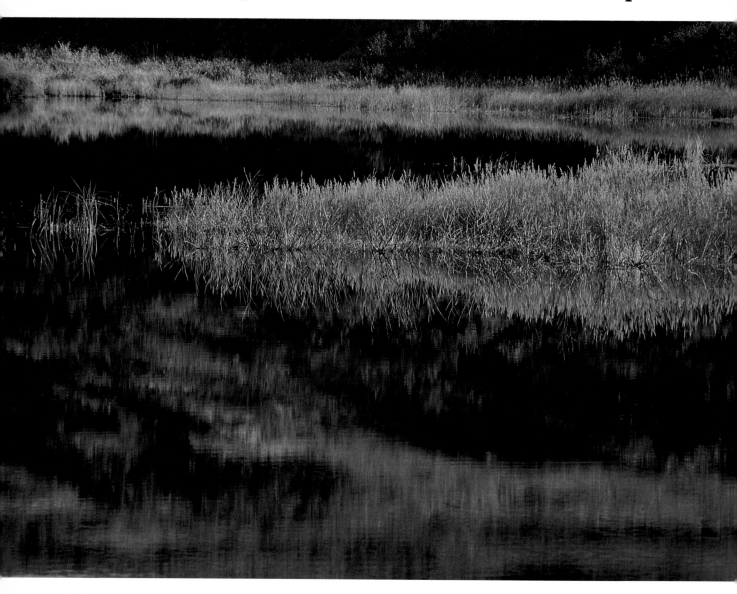

Emphasizing the Abstract in a Quiet Landscape

PROBLEM
This scene barely reads as a landscape. For one thing, the pond is so dark that it doesn't even look like water. The colorful grasses and shrubs offer little identifying detail, and their soft, blurred reflections add to the visual puzzle.

SOLUTION
Don't fight the obvious; use this as an opportunity to explore nature's colors, shapes, and textures in an abstract composition. Simplify what you see even more and forget about literal description and specific detail.

Early fall color reflected in a dark pond becomes a vibrant abstraction of line, shape, and hue.

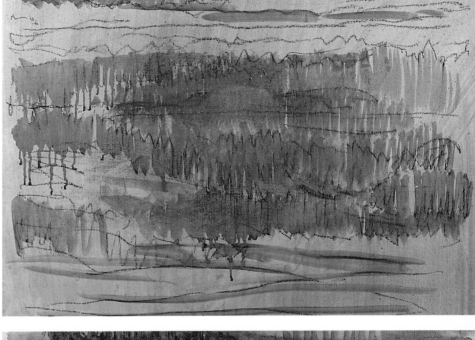

STEP ONE
Use a support with a slightly rough surface that can withstand firm strokes and hold a lot of pastel color, such as the Crescent charcoal board used for this demonstration. Make a very simple preliminary charcoal drawing. Then, with a brush and thinned oil color, establish the composition's main patterns with an underpainting. You can redraw various elements of the subject in more detail as the painting develops.

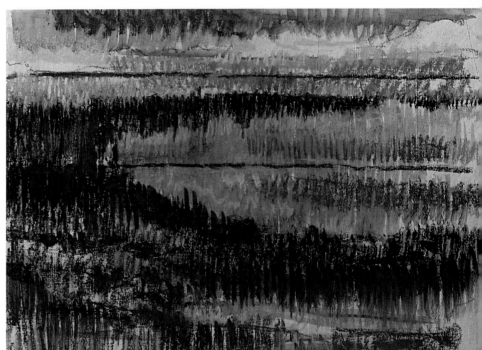

STEP TWO
Apply pastel over your underpainting in layers of short, vertical strokes. Work over the entire surface, describing the colors and values of all the main areas—dark and medium greens, oranges, yellows, brown, and some red-violet. Redraw some of the shapes; the shorelines in particular may need redefining. Add more color, strengthening the pattern of light and dark. Brush the pastel with turpentine to cover the surface quickly.

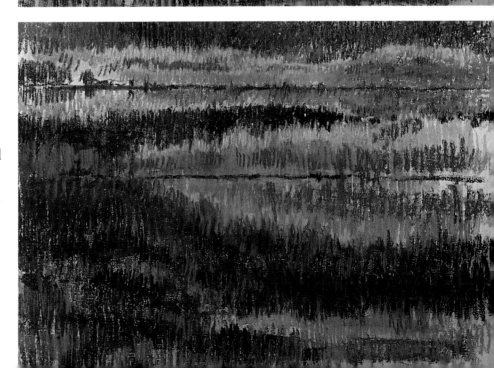

STEP THREE
Keep adding pastel color in generally vertical strokes. At this point, aim for more color variety and further shape definition, and heighten a few value contrasts. Introduce some blue-green, violet, and a few touches of pink for interest. In a composition as abstract as this one, don't worry about the rule that says reflections should be darker in value than the objects that cast them.

FINISHED PAINTING
In the last phase, some areas of the water were smoothed out and made to look more opaque to contrast with the dominant texture of the vertical strokes used for the land and reflections.

Here color really seems to shimmer, the effect resulting from the steady buildup of pastel in short, consistent vertical strokes.

Very dark areas in a painting often run the risk of going flat and dead, but that's not the case here. Instead, a feeling of depth has been achieved by using a wide variety of colors layered one upon the other so that they never quite solidify.

ASSIGNMENT
If abstract paintings interest you but you're unaccustomed to working abstractly yourself, try using something real as a point of departure. Choose a subject made up of complex patterns and shadows, like the water landscape in this lesson. Then sketch the scene, concentrating on the entire subject without focusing on any specific detail. As you draw, don't look at the paper; try to coordinate your hand and eye. Once the basic shapes are down, begin to lay in pastel color, but continue to refer to the paper as little as possible. As you build up color, work loosely, concentrating on overall pattern.

When it's time to add finishing touches to your work, you may find that what you've done doesn't really resemble your subject—just the effect you wanted! Instead of pulling the painting into focus, emphasize the abstract shapes that most appeal to you.

Describing Diverse Textures

PROBLEM

The obvious focus of this simple composition is the juniper, but the real subject is the wonderful juxtaposition of different textures. How can you describe the character of each, yet have them interrelate?

SOLUTION

Because the tree is so important, paint it first, then paint the rocky background around it. Next, concentrate on the strokes you need to develop the tree's texture, and switch to a completely different approach to capture the feel of the rock.

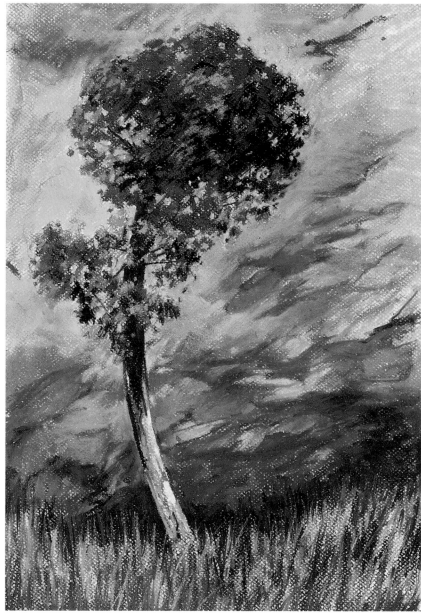

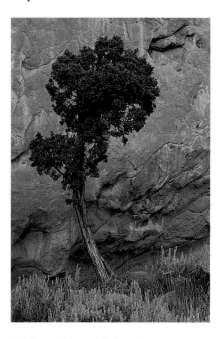

☐ In a charcoal drawing on a light ground, capture the juniper's graceful arc and suggest a few crags in the rock's surface.

Paint the tree. For the foliage, layer on short, half-round strokes of dark blue and black, plus dark, middle, and light greens. Suggest bark texture with long strokes of dark brown, medium gray, and pale orange.

For the rock, use a variety of ochers, siennas, umbers, and reds in a range of values, defining its crisp edges and strong contrasts. Work in smooth, broad strokes, blending according to the rock's contours. The pattern becomes more wavelike, the values and hues more varied as you work downward. Next, describe the grasses with various greens and earth hues in quick, straight, tapering vertical strokes.

Note whether the juniper, rock, and ground relate to one another spatially. Bring more of the rock's orange color up to the foliage and along the trunk to sharpen the tree's definition against the rock and unify their relationship.

In Colorado, a juniper tree takes a graceful pose against a backdrop of terra-cotta-colored rock.

Creating Interest Through Value

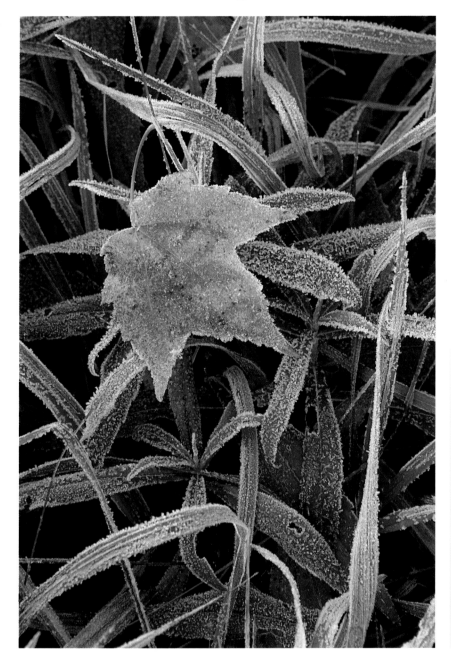

PROBLEM

Three problems confront you here: the intricate pattern of the grasses, the limited color range with only one major contrast for interest, and the delicate coating of frost over the whole scene.

SOLUTION

Deal with one thing at a time. First develop the pattern of intertwined grass blades, then develop an interesting value range within the confines of the scene's limited hues. Don't try to describe the frost—use your lighter values simply to suggest it.

STEP ONE

A patterned subject as intricate as this one demands a strong drawing, so spend as much time as you need to develop its structure and the anatomy of the grass and leaf. Make your drawing in charcoal pencil for greater precision, and work on a dark gray paper. Quickly fill in the dark negative spaces between the leaves at this stage to help clarify the complicated pattern.

Under the sugary coating of an early frost, a tiny maple leaf clings to tangled blades of grass.

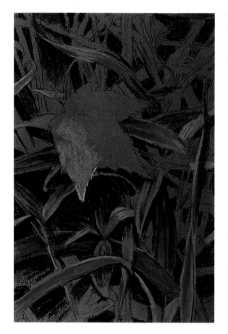

STEP TWO
Strengthen the dark negative shapes and add color to the grass. Work toward developing a value range that includes a wide variety of very dark to very light blues. Add some of the maple leaf's pinkish-orange color to establish the composition's one high-key note and complementary hue contrast. Work over the entire painting, alternating between positive and negative areas to strengthen the value pattern.

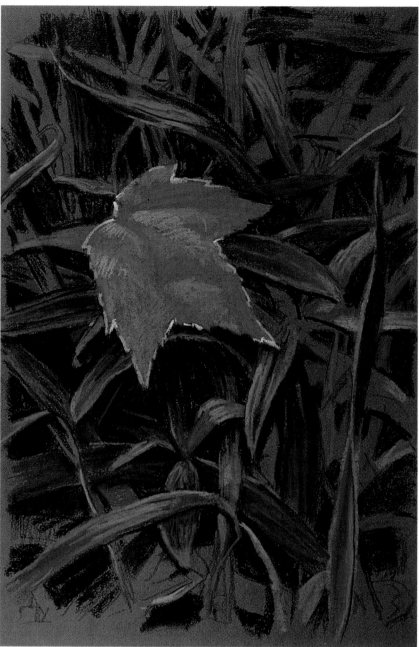

STEP THREE
Now concentrate on defining and sharpening the edges of individual blades of grass. Make some of the blades recede into the background and bring others forward by carefully manipulating values. Exaggerate contrasts between lights and darks to enhance the illusion of depth.

FINISHED PAINTING
The warm orange of the maple leaf sets off the complementary blues of the grasses, making the entire painting seem cool. Besides its color, the maple leaf's simple, flat shape provides a welcome contrast to the intricate grass pattern, and contributes to the feeling of depth.

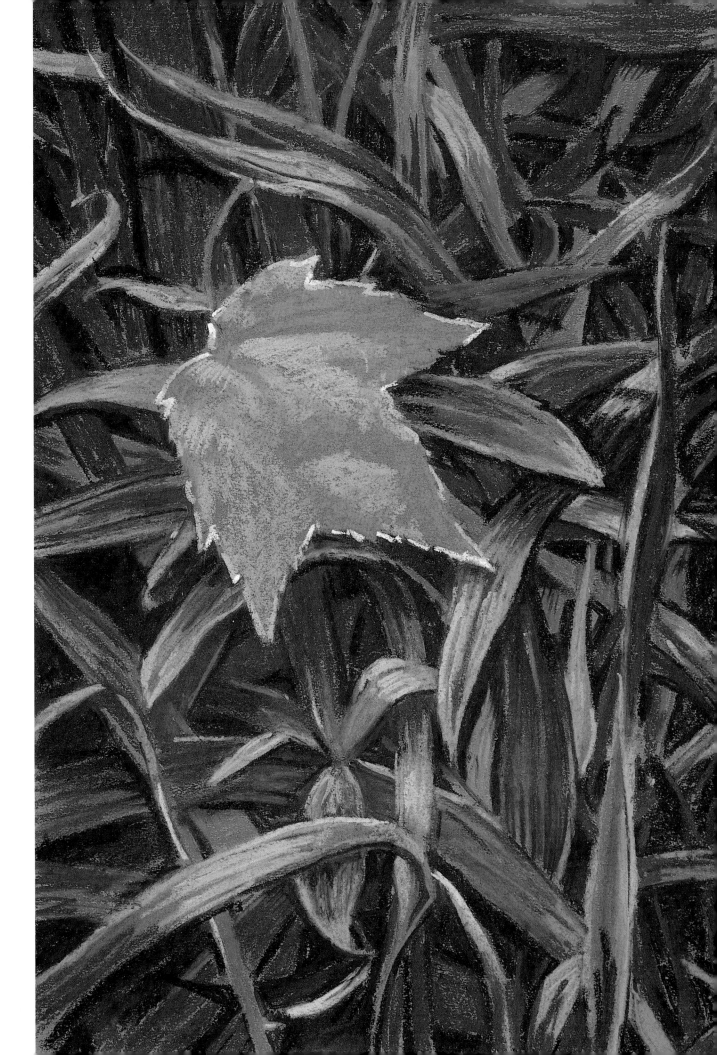

Conveying the Brilliance of a Sunny Winter Day

PROBLEM

The brilliant winter sun that illuminates this scene reflects off the bright white snow, throwing everything into a very high key. But if you make all of the whites equally bright, you'll lose the dazzling quality of the light.

SOLUTION

To avoid overusing pure white, rely on a range of grays for the snow and exaggerate the dark values in the scene for contrast; these darks will make your lights seem lighter.

☐ Don't let the dominant whites in this scene tempt you into using white paper as your ground. Instead, use a strong, bright blue that's light enough to match the scene's overall key but dark enough to provide sufficient contrast for your light values. Make your drawing in charcoal pencil, indicating the icy white tree branches as silhouetted groups for now. Make the dark tree line in the distance more arched, and raise the tops of a couple of the mid-distance trees above it to create a better transition between the left- and right-hand areas of the composition.

Start with your darkest darks, establishing the two large trees on either side of the foreground. Also introduce some browns and ocher on the ground to define the direction of the trail.

Treat the snow-covered trees in the middle ground and branches of the foreground tree as large tonal areas of various grays. With a dark gray, define the dark tree line in the distance. Going back to the snowy forms, define individual branches with strokes of very light gray and touches of white. Use these grays and whites also for the larger clumps of snow on the pine tree, stroking color on to mimic the needles' texture.

Using cobalt blue and light blue-violet, paint the sky in broad strokes, blending as you near the horizon. Selectively paint sky color between the branches of the right foreground tree to define the network of twigs.

Evaluate all color and value relationships. On the right foreground tree, add a few sparkling touches of white and pale orange to the twigs, placing a few thin strokes of dark brown and deep rose alongside these highlights for contrast.

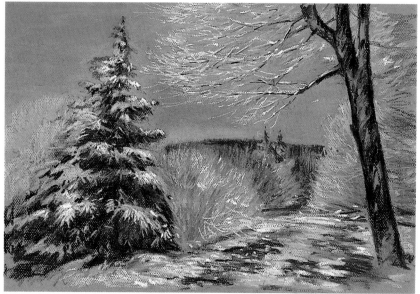

Along a stretch of the Appalachian Trail, snow-covered trees glisten in the midday sun.

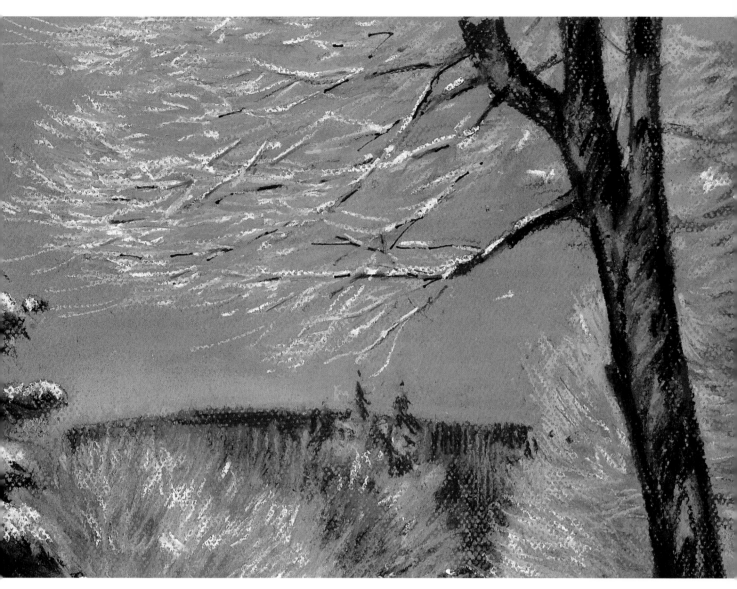

DETAIL
Look at how many colors have been used to describe the snow-covered twigs of the foreground tree—grays, dark brown, deep rose, pale orange, white, plus the different blues of the sky. The paper's bright turquoise color showing through the pastel hues animates the whole painting, especially the sky between these branches.

ASSIGNMENT
If you've completed this lesson, you already know that overusing pure white in your paintings can cause problems. Still, it's easy to think of snow as white—after all, that's its basic color. With careful observation, though, you'll see that snow is actually made up of many different colors that are determined by the sky.

In winter, go outdoors and make quick color sketches of snow scenes in pastel on a variety of colored grounds. Do this over the course of several days, or at different times of day, so you can work with a range of light and weather conditions. When the sky is cool the snow will probably appear bluish or gray. On bright, sunny days, look for touches of unexpected color in the snow—reds, yellows, oranges, and pinks.

After experimenting with color sketches, work out a finished pastel painting. Force yourself to apply what you've learned: Don't let pure white figure in your painting. Instead, describe the snow with pale blues, purples, grays, yellows, and reds.

Handling Strong Form

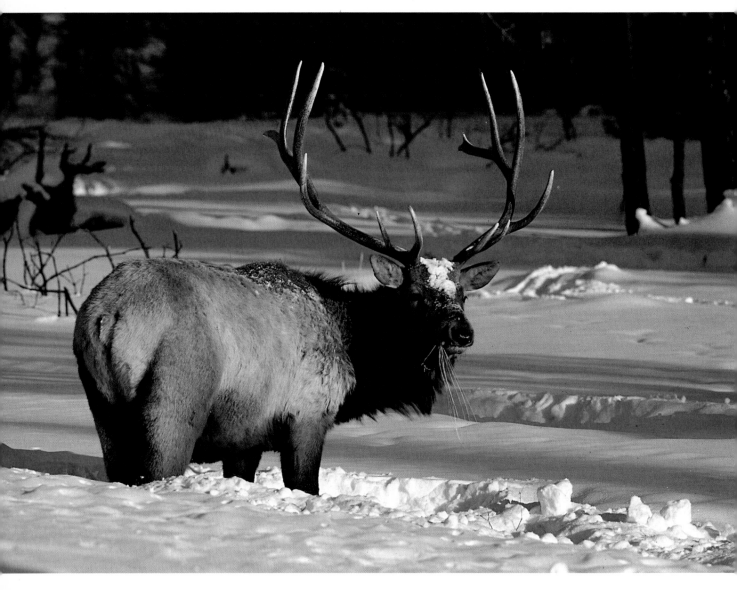

PROBLEM

With its impressive antlers and stalwart body, the elk is a powerful presence in this winter landscape. But the late afternoon shadows encroaching on the woods are so strong and dark themselves that they could easily draw too much attention away from the animal.

SOLUTION

You need to start with a very strong, well-defined drawing of the elk's form that will stand you in good stead as the painting progresses. Work over the whole painting as usual, but always keep the elk's image in a more advanced stage of development than the rest of the composition so you never lose sight of your focus.

Knee deep in snow, an elk searches for food as lengthening shadows creep into the forest.

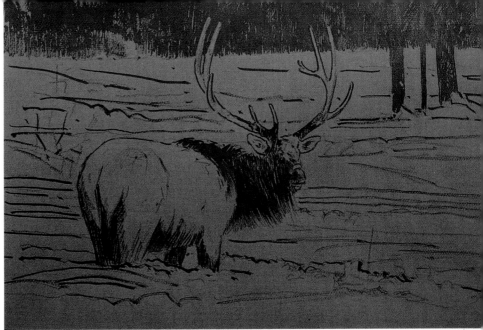

STEP ONE
To echo the value of the dark shadows, use a dark blue ground. Make a very careful charcoal drawing, then strengthen it with a small, pointed round brush and black drawing ink.

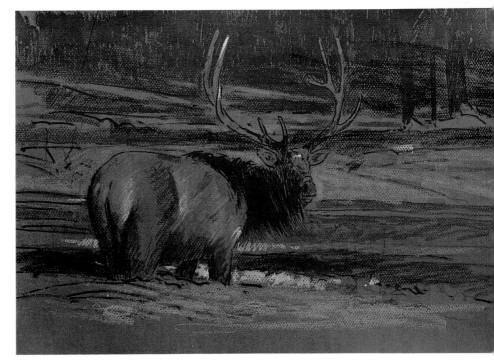

STEP TWO
Working from dark to light, begin to lay in pastel color over the whole painting. At this stage concentrate on establishing a full color and value range, but hold back your lightest lights; you don't want to get too light too soon. Keep the elk slightly more developed than any other compositional areas.

STEP THREE
As you work slowly toward the light values, the image begins to emerge. Maintain variety in your strokes, using long, linear ones to describe the elk's shaggy winter coat and broad, flatter shapes for the snow. Also maintain color variety in the dark shadowed areas to keep them from going flat and lifeless.

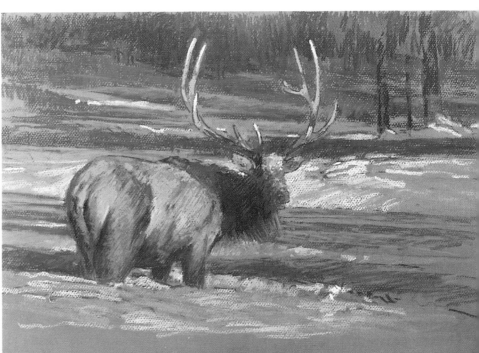

FINISHED PAINTING

Now concentrate on the placement of your lightest lights. Darken some of the dark areas further to strengthen contrast. The contrast between the elk's graceful antlers and the dark background is especially important. Make sure any other edges that describe form are sharp.

ASSIGNMENT

Fleeting scenes like this one, with an animal paused for only a few moments, have to be captured quickly. One of the most practical ways to do this is to use a camera. Most artists rely on photography in one way or another; here, the camera not only can freeze the animal on film for you but also can record the fascinating shadow patterns before they shift.

Get into the habit of carrying a camera with you when you go outdoors in search of new painting situations. It is an invaluable tool for gathering information on animal and plant life, and on changing light and atmospheric conditions. Back home, organize a file for your photographs. Separate the images according to time of day, season, animal species, and whatever other categories you would find useful. Then, when you are working on a painting and need a specific image—a particular animal, tree, or, say, a winter sky in late afternoon—you'll be able to refer to your file.

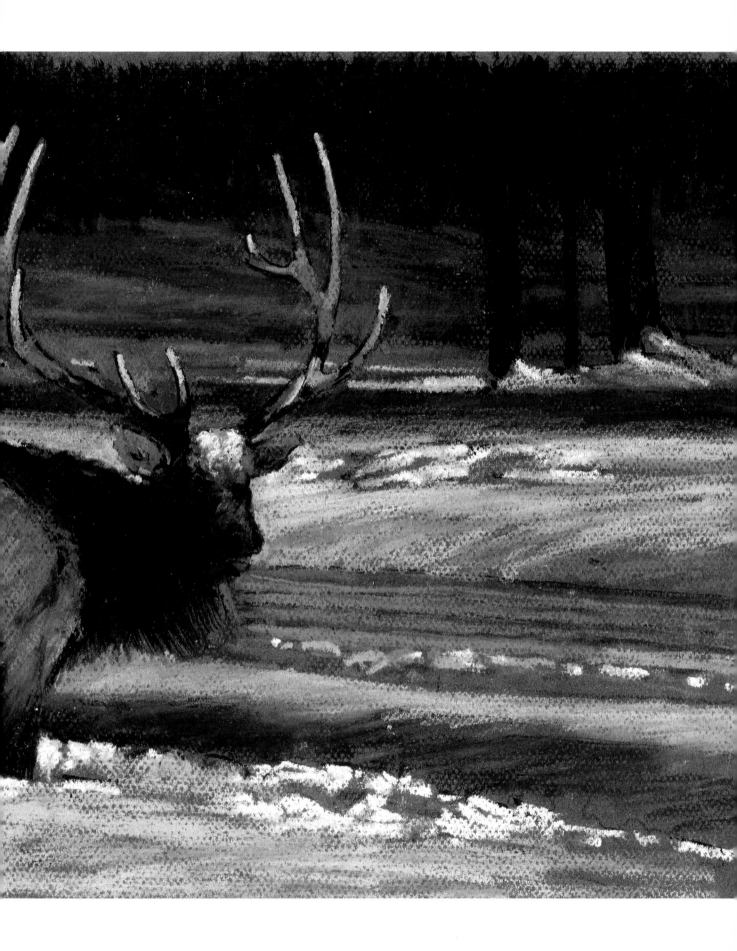

Capturing Winter Twilight Reflected in a Still Stream

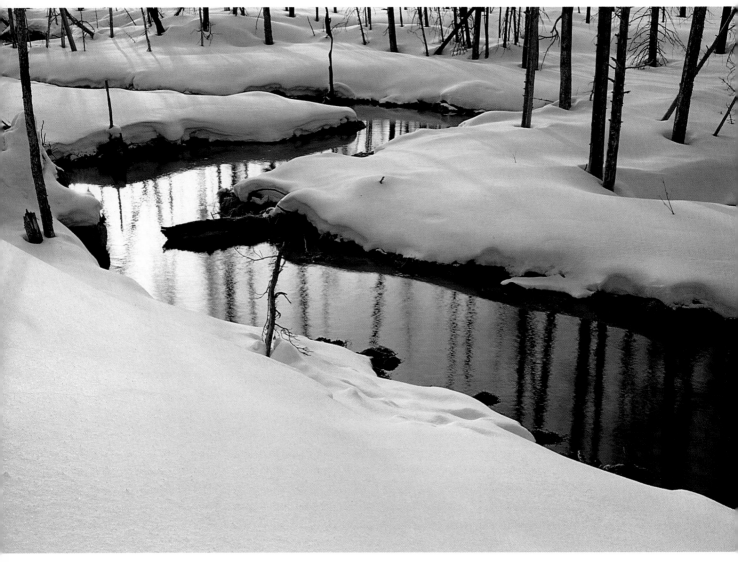

PROBLEM

Reflected in the meandering stream is a glimmer of sunlight that bathes this wintry landscape in warm color, soon to fade. The effect is so subtle; how can you introduce warm color in just the right amount so it won't overwhelm the dominant cool feeling of the scene?

SOLUTION

Establish your middle value first with a loose wash of blue-gray acrylic. Limit your use of warm color to very light tints of orange and yellow, keeping their value closely keyed to the cool, light grays, blues, and violets of the snowy stream banks.

☐ On a sheet of cold-pressed (medium-textured) watercolor paper, lay in a wash of blue-gray acrylic paint, allowing it to flow at will and form accidental patterns. When the wash is dry, sketch the scene in charcoal. To avoid monotony, vary the sizes and placement of the trees from what you see in the photograph.

Begin to model the contours of the land, working with a variety of medium- to light-value grays, blues, blue-grays, blue-violets, even some blue-green. Pay close attention to where shadows fall. Save white for highlights. The

As twilight approaches, a quiet stream meanders through the woods, its banks blanketed in fresh snow tinged violet and blue.

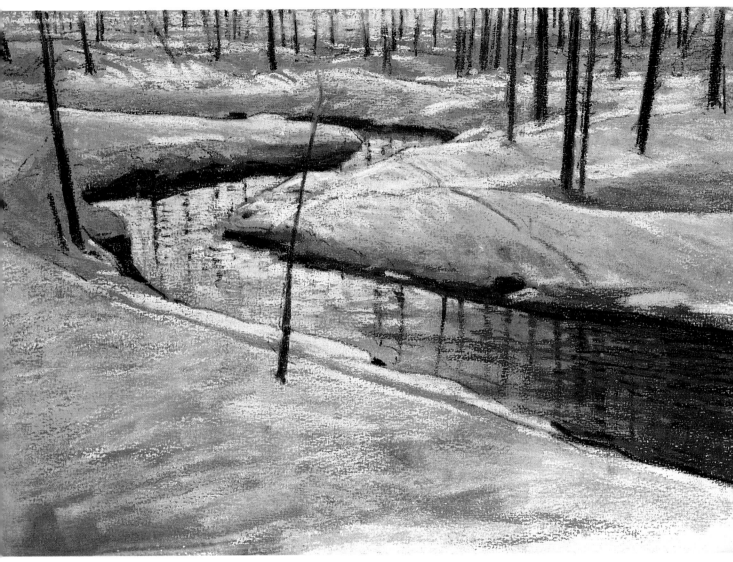

acrylic wash you started with will work as your main middle value.

Move on to the water. First, make sure the shoreline between water and land is well defined. In the middle ground, where the stream curves, lay in a pale orange tint using short strokes, alternating with a pale yellow or pale ocher to capture the sky's fading reflection. Also in the middle ground, apply a few long, horizontal strokes of these colors as highlights following the contours of the land. Use the same colors, along with some light gray and light blue-

gray, to establish the very narrow glimpse of sky in the background.

Now concentrate on your darkest values. Paint the vertical pattern of the tree trunks, making those in the background lighter so they appear farther away. Add more definition to the edge between the stream and its banks with a dark reddish brown, some black, and a dark blue-gray. Paint the darkest stretch of the water—in the right foreground—in dark values of olive, gray-green, and blue-gray, with a few strokes of black.

Establish the reflections of the tree trunks in the water, making them slightly lighter in value than the trunks themselves.

To finish painting the scene, add a few more highlights to areas of the snow illuminated by the sun, as well as to the water. Place some more pale yellow sky color between a few of the trunks in the background. Sharpen contrasts and contours, especially along the stream banks. The balance between your warm and cool hues should convey the feeling of the setting sun and nightfall's chill.

Exploring Complicated Pattern

PROBLEM

A tangle of twigs and grasses tinged with frost, the old, abandoned robin's nest is a fascinating subject. The challenge here is not only to make its intricacy readable, but also to convey its moody, poetic quality.

SOLUTION

Because the subject demands some precision, use a surface that will accept crisp linear work as well as the fairly painterly buildup of background color you need to offset the intricate detail of the nest.

☐ Make a careful drawing of the nest and tree branch that supports it on fine-grained, light buff-colored sanded pastel board using a sharpened charcoal pencil. Once you've established the drawing, spray it with fixative. Then, with the side of your pastel sticks, lay in large areas of background color—medium to light values of burnt sienna in the upper two-thirds of the composition, plus light blues and blue-grays toward the bottom. To get a rich buildup of color, spray on fixative to isolate each layer of pastel so that more will adhere. As you work over the background, don't hesitate to paint right over some of the twigs and branches; you can always reestablish them later. This approach will help you maintain the illusion that the sky is actually behind the tree and nest.

Now concentrate on developing the intricacies of the nest and tree branches. Here, work from dark to light, relying on the skeleton of your charcoal pencil drawing to guide you. The pattern you weave here consists of multidirectional lines of different hues and values—browns, grays, black, violets, blues, and white, plus occasional strokes of burnt sienna. When you are satisfied with the nest, sharpen the edges between it and the background. For greater control and precision, you may want to use a brush dipped in solvent.

Save your lightest lights— what you need to suggest the coating of frost on the nest and tree—till last so that they'll really sparkle.

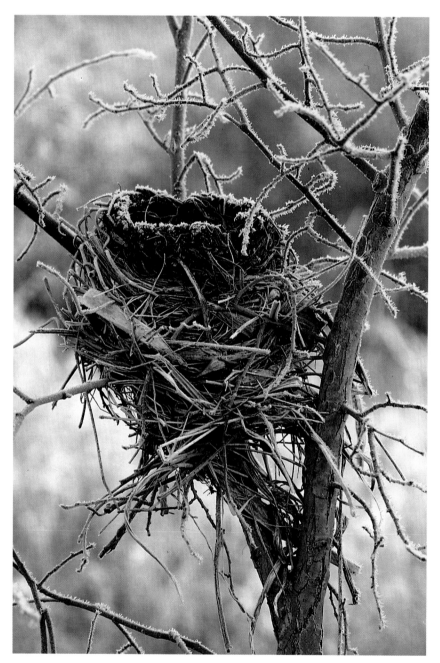

Winter frost coats the twigs and branches of a tree that bears the remains of a robin's nest.

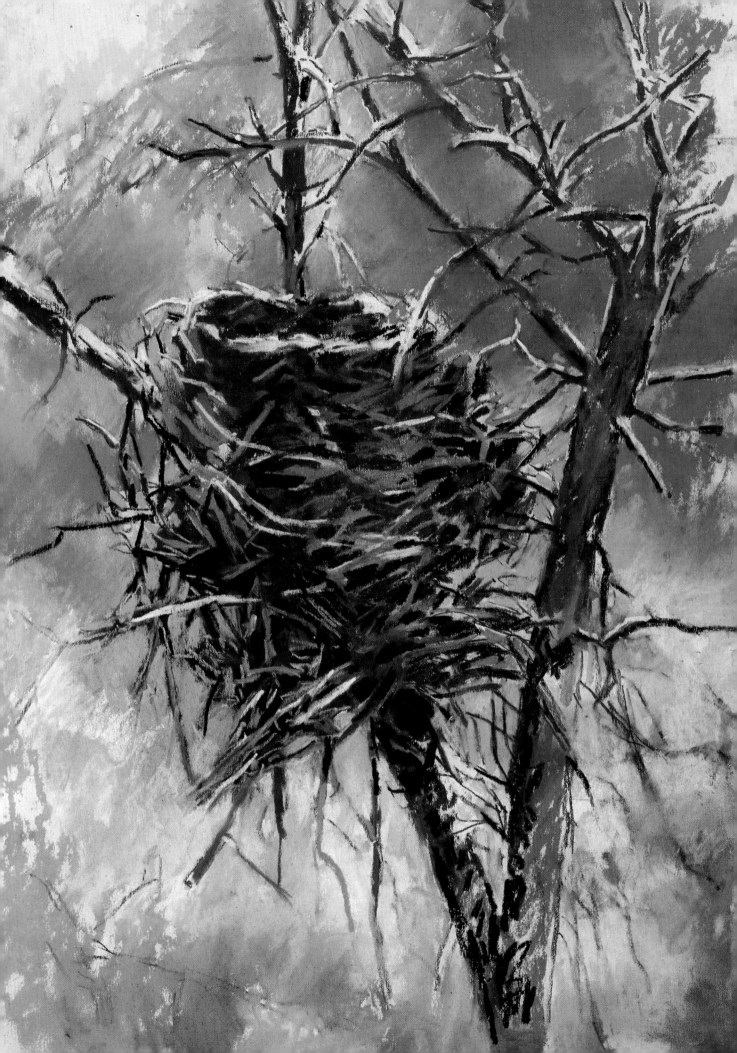

Simplifying Detail for Greater Impact

PROBLEM

The strongly vertical tree trunks interspersed with snow-covered pines form an almost impenetrable screen. Somehow you've got to find a way to let the viewer in.

SOLUTION

What works in a photograph—in this case, the deliberately sharp overall focus—doesn't necessarily work in a painting. Instead of trying to be overly faithful to the photo, simplify the detail you see to open up the space. Introduce more value and color variety to develop the illusion of depth. Work on a ground with adequate tooth so you can achieve a rich, dense color buildup.

In deepest winter, tall, slender lodgepole pines preside over a silent forest.

STEP ONE

Make a simple charcoal drawing on a sheet of watercolor paper coated with a mixture of powdered pumice and medium-gray acrylic paint. Lay in some initial color to establish the basic dark and light patterns of the trees and spaces between them. For now, stay in the darker ranges so your values don't get too light too soon. When you have a sufficient buildup of pigment in place, go over it with a brush dipped in mineral spirits. This lets you cover the rough surface more quickly. Don't worry about losing your drawing; you can redraw the trees on top of your underpainting.

STEP TWO

Now concentrate on developing the pattern of the spaces between the trees—the negative areas. Use a variety of grays here, and try to capture not individual branches but their effect. To suggest the bluish shadows of the snow, introduce a medium-value cobalt or ultramarine blue, light blue and gray, plus a medium violet and blue-violet, applying color in short, horizontal and diagonal strokes over the whole painting to suggest the feel of pine branches.

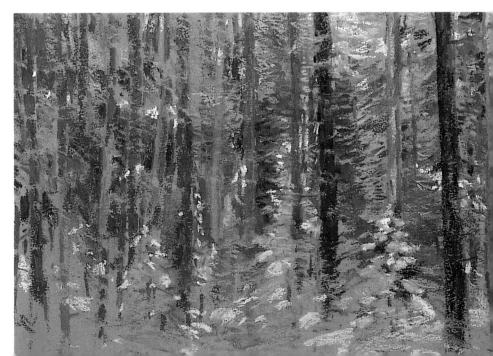

STEP THREE

Reestablish the tree trunks. Note that the two trunks framing the left and right sides of the photograph have been eliminated here to enhance the feeling of depth. Use browns ranging from dark burnt umber to medium burnt sienna, and suggest bark texture on a few trunks. Make some trees come forward in space and others recede. Add more violet, blue, and gray, plus some dark green and blue-green, to further develop the branches. Now, working light over dark, establish your lightest lights: the snow-covered trees in the foreground and a glimpse of sky at upper right.

FINISHED PAINTING

In the final stage, adjust values, redefine and sharpen edges, and look for places where more color may be needed. This painting has a wonderful airy feel; the space seems not only to be accessible but also to invite exploration.

This one little suggestion of sky really helps to open things up—the forest no longer seems impenetrable.

The snow-covered foreground trees are mere suggestions that by themselves look very abstract, yet somehow take on a solidity when they're seen as parts of the whole.

ASSIGNMENT

Don't limit yourself to colored pastel papers; a ground of powdered pumice and acrylic paint like the one used for the painting in this demonstration is easy to prepare and interesting to work on.

Gather a few sheets of 140-lb. or 300-lb. cold-pressed watercolor paper. Then, in wide-mouth containers, mix batches of the ground in different colors. In each container, mix the acrylic paint with about an equal amount of water to thin it, then sprinkle in some powdered pumice. Try different amounts of the pumice to get finer and coarser grounds.

Next, with a housepainter's brush, coat a sheet of watercolor paper with one of your colored grounds, aiming for even coverage and few visible brushstroke marks. Coat the other sheets with the other colors. Let the sheets dry overnight. Then experiment with pastel on each of them to see what effects you can get.

Working with a Palette of Grays and Browns

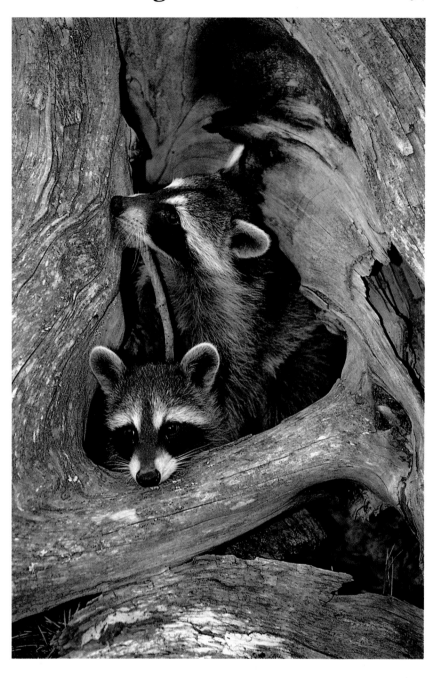

Two playful young raccoons huddle together in the hollows of an old tree stump.

PROBLEM

This is an appealing subject and an interesting study of form, texture, and composition. The real challenge is to find a way to use the limited color range—grays and browns—expressively.

SOLUTION

Look carefully at the photograph and you'll see that the old tree stump consists of mostly cool grays, while the raccoons are warmer in color. Emphasize this difference in your painting.

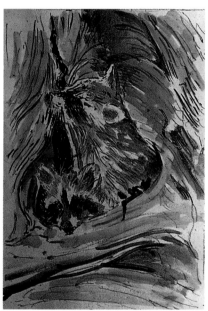

STEP ONE

First, create an interesting ground. Here, a sheet of white pastel paper was sprayed with a mixture of finely ground pumice, thinned acrylic matte medium, and light red acrylic paint for color. On this slightly sandy surface, make a charcoal drawing to establish the placement of the main elements. Then reinforce your drawing with thin washes of oil color, setting up the composition's overall color and value range.

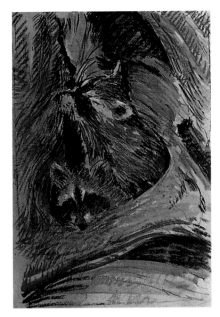

STEP TWO

Select a wide range of gray and brown pastel hues and values to have at the ready, and keep an eye toward which are cool and which warm. Begin to work back over your underpainting with pastel. Cover the whole painting in general terms so you can compare one area to another as the image develops. Use long strokes to capture the texture and linear markings of the tree stump, and shorter, narrower strokes to describe the raccoons' fur. All of your strokes should follow the form of what they are defining.

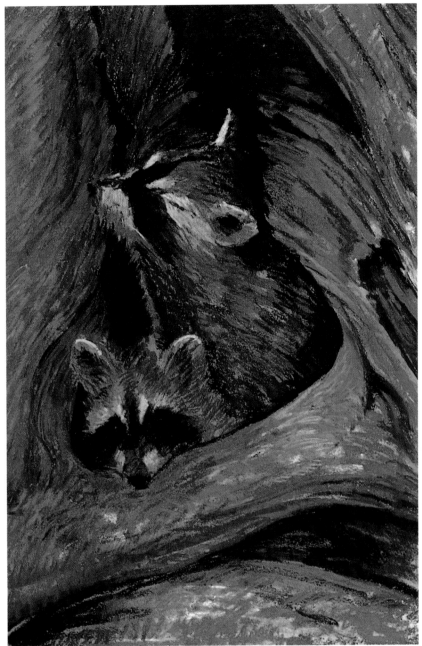

STEP THREE

This stage is crucial. You need to concentrate both on detail and on playing up the difference between the warm and cool elements in the composition. As you continue to add color to the raccoons, pay careful attention to the exact shapes of their distinctive masks. Strengthen your lightest lights—the white areas of the animals' fur—and darkest darks where maximum contrast is needed to further define form and convey depth, particularly in the deepest hollows of the stump.

FINISHED PAINTING (OVERLEAF)

Note how the bits of pinkish-orange background color that show through the browns and grays lend animation to this scene, yet don't overwhelm its subdued palette or interfere with the contrast between cool and warm hues.

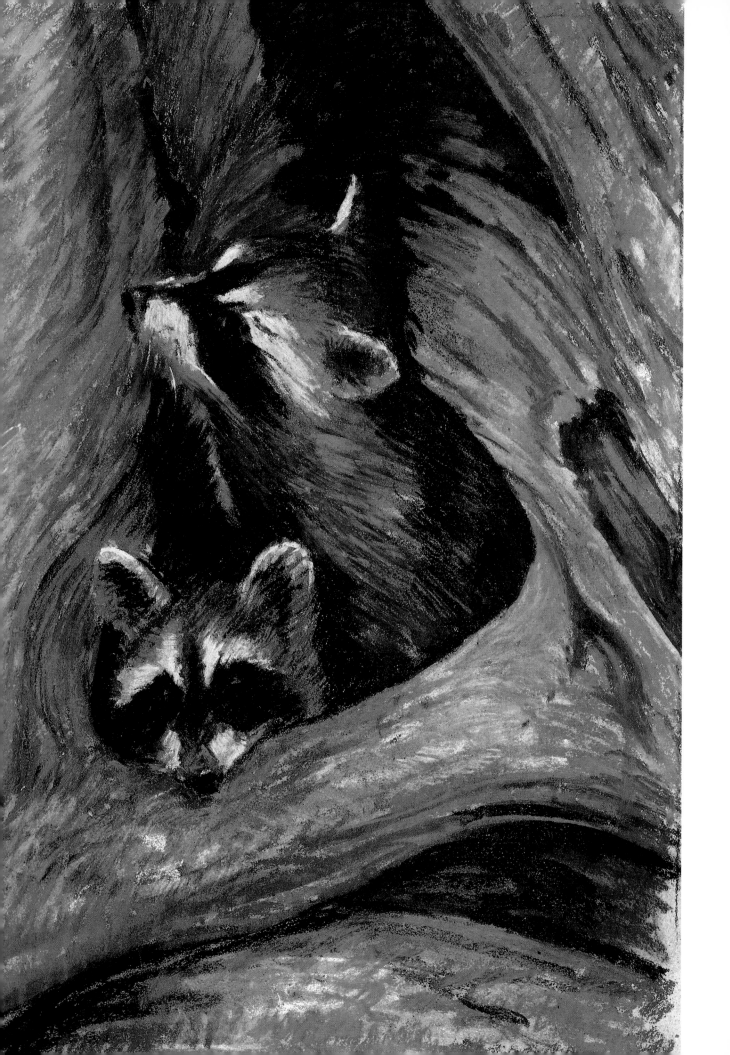

Playing Intricate Detail Against Rough Texture

PROBLEM

With its distinctive markings, especially its precise black-and-white wing pattern, the woodpecker demands a careful, detailed rendering. Yet the tree trunk's bark also has a strong pattern you really can't ignore. You have to find some way to make both patterns and textures work together.

SOLUTION

Don't leave any details of the woodpecker's plumage pattern to chance, or it won't look believable. Make a finished drawing of the bird in charcoal pencil before you do anything else, and use a fixative. You can render the bark texture more loosely to contrast with the finer detailing of the bird.

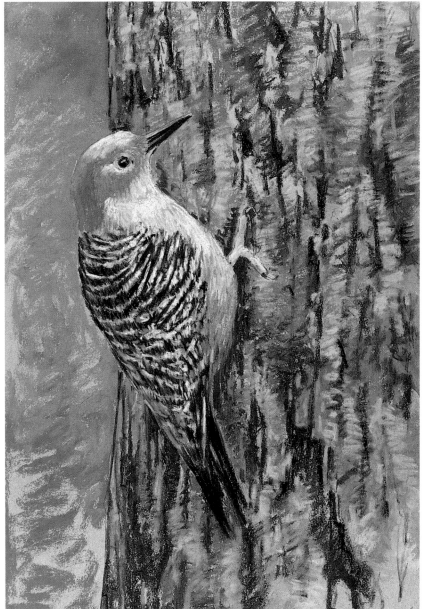

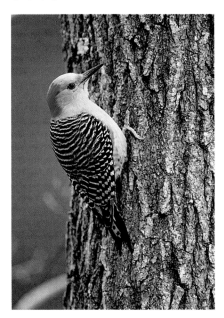

☐ In your charcoal drawing, take your time with the woodpecker's form and markings, but sketch the tree and its bark pattern simply.

Begin to add color to the bird. Start with a very dark gray for the dark parts of the wing pattern, beak, and tail feathers. For the lighter values use light grays, working your way up to white. Apply color in short, layered strokes that follow the bird's contours and describe the smoothness of the feathers. To render the features of the head, use a bright red highlighted with orange for the bird's distinctive patch, echoing these colors in the feathers just above the beak.

Develop the tree's bark texture with browns and grays. Between broken vertical lines, layer on color in short, zigzagging horizontal strokes. Paint the abstract background with greens and blues, bringing color up to the edges of the tree and bird to silhouette them and sharpen their form.

A red-bellied woodpecker on the lookout for food clings to a tree trunk.

Choosing a Focal Point

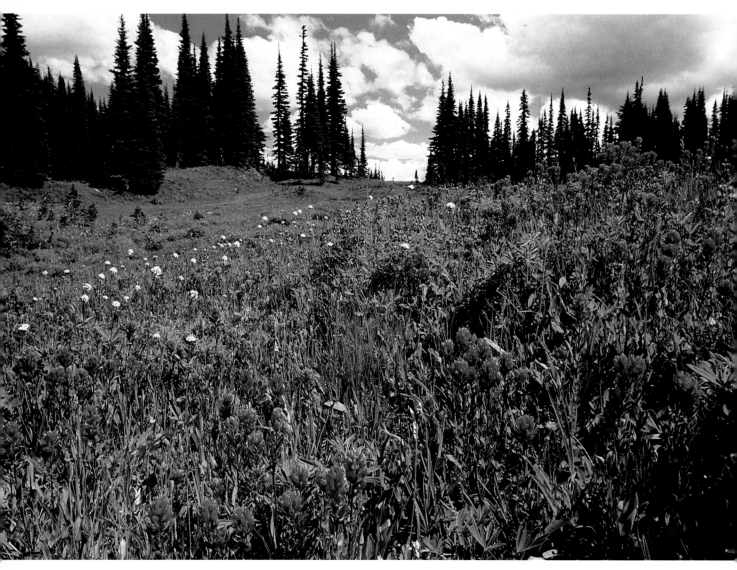

PROBLEM

Everything vies for attention here. The bright red-violet flowers in the foreground are very appealing, but a clearing leads the eye toward equally appealing trees and the cloud-studded sky in the background. You can't give all elements the same importance.

SOLUTION

Simplify the land's contours and play down foreground detail, using the flowers' color to lead the eye back toward the horizon. There, emphasize the contrast between the sculptural forms of the clouds and the silhouettes of the trees.

☐ Make your charcoal drawing on rough gray paper. Then, with a brush and black drawing ink, paint in the dark tree silhouettes on the horizon and the dark shadowy shapes beneath the flowers in the foreground. You can use these, your darkest elements, to judge the rest of your values. Next, work over the whole painting with pastel to establish the overall color structure, indicating the flowers as little more than spots of dark red to orange color. Letting the gray

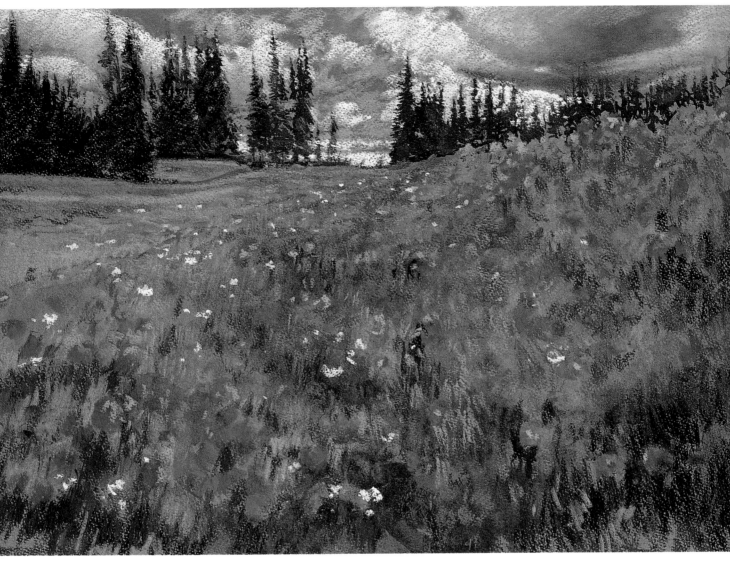

of the paper stand for the middle-dark value of the clouds, begin to sculpt them with a lighter gray, reserving your lightest lights for the time being. Add blue to the sky areas to further define the clouds' forms. Layer different blues to create the intense, opaque color you need here to contrast with the clouds and attract the eye.

Use a variety of dark and light greens for the meadow. Apply color in short vertical strokes in the foreground to suggest the texture and growth pattern of the foliage, and in long, gently curving strokes to describe the simplified contours of the clearing in the left middle ground. Here and there, define edges of flowers with juxtaposed strokes of green.

Add dark greens and black to the trees in the near left background; for the trees along the horizon at right, your ink rendering should suffice. Develop the sky further, adding your lightest values where the clouds are most brightly lit and where strong contrast is called for, especially right at the horizon line in the gap between the stands of trees, and behind the silhouetted row of trees at right. Also indicate a few bright white flowers to the meadow. Adjust values and sharpen edges where needed. The eye should stop only briefly in the foreground and, directed by the pattern of the flowers, move back toward the strong color and value contrasts and powerful shapes of the background.

Conveying the Power of a Threatening Sky

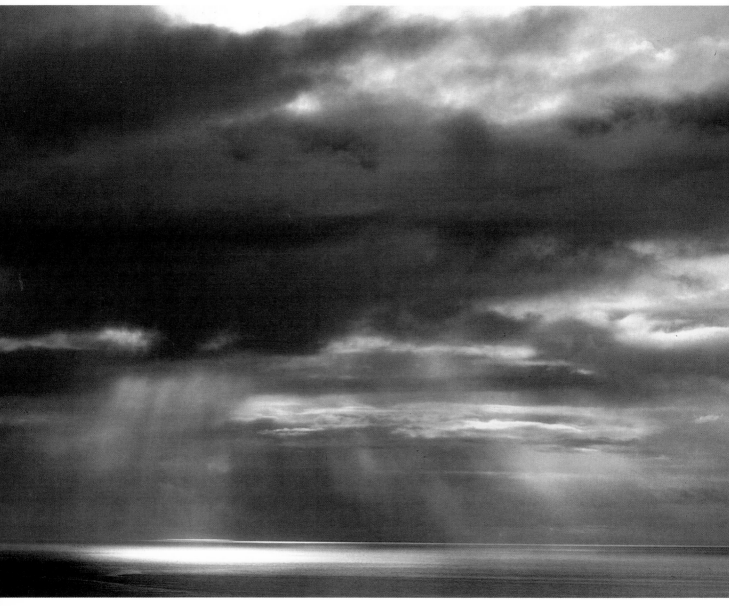

PROBLEM

What makes this scene so compelling is the contrast between the dense, dark snow clouds and the rays of sunlight that break through them to reflect brilliantly in the water below. Capturing such different atmospheric effects in a single painting is difficult.

SOLUTION

Exaggerate the contrast between the darks and lights. Your darks need to be very strong—strong enough to increase the dramatic glow of the lights.

☐ A sanded pastel board is a good surface for a subject that calls for as much color buildup as this one does. Here, a white sanded board was used; a previous image had been washed off it, leaving an abstract neutral tone perfect for this subject.

Lay in the basic dark-and-light pattern in broad strokes using the flat side of your pastels. At this point you're aiming to achieve a soft overall appearance; eventually you will sharpen some of the edges where dark and light come together. With the general pattern in place, begin to model the cloud forms, working from dark to light. Using dark grays, violets, and black, establish the dark values in the clouds. Remember, if they're not dark enough, the

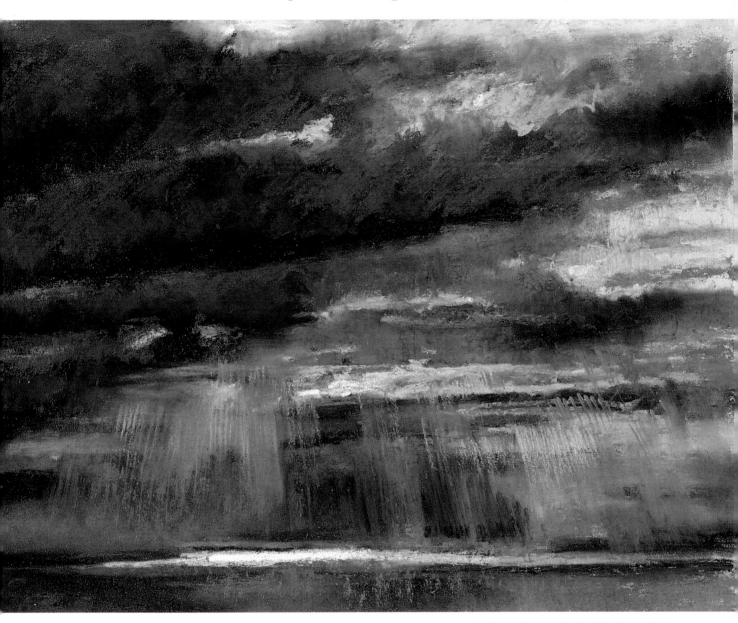

dramatic effect of the lights will never be realized. Fixative can help with this, since it darkens pastel color somewhat.

As you continue to develop the painting, add subtleties of color and value, softening some edges with your finger and sharpening others. For the lighter sky colors, use a deep yellow, pale orange, burnt sienna, and some touches of coral. For the reflection of the sun on the water, a bright orange, a yellow, and one bold, dense stroke of white against the dark sky will really pop. Finally, to indicate the rays of sunlight, drag color over the clouds in very light strokes, then go over them with a fine-pointed brush dipped in solvent for emphasis.

This painting is an interpretation, not a literal rendering, of the scene in the photograph. To capture such dramatic natural phenomena, you need to base color and compositional choices on your own artistic instincts and feelings about the subject.

ASSIGNMENT

Don't discard paintings that just don't work out; instead, recycle those surfaces. Find a painting you're not happy with—one that you've done on a surface such as sanded board or watercolor paper that's sturdy enough to tolerate wiping with a damp rag. Wash off the image and let the surface dry. Then let the traces of color and abstract tone that remain inspire a new painting. You'll be surprised at the ways you can exploit your failures.

Capturing the Drama of a Summer Sunset

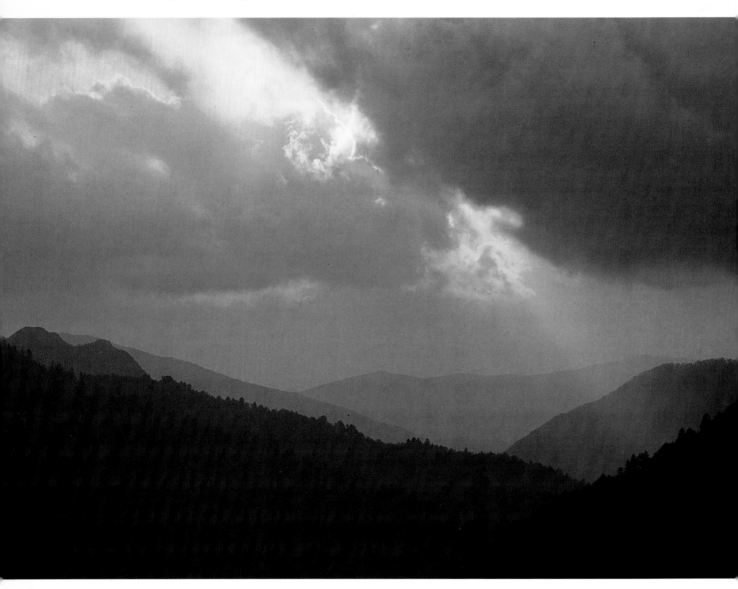

PROBLEM
Brilliant rays of sunlight shoot out from between parting dark clouds, infusing the sky and land with a warm, colorful glow. Conveying the full impact of the scene won't be easy.

SOLUTION
Use a broad array of bold hues, but keep your darks really dark so you attain the sharp contrast needed to accentuate the brilliance of the setting sun.

Above the rolling blue contours of the Great Smoky Mountains, thick clouds part to reveal the glowing sun.

STEP ONE

Use a warm tan or bisque-colored paper as your ground, letting its hue stand as your middle value. Make your charcoal sketch on the smooth side. Then quickly stroke in the shapes of the clouds and land forms. Work from dark to light using colors that range from a dark brown to burnt sienna, blues, and violets, then to pink, deep yellow, and a light yellow. At this point, let the colors blend themselves as you drag one hue over another.

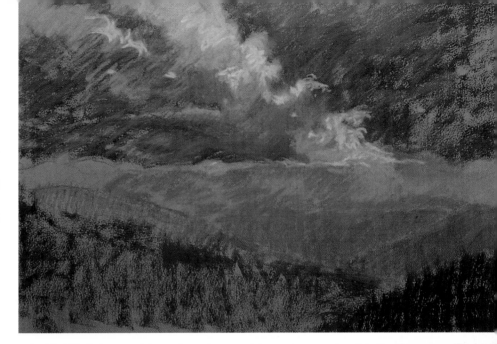

STEP TWO

With your color and value foundation in place, continue to build upon its structure. Apply color so it further describes form, blending wherever you need modeling, especially in the clouds. Remember, your darks need to stay strong to set off the brilliant sunlight.

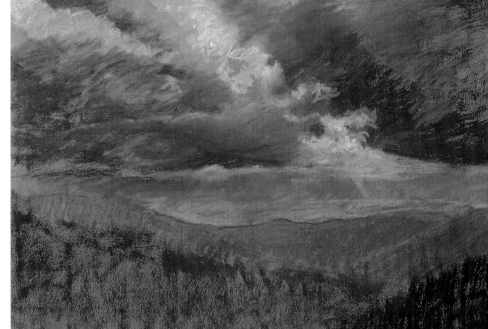

STEP THREE

Work back over the entire painting to refine color and value. Concentrate especially on solidifying the land forms with color, defining the contour of one mountain against another and strengthening the foreground darks. Sharpen the horizon line; you need strong edge contrast there. The edge and value contrast between the dark cloud and pink sky at right must be particularly strong; otherwise the dramatic effect of the sun breaking through the clouds will be lost.

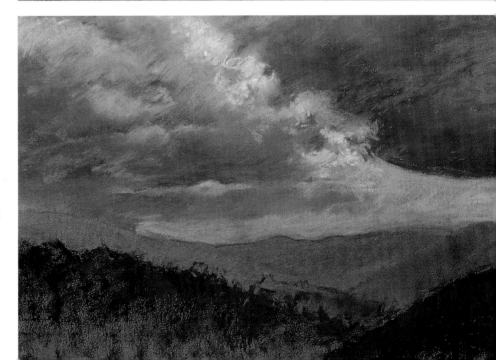

FINISHED PAINTING

Soften transitions between colors in the clouds, modeling their forms as you go. Then strengthen your lights for impact.

The finished painting, a fascinating study of bold color and contrast between solid forms and soft, ethereal ones, truly conveys the exuberant burst of sunlight through the heavy, brooding clouds.

Note how color has been subtly blended to create soft, transitional passages that help describe the softness of the cloud mass.

These few, simple strokes of orange suggest the direction of the sun's rays over the land.

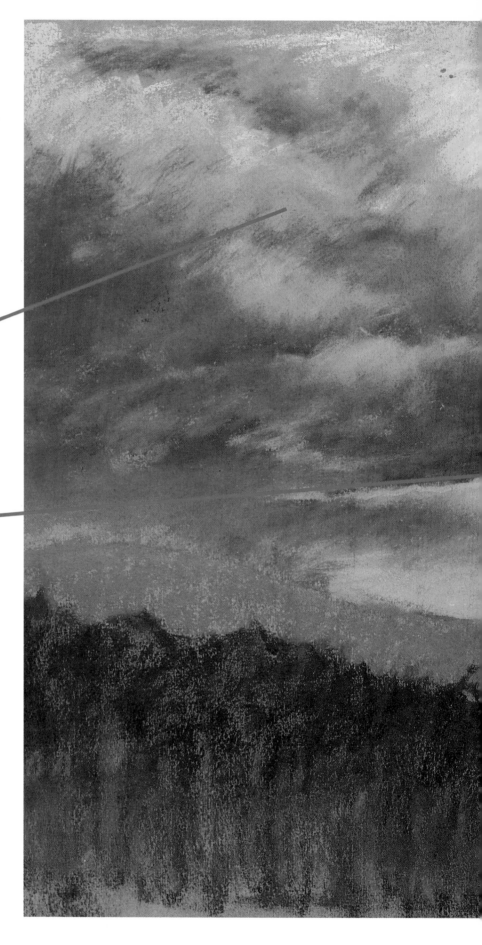

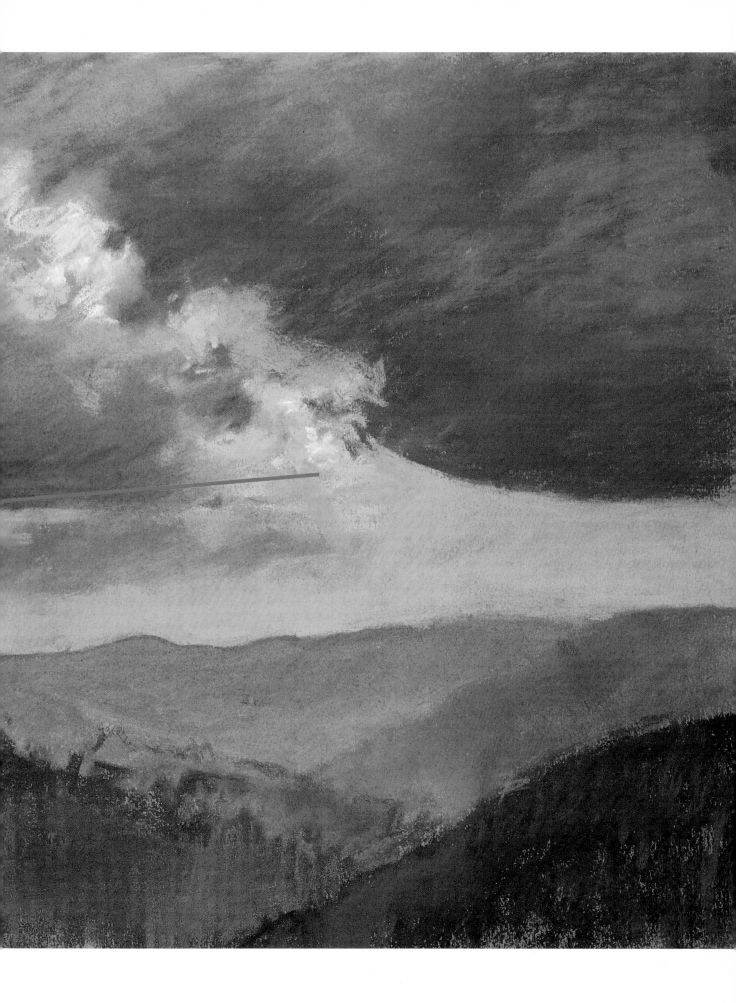

Exploring Color and Pattern in a Cloud-Streaked Sky

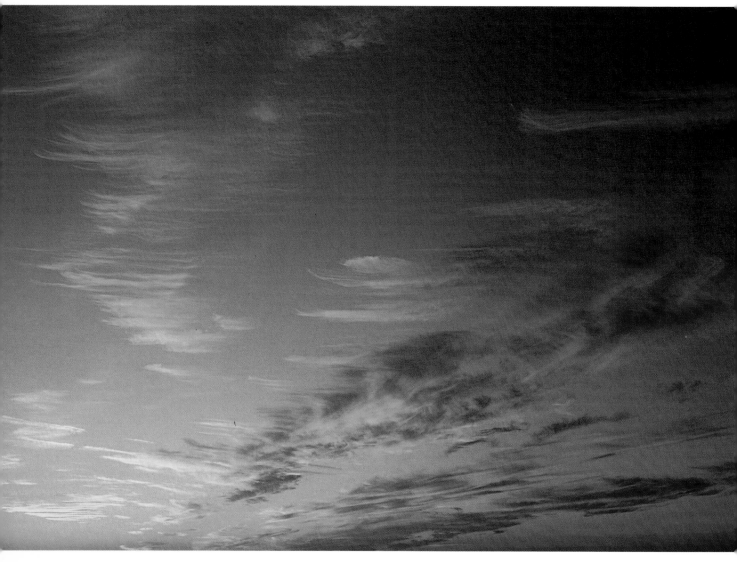

PROBLEM

What makes this abstract-looking sky so interesting is its animated quality. You have to figure out a way to preserve that feeling in your painting.

SOLUTION

Don't bother with a preliminary drawing; a spontaneous approach will help you capture the liveliness you're after. Lay in the sky colors first from top to bottom, but leave parts of the paper open where you'll subsequently add the clouds.

Wispy streaks of cirrus clouds reflect the rosy colors of the setting sun.

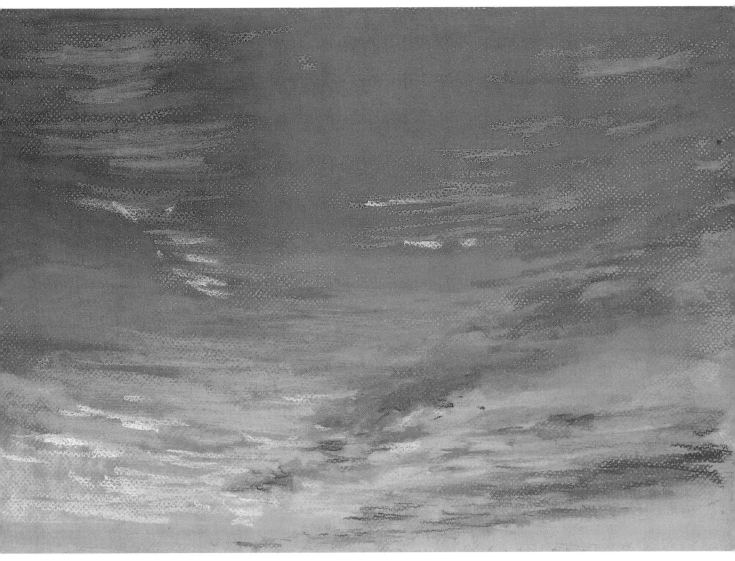

☐ On the rough side of buff-colored paper, apply color to the sky in broad, sweeping strokes using the side of your pastel sticks. Start with the deep, intense blue of the sky overhead, gradually working your way toward the horizon and its warm peach colors. Don't paint the sky solid; leave areas uncovered for the cloud shapes. Blend the blues of the sky with your finger, taking care not to fill in the spaces left for the clouds. Fingers tend to remove less pigment than stomps or rags and yield a smoother tone. This blending method is preferred here, because you need the color of the sky to be rich and deep so it will contrast with the bright clouds.

Depict the cirrus clouds in the upper part of the sky with bold, slightly curving streaks of bright orange and pinkish orange; your strokes need to capture the feeling that these wisps are on the move and about to disperse. Work your way through the sky, painting the clouds as they approach the horizon in bright oranges set off by red-violets and blue-violets. Exaggerate your darker hues to make the lights seem lighter. Reflecting the last of the sun's rays, the clouds at lower left need to be your lightest; paint them as streaks of yellow and white, blending here and there with your finger.

You can almost feel the speed with which these delicate but dynamic wisps of clouds race across the sky before night obscures them.

Rendering a Detailed Silhouette Against a Vivid Sky

PROBLEM

Because the palm's branches are so finely detailed, you might be tempted to paint the brightly colored sky first, then paint the tree over it. But if you do, your darks won't be rich and deep enough to create the extreme contrasts that give this scene its power.

SOLUTION

Establish the palm tree first in a careful and complete drawing executed in black drawing ink and a small, pointed brush. Then paint the sky around and through it.

☐ This subject calls for a fairly dark ground, such as tobacco-colored paper, against which darks will seem darker and lights lighter. Once your ink drawing of the palm is in place, lay in the sky colors. Use soft pastels for the larger areas; apply reds, oranges, and purples in layers, dragging one color over another in light strokes to create a smooth overall appearance. Paint the sun in bright yellows, and make sure it contrasts strongly with the surrounding sky. To weave sky colors around and between the fronds without losing their detail, use pastel pencils and hard pastels, eventually switching to soft pastels to pull everything together.

Lay in your foreground darks, adding these colors as well to the tree silhouette to darken it and give it more depth. Finally, sharpen the edges of the palm tree's silhouette against the sky by using a small, pointed brush dipped in solvent to remove pastel color and expose the ink underpainting.

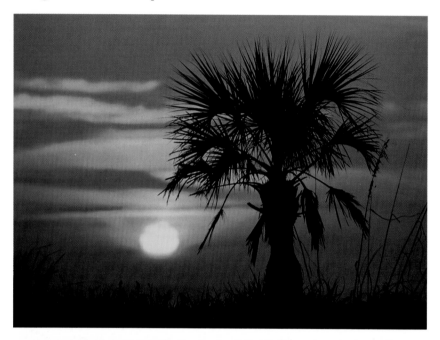

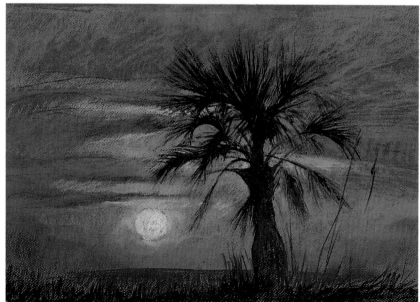

Against the vivid colors of a Florida sunset stands the silhouette of a lone cabbage palm.

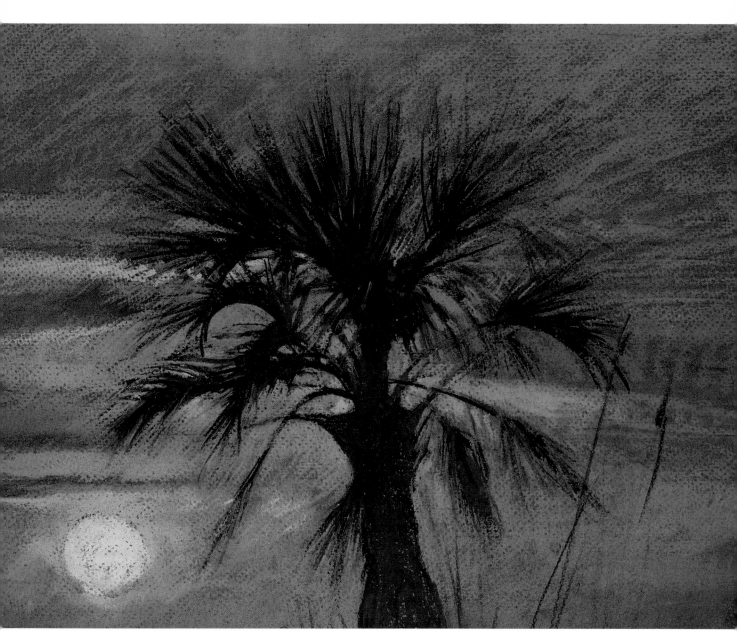

DETAIL
Note how the sky colors and the fine fringe of the palm's fronds are woven together. This helps integrate the tree with its environment, preventing the pasted-down look that often plagues silhouetted images in paintings. The outermost fronds gradually blend into the sky, where in places the warm, dark brown of the paper can still be seen.

ASSIGNMENT
Sometimes a charcoal drawing just isn't a secure enough map for a pastel painting. Black drawing ink is a great help when your subject involves strong contrasts of dark and light. It's invaluable for establishing bold silhouettes with a lot of detail, like the palm tree in this demonstration, and for setting up underlying value structure for complex compositions. If you're not accustomed to using a brush as a drawing tool, practice to gain better control. Use a small round watercolor brush—a good-quality one that holds a point. Make several ink drawings of different subjects to get a feel for the medium. Trees with intricate branch patterns are ideal for this kind of practice; so are scenes that form abstract-looking patterns of dark and light. Once you feel comfortable working in ink, select some of your drawings and work over them with pastel to see how the two mediums interact. You can easily retrieve parts of an ink drawing you've covered up by moving pastel pigment with a brush dipped in solvent.

Emphasizing What's Important

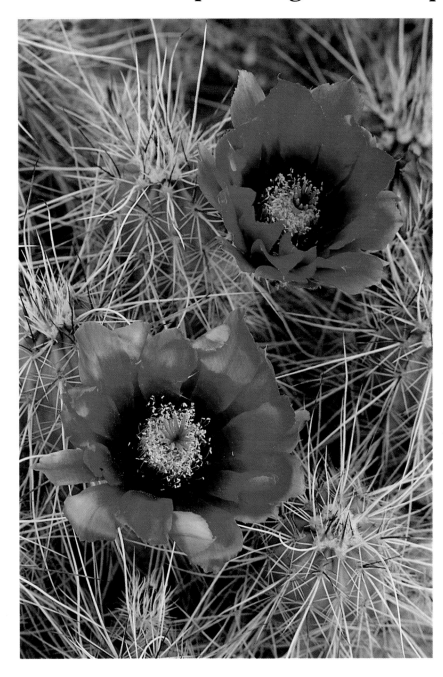

In an Arizona desert, a prickly mammilaria cactus sends forth its lovely blossoms.

PROBLEM

At first glance this scene appears simple, but a second look tells you there's almost too much detail. The beautiful cactus flowers are the obvious focus, but the intricate network of sharp needles that surrounds them is too important to ignore.

SOLUTION

Go ahead and render the flowers' forms accurately, but just suggest the needles between them, and use dark values to suggest depth.

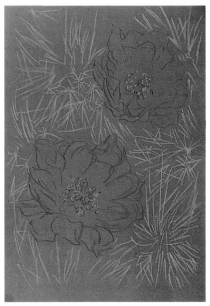

STEP ONE

Use a medium-dark paper keyed to the cool blue-gray tones of the cactus plants. Make a preliminary charcoal drawing of the blossoms. Then, with simple, linear strokes of a light gray, suggest the pattern of the spiny cactus needles in the background. Next, outline the flower petals with their basic local color, a medium-value red-violet. Outline the shapes of the stamens with yellow. The color structure of your painting is now established.

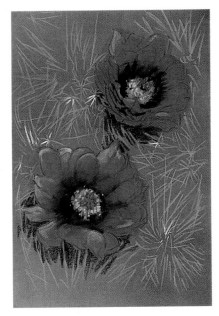

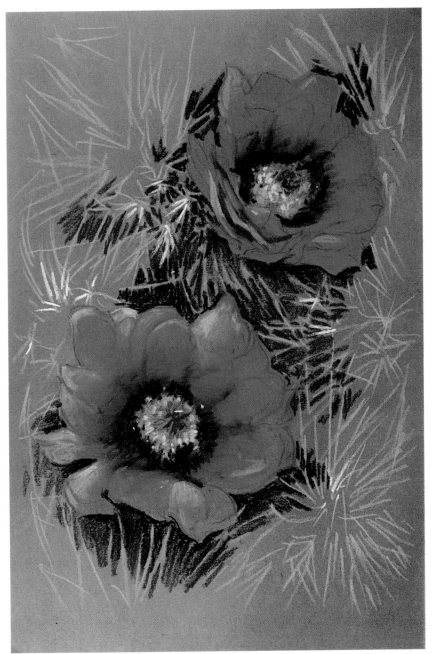

STEP TWO

Work with a variety of red-violet values to develop the flowers' forms, modeling the petal shapes carefully to suggest volume. Aim to keep your colors clean and vibrant. The lightest values belong at the tips, where the petals are closest to the light source, and the darkest values toward their centers, where they are in shadow. Use black around the yellow stamens for contrast, as well as just beneath the two blossoms to make them stand out from the background. Add a few strokes of cream and white as highlights on some of the needles.

STEP THREE

Continue developing the darks surrounding the flowers and between needles, using black along with a dark blue-gray. Use a dark green to paint the details at the very centers of the flowers.

FINISHED PAINTING (OVERLEAF)

Add more black above the to flower to sharpen its profile against the background. With a few more adjustments to the darks and sharpening of edges for depth, the painting is finished. The soft, glowing red-violet blossoms contrast beautifully with the spiky texture of the cactus needles.

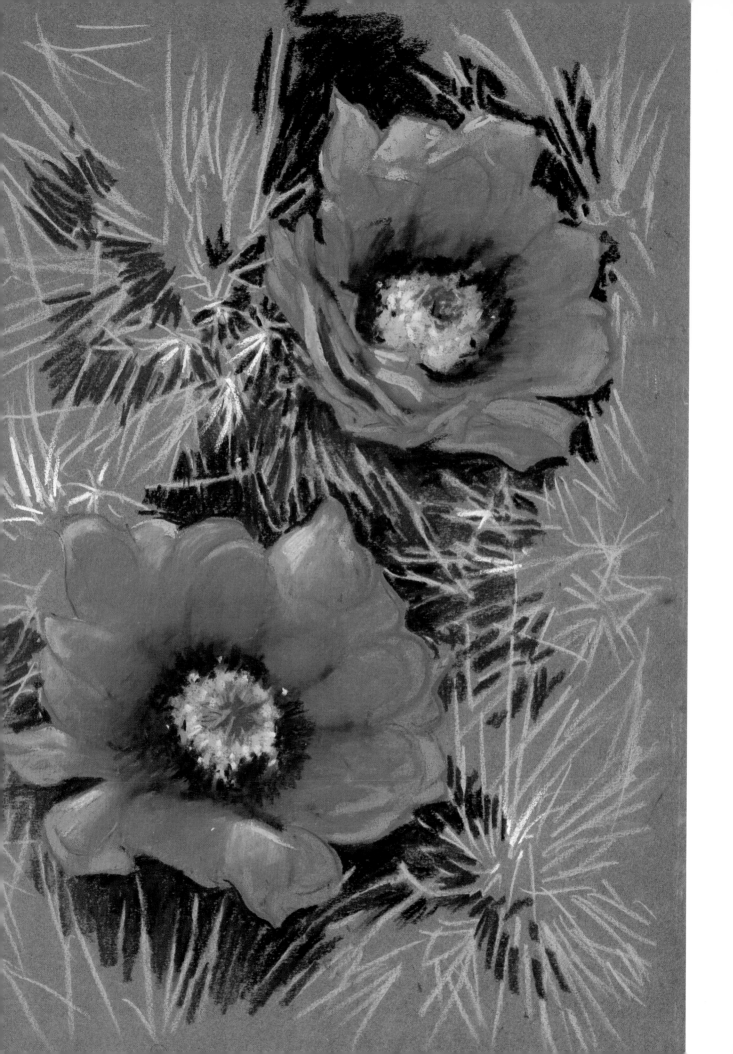

Composing with Simple, Repeating Shapes

PROBLEM

What makes this peaceful scene so special is just what makes it a difficult subject to paint—repeating, soft-edged shapes, a limited color range, extremely subtle value shifts, and no real focus.

SOLUTION

Play up the feeling of vast space by choosing a long, narrow horizontal format, and concentrate on controlling values to create the illusion of receding planes.

☐ Make a simple charcoal sketch on a medium-gray ground that is about twice as wide as it is long. It's a good idea to vary the size and shape of your paintings, because when you work in the same height-to-width ratio, you tend to repeat your spatial arrangements of compositional elements. Here, all you need are a few lines to divide the surface into the bands of mountains.

Lay in the basic color and value structure of the painting, and don't slavishly follow what you see in the photograph. Layer on blues, violets, and grays in overlapping strokes of varying values for the mountains, with the darkest darks in the foreground. For the narrow band of sky, use a mixture of bright orange and pink—a brilliant, warm contrast to the cooler, darker hues of the mountains.

Concentrate on developing value and color subtleties; let blues show through violets and let pinks show through grays to create a vibrating effect. The contours of individual mountains should be distinct enough to suggest the valleys between them but not so hard-edged that they become flat, one-dimensional shapes.

With its subdued color and extremely simple forms, the finished painting evokes a feeling of gentle, almost infinite space.

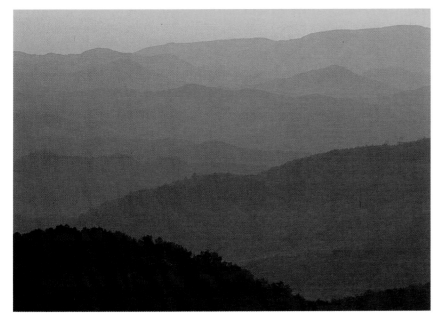

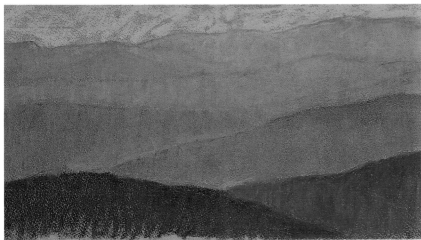

In seemingly infinite waves, blue mountains stretch toward the Tennessee horizon.

ASSIGNMENT

Try formats with unusual proportions. A long, narrow horizontal format or a square one might inspire you to see your subject in a unique way. Try working larger than you normally would, too; although you may feel some loss of control at first, chances are you'll discover that painting on a big surface gives you a great sense of freedom.

Exploring Form and Detail in a Closeup

PROBLEM

What makes this image so interesting is the juxtaposition of the shells' varied forms, subtle colors, and distinctive markings. If you generalize too much, your painting will look flat and merely decorative, like wallpaper.

SOLUTION

Make an extremely detailed drawing in charcoal pencil to establish the form and placement of every shell, and then build color slowly in a linear technique using pastel pencils and hard pastels.

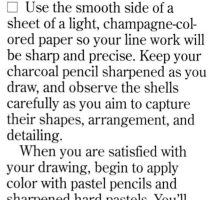

☐ Use the smooth side of a sheet of a light, champagne-colored paper so your line work will be sharp and precise. Keep your charcoal pencil sharpened as you draw, and observe the shells carefully as you aim to capture their shapes, arrangement, and detailing.

When you are satisfied with your drawing, begin to apply color with pastel pencils and sharpened hard pastels. You'll need a range of grays, blues, violets, browns, and oranges, plus a deep rose and white. Build color slowly in controlled linear strokes so the shell shapes and contours remain legible and their textures distinctive. With a design as complicated as this one, you'll find that to maintain order you need to work over the entire painting, developing all areas at about the same rate. To define individual shells, keep edges crisp and sharp by adding dark accents against the lights. And because so many of the shells are very light, even white, it's important that you exaggerate their value and color range; this will make it easier to render the shadows, profiles, and convex and concave contours that describe three-dimensional form.

Finally, stand back from your work and check to see how well individual shells read. Darken the spaces between some of them to enhance the feeling of depth; sharpen any edges that may need stronger separation.

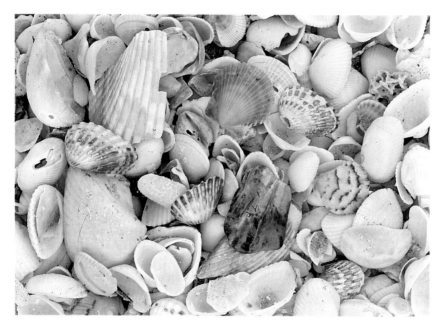

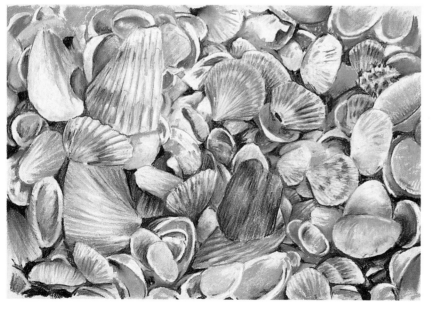

On the shores of Sanibel Island, the ocean has yielded up a rich bounty of delicately colored and patterned seashells.

Evoking the Feeling of Receding Surf

PROBLEM

Your painting will succeed only if you are able to capture the color, value, pattern, and movement of the water. Each of these elements must work, or your painting won't read intelligibly.

SOLUTION

Analyze the water's anatomy— the lacy foam pattern and the gentle waves forming just beyond. Examine how the water relates to the shore. Capture all these details in a strong drawing, then build color slowly using pastel pencils and hard pastels.

☐ On a sheet of light gray-green paper, draw the scene carefully in charcoal pencil, taking the time to concentrate on every detail. It's important to capture the water's underlying structure at this stage. Begin to add color to define the water's complicated patterns. Establish the value and color range of the whole painting, but don't add your lightest lights too soon. For the water you need a good range of blues, blue-greens, greens, violets, grays, a pale orange, and white; for the sand, a range of ochers and related earth hues.

Use long, horizontal strokes of cool blues and greens to describe the gently rolling waves in the distance, and take care in rendering the transition from that area to where the foam pattern begins. The lightest areas of the foam are infused with a warm light, so use a very pale orange and creamy white to depict them; these hues will contrast nicely with the cooler blues and greens of the rest of the water.

Using your earth hues, paint the sandy beach in long, nearly vertical linear strokes that radiate from the water's edge, widening as they approach the foreground to help describe the wave's receding. Add a few small touches of white on the sand to suggest traces of sea foam.

The edge that separates the receding water from the beach is very important; model it carefully with subtle, thin, curving strokes of gray and brown.

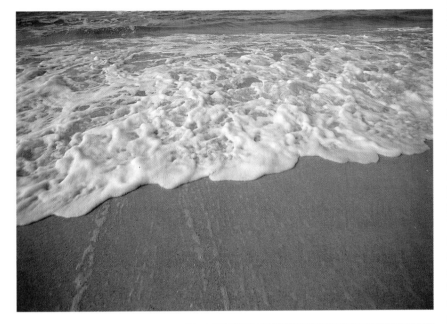

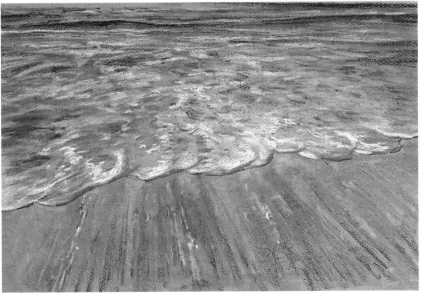

Sea foam deposited by a crashing wave retreats from the smooth sands of a Florida beach.

Learning How to Paint Rapidly Moving Water

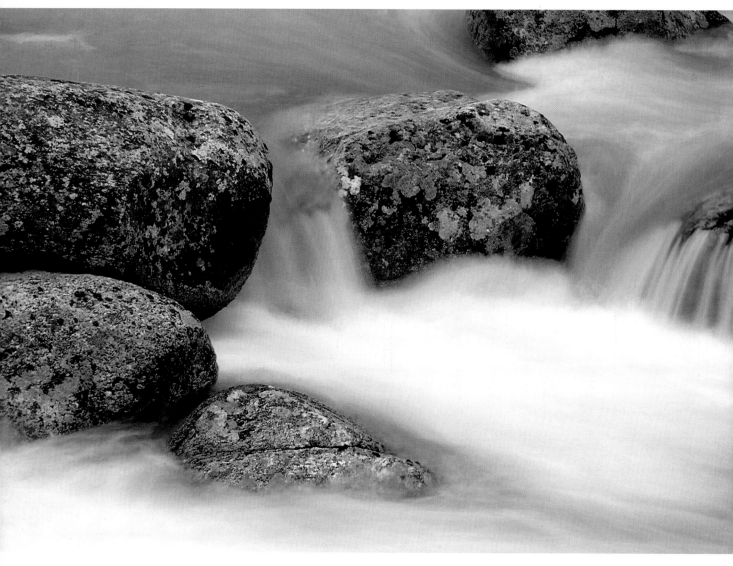

PROBLEM

In contrast with the highly textured, lichen-covered rocks, the rushing water appears as a soft white blur. Yet if you paint the water the way you see it, you'll lose all sense of its dynamic quality.

SOLUTION

Simplify the rocks' texture to play down their drama, then use crisp, clean linear strokes to define the water's movement.

☐ Although expressing the forceful motion of the water calls for a somewhat linear handling, the scene has a painterly quality that also deserves attention. La Carte Pastel board, the support used here, is a slightly abrasive but soft surface on which pastel strokes spread somewhat for a painterly feel while retaining crispness where you need it. For this subject, a light gray board is an appropriate choice. On this surface, make a simple charcoal drawing to establish the main compositional elements.

Once you have a workable drawing in place, begin to lay in your dark values, letting the gray board serve as the middle value. Define the darkest parts of the rocks with short, choppy strokes of black, dark grays, gray-violet, and dark browns, following their contours as you apply color while simultaneously concentrating on their mottled lichen pattern. For the water, your darkest values are a dark bluish green, dark green, medium green, and some grays, all applied in long, flowing strokes that convey

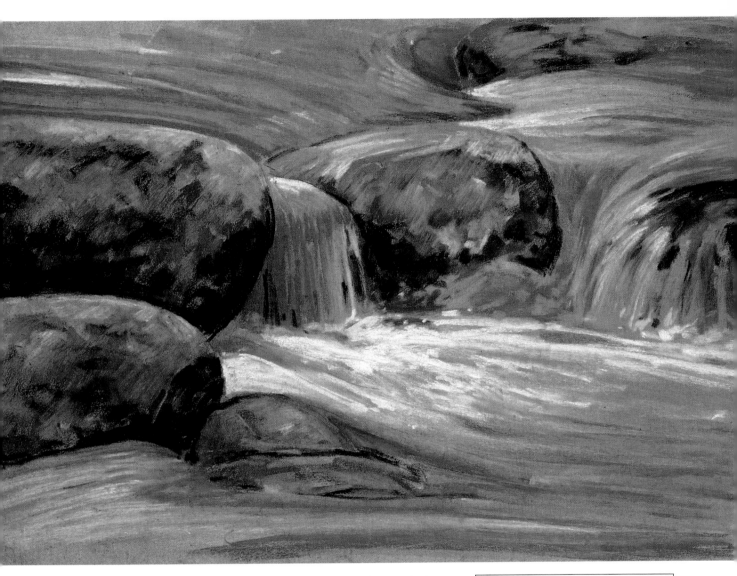

the flow of the stream.

Move upward in the value scale throughout the composition. For the rocks' middle values, use a couple of olive greens, burnt sienna, muted violet, light blue-gray, and a medium burnt umber, again applying color to achieve a mottled effect but muting it so the water's texture can dominate. For the light rock values, use a pale gold ocher or pale orange. As you turn your attention to the water, concentrate on defining the way it curves and eddies around the rocks, helping to define their contours. Medium grays, blues, and violet work for the middle values here. It's the lightest value—white—that will really convey the water's forceful motion, so take pains in the way you apply it. In selected areas, use linear strokes that describe the directional flow of the stream; just below the little cascade near the center of the composition, apply thicker, shorter, more irregular strokes that convey the splashing, spraying feel of rapids.

ASSIGNMENT

Execute several closeup studies of water. For each, focus in on a square foot or less of water, then draw the composition slowly, capturing every detail. Look for submerged rocks, vegetation, and the patterns formed by mud, stones, or weeds that lie beneath the surface. If your subject is likely to change rapidly, photograph it, then work from these photos back in your studio. Sketching closeups will train you to really look at what you see. You may like your studies well enough to translate them into finished pastel paintings.

Establishing Structure with an Ink Underdrawing

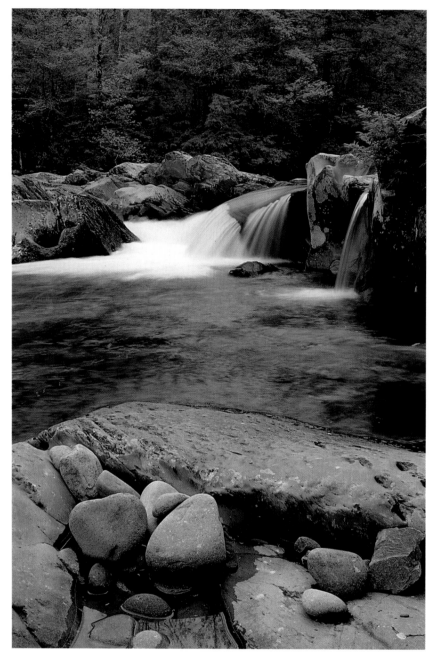

PROBLEM
The white water rushing down and around the rocks lends excitement to this otherwise quiet scene. To capture this effect you need strong contrast, but must control it so the water doesn't end up looking artificial.

SOLUTION
State the overall pattern of your darkest values first in black ink; this will make it easier to judge all other value relationships and set up areas that call for significant contrast.

STEP ONE
Make your initial drawing in black ink on gray paper, establishing all your darkest values. This will be the foundation on which you'll build the rest of the painting.

Swelling with springtime rains, the Little Pigeon River spills over a rocky waterfall in the Tennessee woods.

STEP TWO

Working back over the ink drawing, lay in the painting's overall color range—various dark to medium greens for the trees, plus a light yellow-green for highlights; grays, blue-gray, and light but muted earth colors for the rocks and calm water, plus some strokes of white for the rushing water. At this stage the black ink still serves as your darkest dark in most areas, but in the calm water and foreground rocks you can add dark brown and dark blue to start building depth.

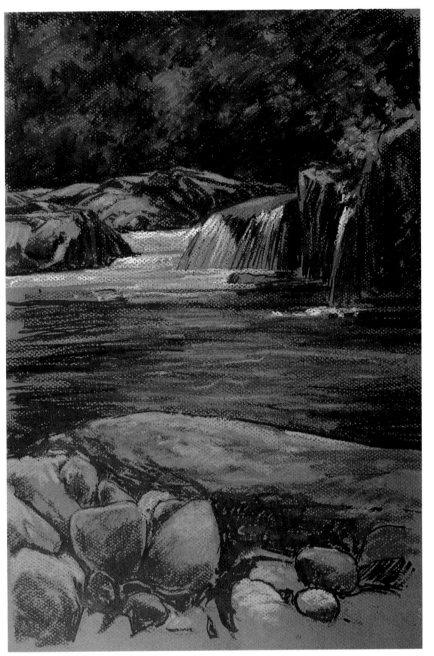

STEP THREE

With color, reestablish the darks you originally stated in ink. Define the foreground rocks further, and keep refining colors and values all over the painting. Then focus your attention on the center of the composition, adding very dark colors to the rocks so they will contrast with the white water. Limit your lightest lights—strokes of white—to the rushing water so it will really come to life against the dark rocks and background foliage.

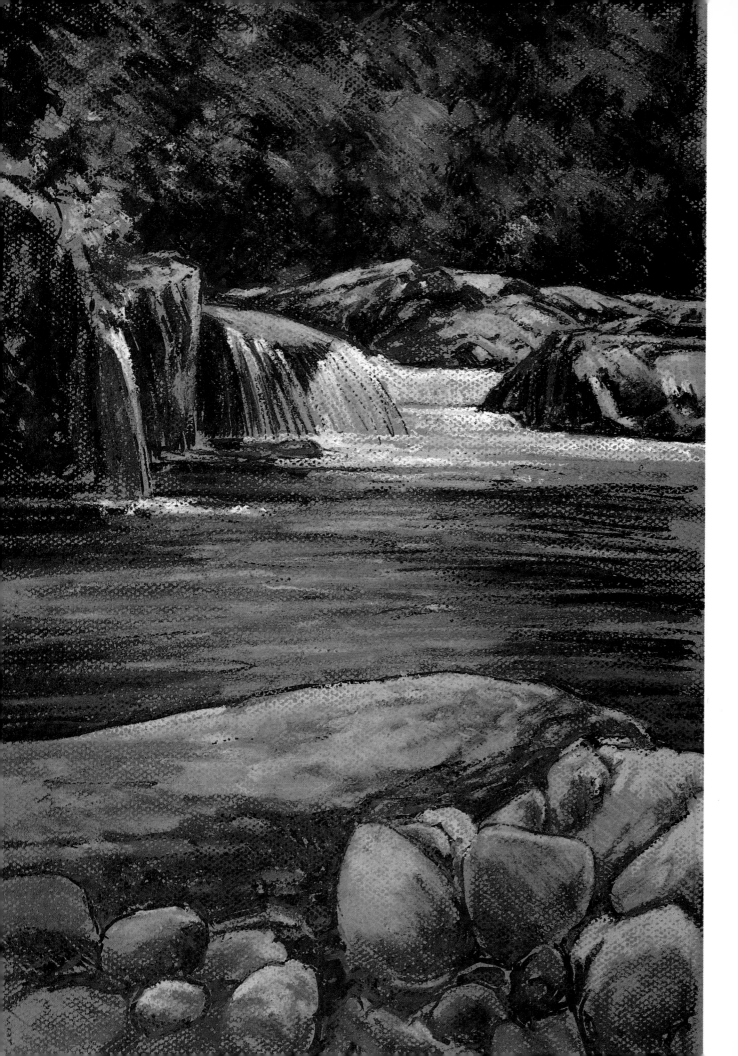

FINISHED PAINTING
As the painting nears completion, strengthen colors without changing values. Use long, horizontal strokes of various blues and blue-greens, along with a few shorter strokes of violet, to further define the calm water. Sharpen the edge between the middle-ground rocks and the background foliage, and between the foreground rocks and the water.

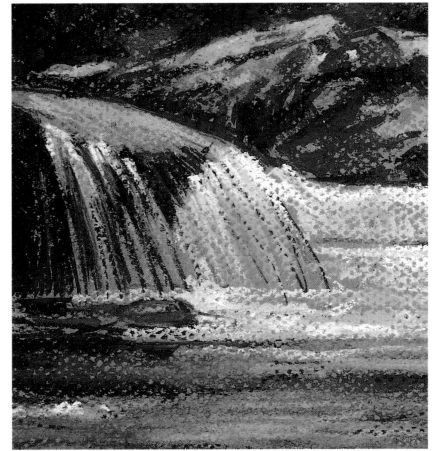

DETAIL
What makes the rushing water really sparkle are the very few, deftly placed touches of white over its predominantly gray local color.

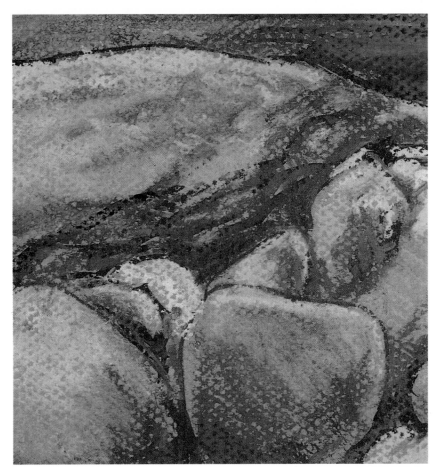

DETAIL
The black ink drawing can still be seen through the pastel in a number of areas. Note in particular how it helps the foreground rocks maintain their shapes.

179

Working Negative to Positive

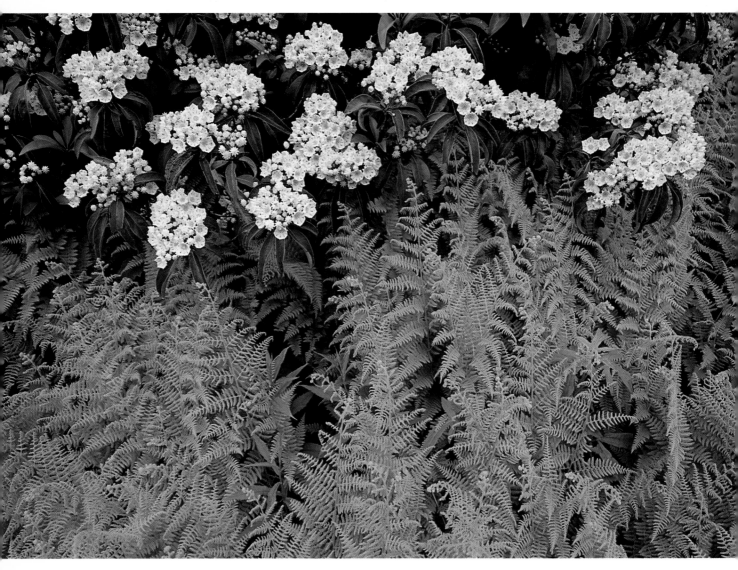

PROBLEM

The lacy, delicate ferns and intricately patterned mountain laurel blossoms make for an interesting juxtaposition of complex textures, forms, and colors. How can you sort out all the detail?

SOLUTION

With a subject as detailed as this one, it's best to lay in the dark negative shapes first so you have some structure to build on.

☐ Make your charcoal drawing on a sheet of medium-dark green paper. Then develop the shapes of the flowers and ferns by painting the very dark green negative shapes behind and around them. Use a variety of dark green pastel hues, plus dark blue and some black.

Once you've established these darks, begin to lay in the lighter greens of the ferns, as well as

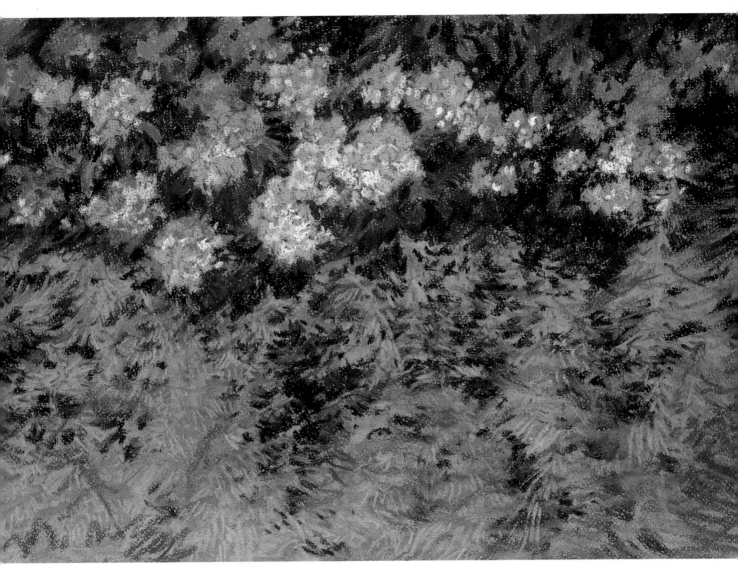

Lacy fern fronds surround a stand of pink-blossomed mountain laurel.

some of the pinks for the flowers. Work back and forth between the light ferns and dark green negative spaces, and follow the same procedure for the flowers. Let your strokes of color follow the plants' contours and textures: Use short, linear strokes to describe the ferns' delicate fronds, and very short, rounded strokes applied in clusters to describe the individual

segments of the mountain laurel blossoms.

As the painting progresses, keep working back and forth between positive and negative areas to further define form. Aim not so much to describe, but to suggest the delicate anatomy of the ferns and flowers; you can't hope to draw and define each one in intimate detail. What's important to emphasize here are

the contrasts between their forms and colors.

When your painting is nearly completed, step back from it. Does the lacy quality of the ferns come across? Are the mountain laurel blossoms varied enough in shape and value, and does their color leap forward? Use your dark values around any light areas where further contrast may be needed to sharpen form.

Using Darks to Organize Composition

PROBLEM

Because both foreground and middle ground are in sharp focus, there's so much detail that it's going to be difficult to lead the eye comfortably through this scene and maintain any sense of spatial depth.

SOLUTION

Determine the pattern the dark values make, then use it to organize your composition and create the illusion of receding space.

☐ On a sanded surface, in charcoal define the trees and distant hills as flat shapes with no interior detail. In the foreground, with pastel, establish the dark, negative shapes between the laurel blossoms. Continue the pattern of darks toward the middle ground, simplifying it to lead the eye back in space. Also establish the dark tree line. To lay in this dark value structure quickly, put down pastel color first and spread it with a brush and solvent.

Now add color to all areas. For the foreground flowers, stroke in a deep rose color, indicating a few smaller spots of this hue in the mid-distance. Soften these flower shapes with a brush and solvent. Paint the leaves in overlapping linear strokes of various greens. Simplify detail as you move toward the background to make the foliage recede.

Develop the mountains and sky as areas of flat, nearly solid color. Paint the blues of the mountains around the tree branches; you'll restate them later.

Go back to the blossoms in the foreground. Add small, rounded strokes of red-violet, rose, and pink, and touches of cream and pale blue. Restate negative dark areas wherever contrast is needed. Suggest the texture of the trees with olive green and black. With a medium-value green, sharpen the edge between the dark tree line and the mountain laurel foliage. With a brush and solvent, bring the blue mountain color around the pine branches.

Check the pattern of dark values. The eye should linger in the foreground, where the darks contrast strongly with the bright pink flowers, then move slowly across the middle ground, following the gradual dispersal of the pattern toward the background.

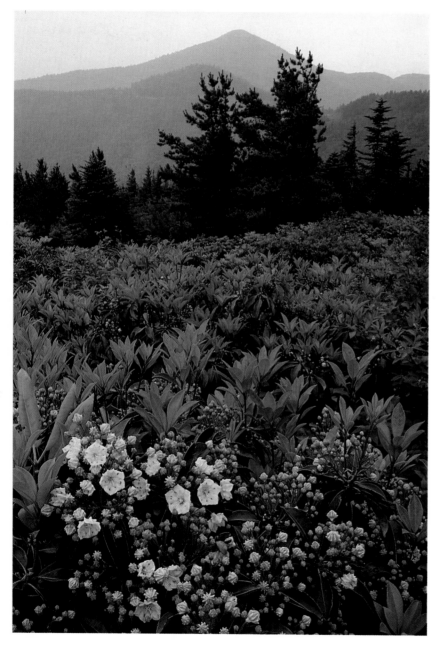

Mountain laurel shrubs unfurl bright new leaves and flower buds to greet the arrival of spring.

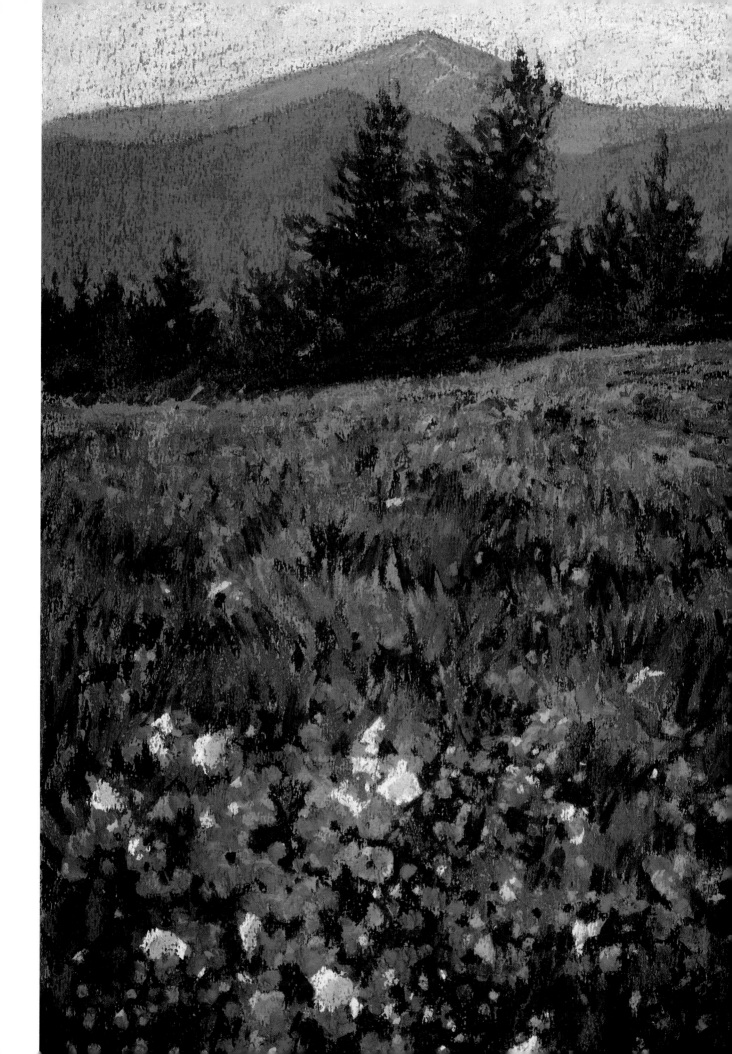

Building Bright Color on an Acrylic Underpainting

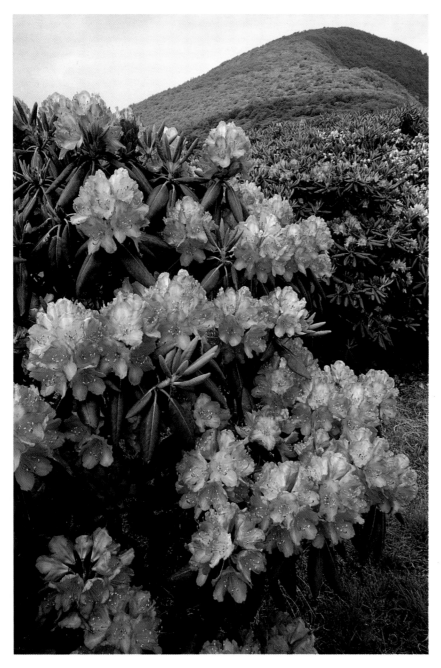

On a warm, sunny day in the Blue Ridge Mountains, brilliant pink rhododendrons blaze in glorious display.

PROBLEM

The lush greens and vivid pinks of this scene are almost unbelievable in their intensity. Somehow you have to capture the rich, saturated feel of the colors, which are the real subject here.

SOLUTION

To make the pink rhododendron blossoms really pop, you need the strong value and color contrast of a deep green ground. A wash of phthalo green acrylic will do the job.

STEP ONE

On a sheet of watercolor paper, lay in a wash of phthalo green acrylic paint (to which you can add other dark greens), letting it run freely from bottom to top. When this is dry, make a simple charcoal sketch of the flower pattern and hill silhouette. Then, with pastel, begin to lay in the blossoms' vivid rose and pink colors, at this point just suggesting the flower heads as masses of color, with no attempt at showing individual petals.

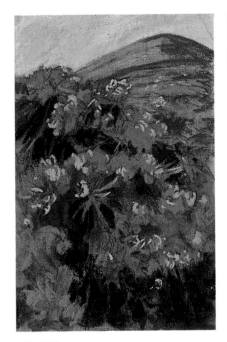

STEP TWO

Paint the sky with short, broken strokes of warm ocher and cool light blues, and define the hillside in the distance with layers of various greens. Now turn your attention to developing the flowers. Strengthen their pattern so it leads the eye back in space; then model their forms in the foreground by developing the negative darks of the shrubs' foliage and interior shadows around and through the blossoms. Use the darks to sharpen and refine the drawing of the flowers' edges. Add a lighter pink value to further model some of the petals, and suggest a few individual leaves with curvilinear strokes of a medium green and yellow green.

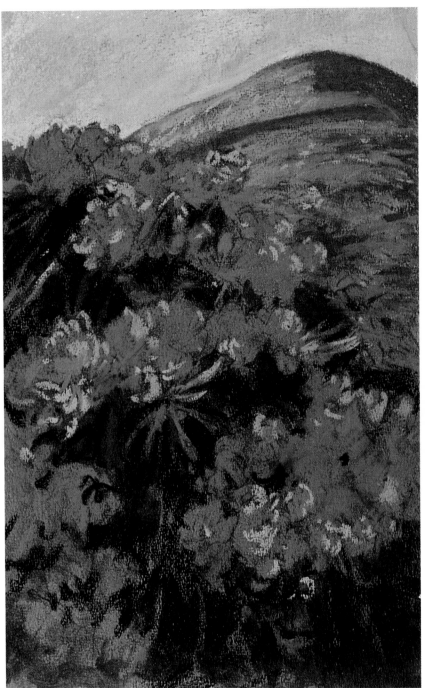

STEP THREE

Work back and forth between the positive flower shapes and the dark values that surround them. Add some warm and cool greens and blues to the hillside; there, too, restate the simple spots of rose and pink color that indicate the flowers receding into the distance. A very subtle, softly blended stroke of pale pink along the left edge of the hillside helps animate the sky.

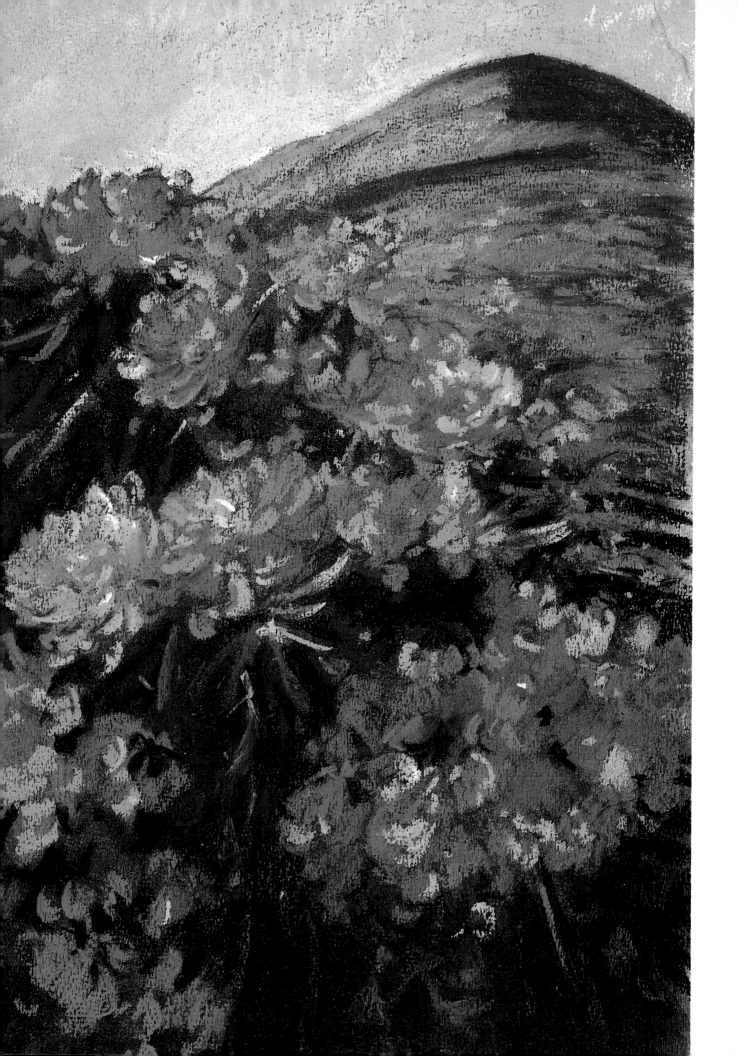

FINISHED PAINTING
Refine the flowers' forms fur-
ther, adding violet to petals in
shadow and a few strokes of pale
blue and white for highlights.
Strengthen darks along the right
side of the composition to help
define the ground.

DETAIL
What makes this painting work
is the dark green ground show-
ing through the rhododendron
blossoms, sculpting them and
supporting their vivid color.
The contrast is one of both
value—light flowers on a dark
ground—and color, the warm
reds and pinks complements of
the cool greens and blue-greens

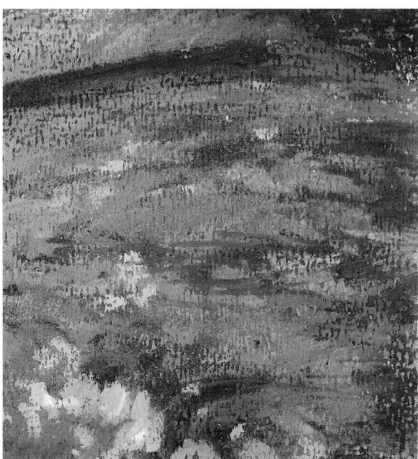

DETAIL
The flowers in the distance are
indicated as no more than spots
of color, helping to convey the
illusion of receding space.

Learning How to Paint Transparent Drops of Water

PROBLEM

Two challenges confront you here: the delicate form of the violet and the drops of dew that cling to its petals.

SOLUTION

Develop the flower, grass, and background first, then concentrate on painting the dewdrops. Leave out some of the droplets you see so you can emphasize the importance of those that remain.

☐ Sketch the flower and some of the larger blades of grass in charcoal on a sheet of light green paper. Quickly lay in patches of color in the background, which is a simple, abstract blur. State the color of the flower, as well as the greens of the foreground and blades of grass.

Continue developing the form, color, and details of the violet. It's in sharp focus, so its edges must be crisp against the background. Add more color to the background, and begin to pull these areas together with blending. Now work back and forth between the flower and the background, exaggerating color and value contrasts as you go and always keeping the violet's edge sharp and well defined.

Now for the dewdrops. Each is made up of a highlight, a shadow, and a cast shadow, and much of their color is what shines through them—in other words, for most of them, the violet's local color. Using small, circular strokes, lay in dabs of a hue just slightly darker in value than that of the flower's petals to define the shapes of the dewdrops. Then work with lighter hues— white, light orange, light yellow—to model the droplets' form. Define the shadows they cast on the violet's petals with small, half-round strokes of a medium-value blue or blue-violet. Don't forget the droplets on the grass; their local color will depend on their location.

To finish, check all value relationships and sharpen any edges that may need it. Restate the darkest blades of grass and the dark blue linear markings on the violet, and make sure the dewdrops are well defined.

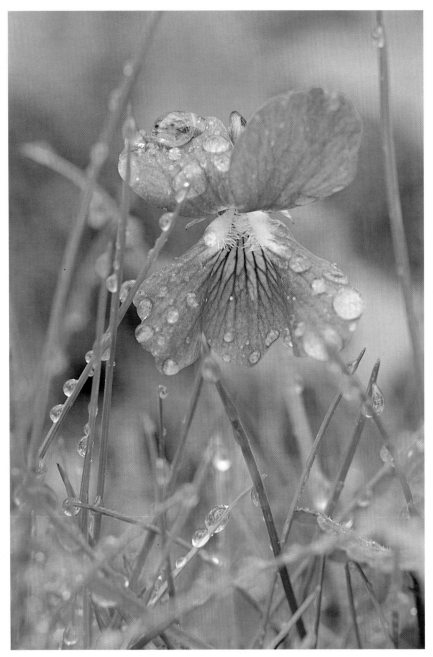

In spring, a blue violet sprinkled with dew awakens to a new day .

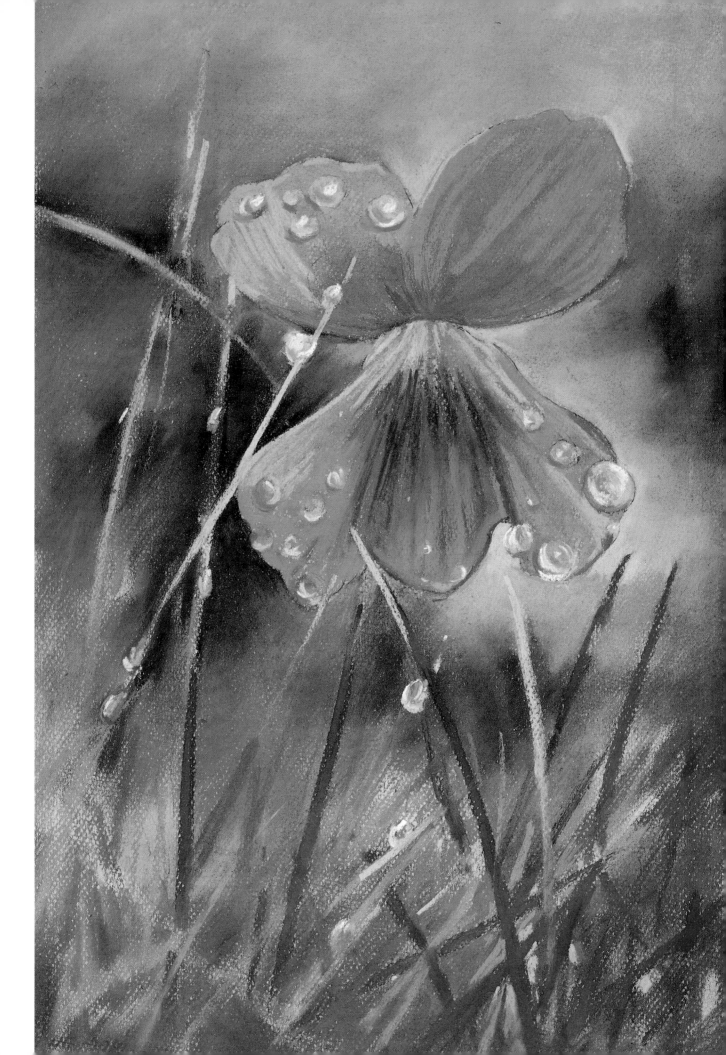

Index